Rémy Desquesnes
Foreword by James A. Fox

WITNESS
MAGNUM
PHOTOGRAPHS
FROM THE FRONT LINE OF
WORLD WAR II

Flammarion

CONTENTS

Foreword

4 **"The most horrible war pictures will
never end wars." (Robert Capa)**
by James A. Fox, former editor in chief
of Magnum Photos

Introduction

6 **Photography and history**
by Rémy Desquesnes

8 **1939–40**
Churchill's Britain alone against the Axis

10 The Blitz in London
18 De Gaulle in London

20 **1941**
The war becomes global

22 Africa
24 East Africa
28 The Levant
30 USSR
34 East Africa
36 Transjordan
38 Iran
40 China

44 **1942**
The Axis reaches its apogee

46 Burma
54 China
56 The Near East
58 USSR

64 **1943**
Hope changes sides

66 Poland
68 Tunisia
74 Algeria
76 Sicily
82 Italy
86 The Pacific
90 China

92 **1944**
The Axis powers in retreat

94 Italy
98 Great Britain
100 France

124 **1941–45**
The War in the Pacific

136 **1945**
Victory for the Allies

138 Germany
152 Belgium and Luxembourg
154 Germany
156 The world of the camps
158 The Pacific
164 Japan
166 China

168 **1946**
Peace among the ruins

170 Germany
180 Children of the war

184 **Bibliography**

186 **Photographers and collections**

188 **Magnum collections**

189 **Photo credits**

190 **Map of World War II
theaters of operations**

191 **Acknowledgments**

Foreword

"The most horrible war pictures will never end wars."

ROBERT CAPA

Never would I have imagined that forty-three years later I would be asked to recall my thirty years working and editing in the Magnum Photos offices of New York and Paris, and to discuss the role of the agency in the photographic coverage of wars.

After three years in the RAF, a stint at the Supreme Headquarters Allied Powers Europe (SHAPE) in Paris and then ten years at NATO headquarters in the Information Service, escorting press teams on military maneuvers along the Iron Curtain amongst other things, in early 1966 I joined the Magnum Photos agency in New York as chief librarian. Here, I undertook the reorganization of the photographic archives, as Magnum's major problem was that each time a librarian resigned their visual memory left with them.

So, what was I in for? A group of photographers, male and female, from multiple nationalities with the initial idea and spirit of four outstanding photographers who met in the 1930s and covered the Spanish Civil War, both in stills and film.

Among them was Gerda Taro—whose real name was Gerta Pohorylle—who was born in Stuttgart to Jewish immigrant parents; a young man by the name of Endre Ernő Friedmann (Robert Capa), born in Budapest on October 22, 1913; and a third photographer called David Szymin, born in Warsaw in 1911, who everyone knew as Chim Seymour and who had come to Paris in 1932 to study at the Sorbonne.

In the Montparnasse area of Paris, they met Henri Cartier-Bresson, born in 1908. After studying art and painting under André Lhote, influenced by the surrealist André Breton, Cartier-Bresson turned to photography in the early 1930s. He made two documentaries on the Spanish Civil War (*L'Espagne vivra*, 1938, and *Victoire de la vie*, 1937), and later admitted his regret that he had not taken any photographs of the conflict.

This period was heavily marked by the Spanish Civil War, which was well documented by Friedmann, Seymour, and Taro. In order to stimulate public interest, Friedmann and Taro invented the character of Robert Capa, a mysterious American photographer. Capa's international reputation soared with his photograph of the shooting of a Spanish Republican soldier on September 5, 1937. The image went around the world and remains today an icon of war photography.

Tragically, Capa's companion Gerda Taro was mortally wounded while covering the Republican offensive west of Madrid, and died on July 25, 1937.

When the Second World War broke out, "Chim" went into the American Armed Forces, working with aerial reconnaissance, Cartier-Bresson was a French prisoner of war in Germany, and Capa settled in the United States, doing a great deal of photo reportages for *Life* magazine. It was then that he met British photographer George Rodger, who was covering the Blitz in London.

Both Rodger and Capa were under contractual arrangements with *Life*, and in those days it was the publisher who owned the rights to the photographers' negatives. Such were the working conditions for reportage photographers.

These photographers envisaged the creation of their own cooperative, where they would not only own the rights to their photos, whatever their subject (escaping all editorial sanction or censorship), but would also deal with their own distribution. A sort of brotherhood of photographers who could interpret the world as it was, and for whom reality was the guiding principle.

During a meeting in the second-floor restaurant of the MoMA in New York on May 22, 1947, the name Magnum Photos was registered under New York State laws.

It is interesting to note that Capa wrote to George Rodger in 1952, "Any story without newsworthiness or drama or exceptional photographic quality is half dead on arrival," and declared "the most horrible war pictures will never end wars."

The Vietnam War and its enormous production of photographs were of considerable importance to Magnum, as Philip Jones Griffiths explains in his book *Vietnam Inc.* The American armed forces took the press right into the heart of the battle zones as if they were on day trips. At a time when television and photographic reporting bore witness to the violence of the attacks, in an era of color, sound, and action, war photographers (for instance, Horst Faas, a photographer for the Associated Press in Saigon) engaged in tremendous and brave undertakings. Let's not forget that reporters and still photographers working for magazines faced censorship from their editors—images that were too horrific could not necessarily be put on the front page. It was also a period when female photojournalists entered the arena, working side by side, to everyone's astonishment, with their male counterparts at the heart of the battle zone.

Consequently, photographer Jones Griffiths fought to have his uncensored visual record of Vietnam produced in book form, as *Vietnam Inc.*, first published in the United States and dedicated to the memory of all the war photographers who had lost their lives on the front line.

In 1938, Robert Capa had already produced *Death in the Making*, which underlined the fact that "no tricks are necessary to take pictures . . . you don't have to pose your camera, the pictures are there and you just have to take them." In fact, the "truth" is the best propaganda. He died on the front line in Indochina in 1954, and David Seymour died two years later, in Suez.

Don McCullin presented me with his autobiography *Unreasonable Behaviour* when we met once in the late 1960s, and with his childhood games of soldiers in mind he stated, "I doubt if any of us knew of Robert Capa's amazing picture of the falling soldier in the Spanish Civil War, but that was our most cherished way to die."

It is important to remember the victims of conflicts, but also the many press photographers killed while covering them. Often, the images I saw on the slides and negatives or contacts sheets that were sent to me to edit were so tragic and powerful that the very fact they were still images caused them to be engraved on my mind, much more so than the flickering images on a television screen.

Thereafter, the live broadcast of warfare, initially dominated by CNN, suddenly imposed new electronic exigencies that beamed the battlefield straight into our living rooms by satellite. Public reaction thus became a crucial factor that affected national and international policy.

According to John Taylor in his book *Body Horror: Photojournalism, Catastrophe and War* (1998), war reporting in the Gulf War represents the triumph of bureaucratic censorship over the right to be informed—a war without corpses, where "the act of killing is so impersonal that it scarcely signifies as murder at all."

As for another international war reporter, Sal Veder (Pulitzer prizewinner in 1974 for his work on the Vietnam War), he defined his role as being "to record history, not make it or manipulate it." Inventing stories, making the news "palatable" to the public, may occasion "a kind of moral lethargy and historical amnesia," and create a real danger of the younger generation mixing up reality and fiction. How then can a war photographer file a report without it being twisted or manipulated by the media?

The present volume features some of the finest Second World War pictures by all the photographers with direct links to the Magnum Photos agency—among them several iconic images—as well as images from the archives handled by the agency (including Russian archives commemorating the famous meeting between Bob Capa and the doyen of them all, Dimitri Baltermants, in Berlin in 1945).

It forms a unique testimony of the conflict, of the unflinching engagement of photographers in the war on land, in the air, and on sea, as well as providing visual evidence of the lives of civilians, servicemen, and the wounded.

A concluding word in tribute goes to a man who is a living monument to his profession: John Morris, a photo editor at *Life* magazine and friend of Capa's and of all the founders of the cooperative, whose role in disseminating war images and reports was paramount. It was his actions that later made it possible to preserve this photographic heritage as a respectful homage to its creators and their works alike.

James A. Fox, former editor in chief of Magnum Photos

Introduction
Photography and history

It is no easy task to present some two hundred photographs of the Second World War, selected from the Magnum Photos agency, and show how this exceptional and revealing collection of images contributes to our understanding of the conflict. For historians, each piece of visual material resembles a piece of a puzzle. To prepare the ground for analyzing it, they first have to observe the image closely, examine every last detail, get under its skin. The foundation stone of any historical approach, a subsequent and still more crucial stage involves thoroughly investigating the material and subjecting it to rigorous critical analysis, including dating it, identifying its author, determining the conditions in which it was taken (frame, lighting, composition), and contextualizing it, in an effort to tease out its meaning by correlating it with the written evidence.

An even more delicate phase of analysis remains, however, since it is still important to discover whether it has been set up, staged, or touched up in the lab, as we know that some of the most celebrated and iconic images of World War II are in fact reconstructions.

Long neglected by historians or relegated to the level of mere illustration, photography—like moving pictures—has gradually acquired the status of a document in the fullest sense of the word, on a par with more traditional material such as manuscript or printed sources.

In point of fact, this new reliance of history on the photographic medium has considerably widened the scope of the documents available to it. A precious, unique tool, photography has the advantage over text of giving the impression of instantaneously recalling the recent past. Its immediacy of impact is still more accentuated by its predominant aesthetic of black and white, which at the outset creates an atmosphere with which other documents can rarely compete. It should be pointed out that however truthful, authentic, and superficially objective a photograph might appear, it remains an interpretation of reality rather than a mirror of the world.

In giving material form to the war, the following selection of photographs plunges the viewer into the virile and pitiless universe of combat in the tropical forests of the Pacific islands, the frozen steppes of Russia, and the vast deserts of Libya.

In addition to the information they provide as to the servicemen and the military matériel deployed, such images are bound to arouse emotional responses.

It is then not entirely surprising that the traces of the Second World War—*the* key event of the twentieth century—engraved on the collective visual memory are today limited to a handful of extraordinary photographs taken by a few courageous witnesses: Russian women searching for the body of their nearest and dearest through the thawing mud as photographed by Dimitri Baltermants; the American soldiers crawling over Omaha Beach immortalized by Capa; or the portrait by the American reporter Eugene Smith of two marines, taken during a pause in the hellish battle of Saipan Island. As for the view of Bergen-Belsen piled high with corpses, taken by the British reporter George Rodger, it alone encapsulates the full horror of the Nazi regime.

As will have been surmised, though it follows the course of the conflict, this volume does not aim to be a history book on the war: it is first and foremost an album of legendary photographs.

A convenient instrument of mass communication, all the belligerents turned to photography to provide reports designed to convey a message, to fire the public imagination, or to act on hearts and minds in some other manner. Celebrate the victories, minimize the setbacks, and show the dead—the enemy's, that is, but never those of one's own side: these were the instructions handed out by chiefs of staff to all photographers engaged by the various governments on the Eastern Front, as well as to the privately employed pressmen in other theaters. Respected by all reporters, these rules tended to give a rather stereotyped character to many war pictures; nonetheless, some especially talented official photographers transcended these constraints and succeeded in capturing many emotionally charged moments on film.

In the last analysis, this selection of some two hundred reproductions illustrating the war constitutes a unique and eloquent testimony. Like an archaeological discovery, photography, by offering a different view of reality, indubitably enriches our knowledge of history.

Rémy Desquesnes

1939–40
Churchill's Britain alone against the Axis

It was in Europe, in September 1939, that the second worldwide conflict was born, provoked by Hitler's excessive ambitions and the Reich's repeated aggressions against other countries. The first country to suffer the ravages of the Blitzkrieg (a lightning-fast attack) was Poland, which was shattered in three weeks. Split between Germany and the Soviet Union, the country ceased to exist. After crushing Poland, Hitler hesitated before taking military action on the Western Front. A long period of inactivity, "the phony war," lasted until April 1940, when the Wehrmacht invaded Denmark and Norway. One month later, Germany began its offensive on the Western Front, leading to the collapse of the Netherlands, Belgium, and France.

On June 17, 1940, Marshal Pétain, France's new head of government, joined, as General Charles de Gaulle observed in his war memoirs, "those resigned to defeat and those who believed that the war is lost," and requested an armistice with Germany. On the same day, de Gaulle, former undersecretary of state for defense under Prime Minister Paul Reynaud, an advocate of continuing the struggle against the Reich with the help and support of Britain and the British Empire, decided to fly to London and continue his fight.

Churchill's Britain stood alone in Western Europe against the Reich, and against Italy, which had recently entered the fray, refusing any form of compromise "against a monstrous tyranny." The country was preparing for a possible invasion from the sea. In August 1940, after having ruled out, yet again, any deal with "the devil of Nazism," the resolute prime minister, in a moving speech made over the airwaves of the BBC, proclaimed his determination to resist, and to see through to victory the fight against Hitler.

In spite of the daily attacks from the air by the Luftwaffe, the numerical superiority of Nazi planes, the heavy losses in planes and pilots, the terrible fire bombings, and the terror raids on England's capital, London, the country held fast. When, after a month of bombing, Hitler had failed to bring the country to its knees, he put off his plans for invasion to early autumn; Hitler thereby avoided having to explain what could have been viewed as a failure. But Germany had just suffered its first setback in its attempt to take control of Western Europe. The victory would remain incomplete: a base remained in the West from which the struggle against the Reich could continue.

As Albion remained elusive, Hitler looked for another outcome to the War by attacking the Soviet Union. If the USSR were liquidated, Britain, losing all hope of obtaining support in Europe, would be forced to lay down its arms. However, by starting a war against Russia, and not yet eliminating Great Britain to the west, Hitler exposed himself to the risk of a war on two fronts.

Facing page: LONDON, TEA-TIME

A couple is drinking tea on a makeshift table in an air-raid shelter. In the background, wooden bunk beds can be seen and, in front of them, three men are playing darts. Full of humor, this picture captures the spirit and composure of the British in wartime.

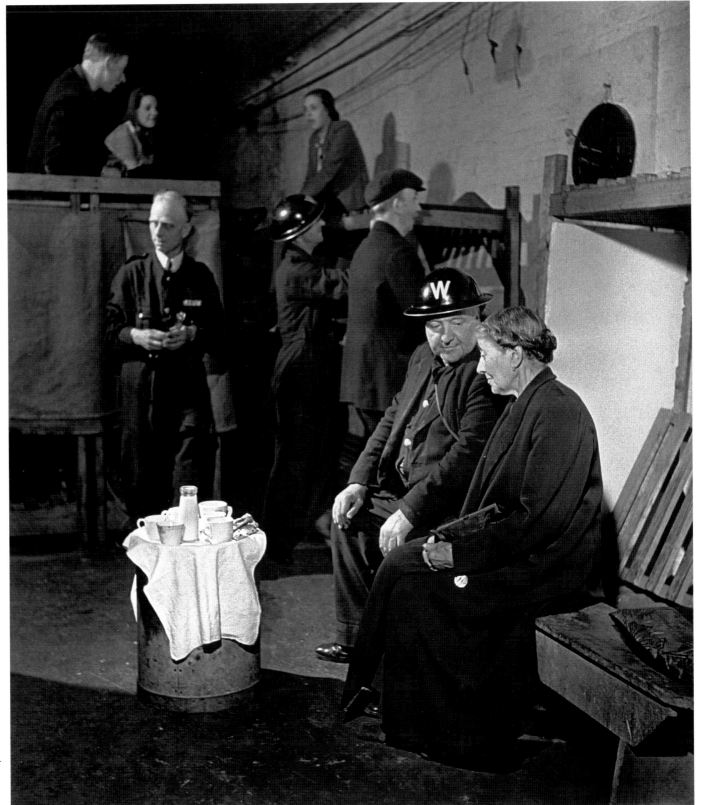

9

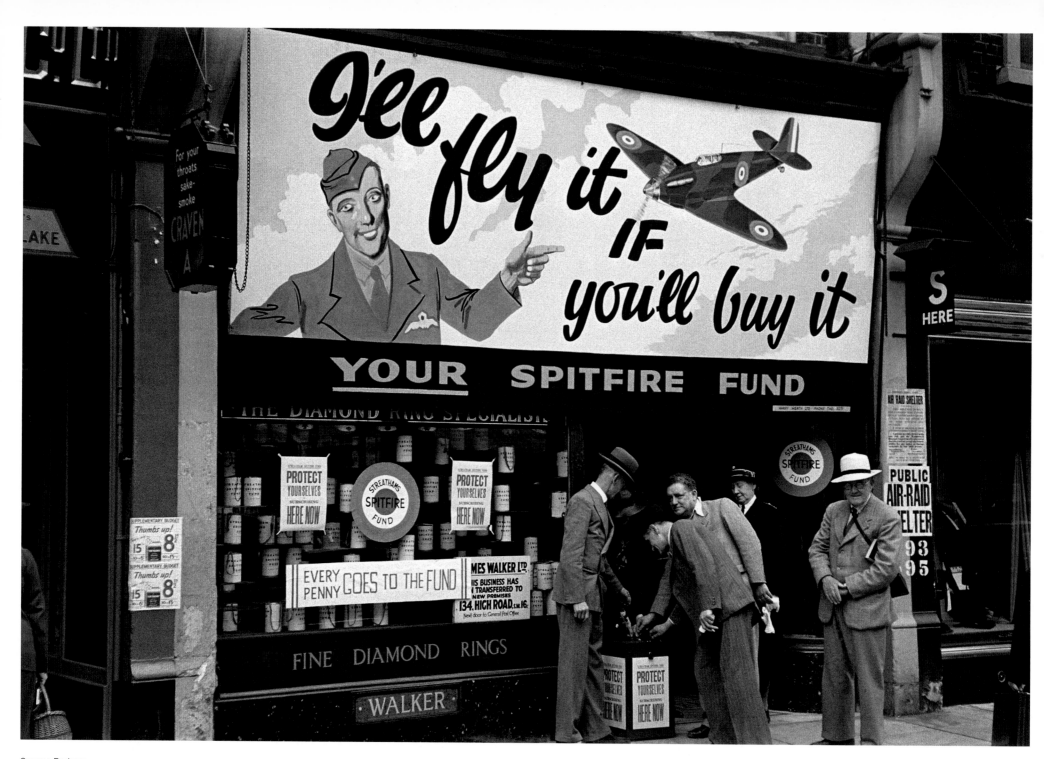

George Rodger

The Blitz in London

A PATRIOTIC DIAMOND DEALER

Demonstrating his patriotism, this London jeweler has given up trading in order to collect donations to help fund the production of fighter planes. The sign above his window shows an RAF pilot pointing at the Spitfire that he'll fly if he gets a chance. An entrance to an air-raid shelter can be seen to the right of the jewelry store.

DAYTIME AIR RAID

In July, the Luftfloten (air fleets) based on the continent focused their attacks on British ports and convoys in the English Channel. The following month, Messerschmitts tried to decimate formations of RAF fighters in the air, while bombers destroyed ground infrastructure (airports, radar stations, and airplane factories). At first, the British people followed these air battles as though they were contests between the Luftwaffe and the RAF. They soon learned that there was no sport in these duels to the death.

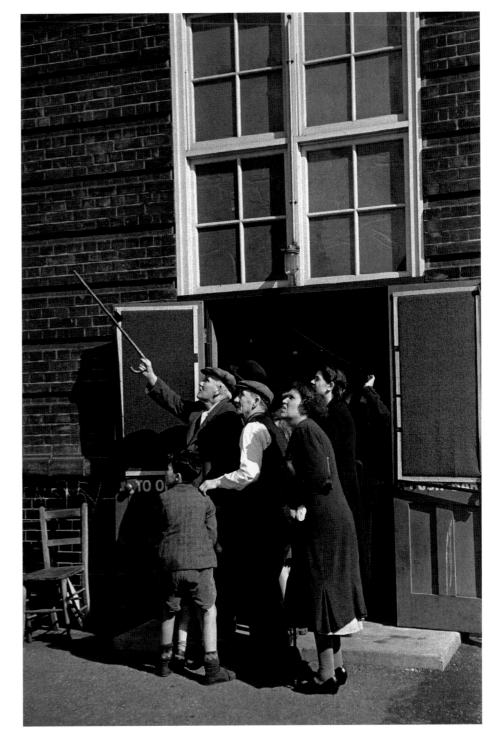

George Rodger

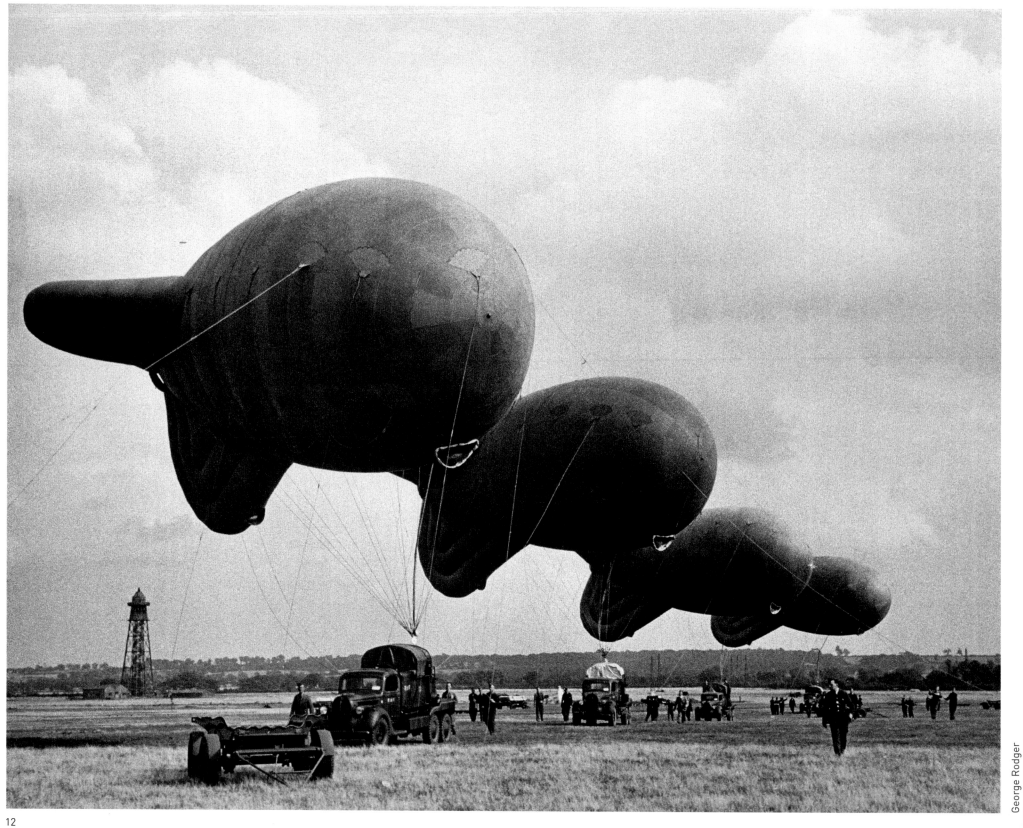

George Rodger

ENGLAND, BARRAGE BALLOONS

In addition to squadrons of fighter planes and anti-aircraft defense, the British used barrage balloons to prevent enemy planes from flying at low altitudes over particularly vulnerable areas, such as cities, ports, and strategic industrial centers. These simple balloons were filled with lighter-than-air gas and were held in the air by steel cables, whose length could be changed using a winch on the ground. However, barrage balloons presented a mortal danger to airplanes. Even if only a limited number of planes were taken down by this means, the 1,500 balloons used by British defense reduced the amount of airspace in which the Luftwaffe could fly, making it easier for the RAF and anti-aircraft defense to shoot down planes.

LONDON, A BOMBING IN THE CITY CENTER

Debris spread across the ground, a phone-booth door ripped from its hinges, and broken glass in windows all around are signs of a powerful bomb that fell in this London neighborhood. In the phone box stands a member of the Home Guard, a volunteer charged with watching over the area and providing the authorities with early reports about the level of damage. This information made it possible for emergency services to get quickly to damaged areas, clear streets, rescue victims caught in the rubble, fix water and gas mains, and put out fires.

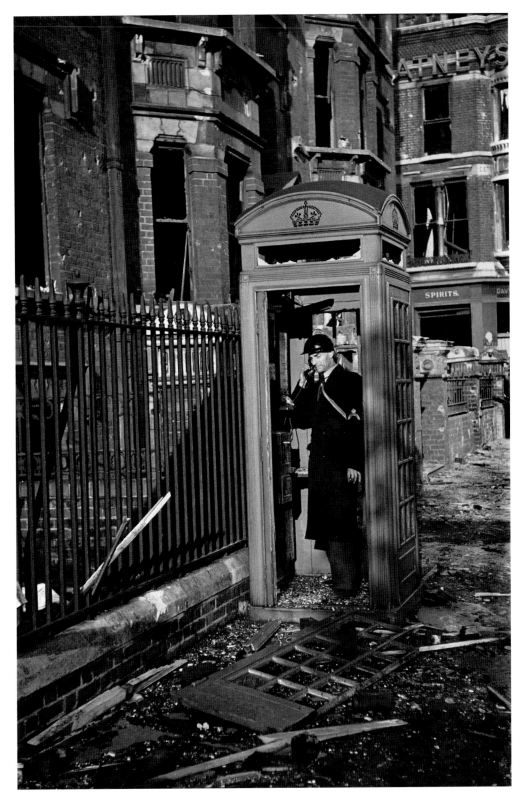

George Rodger

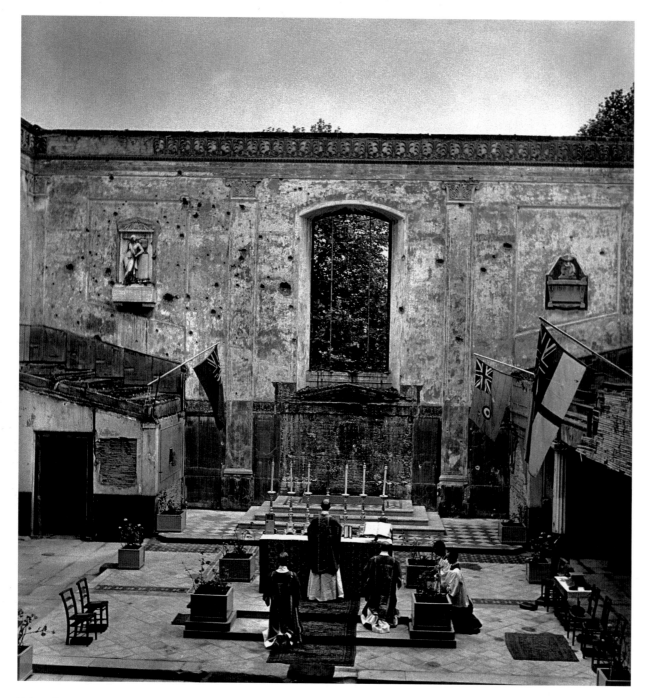

Robert Capa

The Blitz in London

ROOFLESS CHURCH, 1941

The area around Waterloo Station, on the south bank of the Thames, where St. John's Church is located, was heavily damaged by air raids. This unusual picture shows the stone framework of a church, which now stands roofless. In the center, a priest conducts a service as normal, in spite of the fact that the altar is open to the elements. Two vicars and some choirboys kneel on the steps of the altar, which is marked by four flowerpots and several flags begging for divine protection. The composition of this picture makes it impossible to see whether faithful parishioners were attending this Sunday service.

CONCERT IN TRAFALGAR SQUARE

During the Blitz, the English did their best, at least in residential neighborhoods, to live their lives as normally as possible. This picture shows a crowd in Trafalgar Square, a huge square in the center of London dominated by Nelson's Column. Beneath the cornice covered with pigeons, the square base of the column, with crouching lions at the corners, is covered with patriotic slogans. Traditionally, this famous London square is the site of political rallies and open-air concerts.

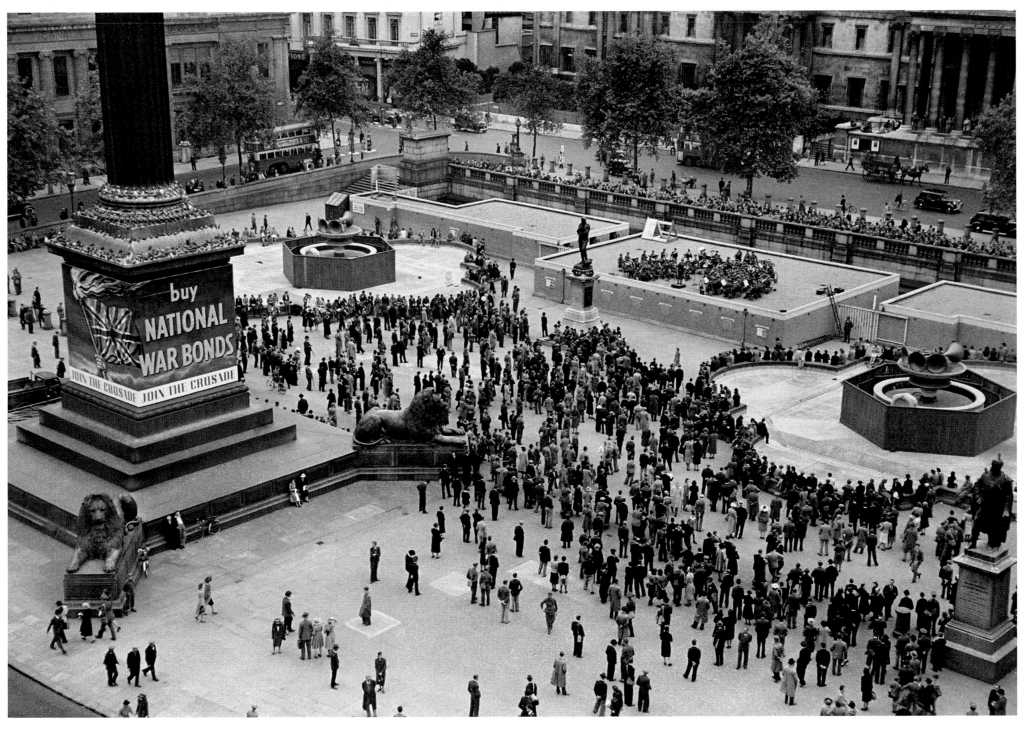

George Rodger

15

George Rodger

The Blitz in London

A BUDDING SOLDIER

War is not a game, alas. As the Blitz intensified, and the number of victims increased, the British government decided to evacuate London's children by the trainload. Taking refuge in the country, or in small cities that were safer than the capital, these children, together with their teachers, were taken in by volunteer host families who, in exchange for their support, received a small stipend from the state.

CONTINENTAL BUFFET

With its windows protected by plywood, and its waitresses in military uniforms, this restaurant does not have many customers. It is true that the poor, working-class population of the London docks suffered the most from fire bombings and had fewer air-raid shelters than those in the center of the capital. For these people, times were less lively, and the hardship became increasingly unbearable as the time went on. With repeated deadly bombings, the Germans had managed to undermine the morale of the people who lived near the ports. When the government announced that the RAF would carry out a reprisal raid on Berlin, on the night of September 10–11, the people were delighted. As was often seen in front of stores, a huge poster attempted to boost moral with the slogan, "We are carrying on! Hitler will not beat us."

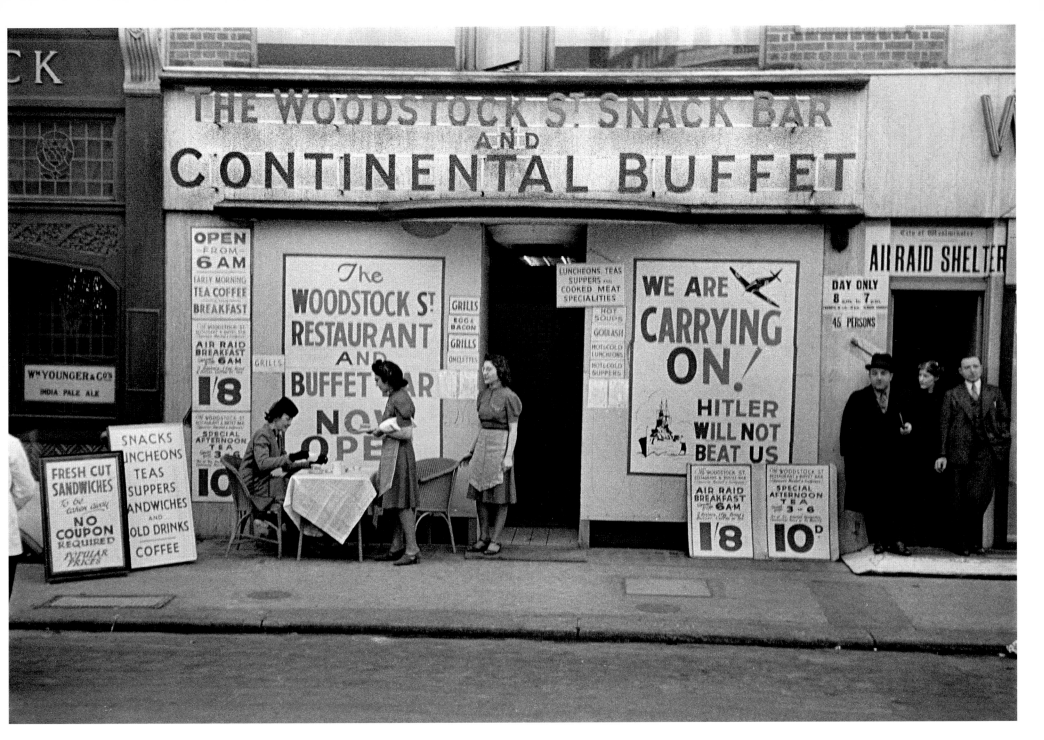

George Rodger

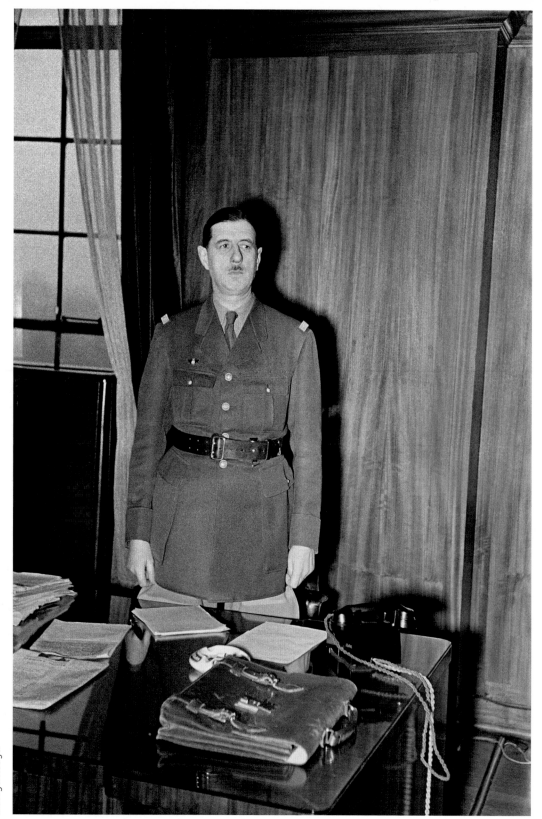

De Gaulle in London

LONDON, GENERAL DE GAULLE

On the morning of June 17, 1940, as the government of Marshal Pétain was asking Germany and Italy for an armistice, General de Gaulle left for Britain from Bordeaux-Mérignac Airport. When he reached London, de Gaulle established the headquarters of the Free French in Carlton Gardens, a street in an elegant residential neighborhood near Buckingham Palace. The day after he arrived, the first thing that de Gaulle did was "raise the colors"; to accomplish this, Churchill provided de Gaulle with a BBC studio: "At the age of forty-nine, I was embarking on an adventure," de Gaulle said.

GABON, DE GAULLE IN LIBREVILLE

Africa, for de Gaulle, was an excellent starting point: not North Africa, which remained faithful to Vichy, but sub-Saharan Africa. Without a single drop of blood being shed, equatorial Africa, starting with Chad, joined the Free French in August. The enclave of Gabon, which refused to join the French, had to be conquered at the beginning of November. A few days after its surrender, de Gaulle went to Libreville, the capital of Gabon, to meet the colony's civil, military, and religious leaders. Two days later, he returned to London "where fog envelops souls" (*The Complete War Memoirs*).

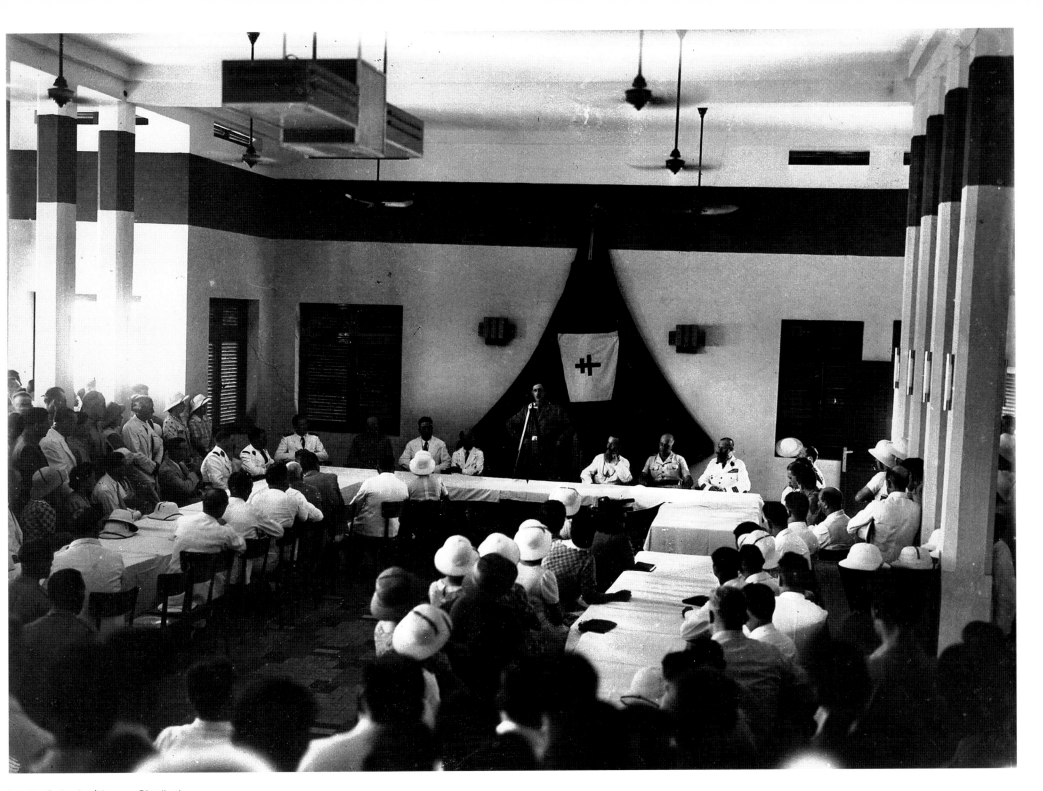

1941 The war becomes global

While initially limited to Europe, the war spread to Africa and the Middle East in 1941; to Russia in June; and, at the end of the year, to the United States.

Still alone against the Axis powers, Great Britain had to reinforce its Egyptian army to fight against initiatives by Italian and German forces heading toward the Suez Canal. They also had to intervene—with the help of the small Gaullist army—in East Africa to drive out Mussolini's troops and liberate Ethiopia. In the Middle East, where the Luftwaffe tried to get a foothold with the complicity of Vichy France, Great Britain, with support from the Free French forces, invaded the Levant and flushed out the German air force.

In the middle of 1941, Hitler invaded Soviet Russia, despite knowing that the same action had been fatal to Germany in the First World War. Relieved to no longer be the only opponent of the Axis, Churchill offered Stalin military equipment, which was soon doubled by that supplied by the United States as part of the Lend-Lease program.

Among the gateways selected to supply the USSR were ports located in the Persian Gulf. While there were no problems moving Allied convoys through Iraq to the ports of the Caspian Sea, this was not the case with Iran, formerly called Persia. The Russians and British had to carry out military operations there, in the summer of 1941.

At the end of the year, the Japanese attack on Pearl Harbor marked the end of American neutrality, provoking the United States to join the war alongside Great Britain and Russia. Stretching beyond the Old Continent, the war now spread across the entire world. In the Far East, where the Sino-Japanese War had begun in 1937, the situation was made more complicated by the existence of three Chinas. Eastern China, that of rice and large cities, was occupied by Japan; central China, also called Free China, was governed by Chiang Kai-shek, leader of the nationalist Kuomintang Party; and the Chinese communists had taken refuge in the faraway northern parts of the country. In spite of the United Front agreement, made between Chiang Kai-shek and Mao Zedong, to fight the Japanese, this collaboration remained ineffectual.

Facing page: SUDAN, DE GAULLE IN AL-FASHIR

General de Gaulle reviewing a detachment of Free French troops in Al-Fashir, Sudan. There was a marked contrast between his stature as a leader, the grandeur of his project, and the lack of military resources supporting him.

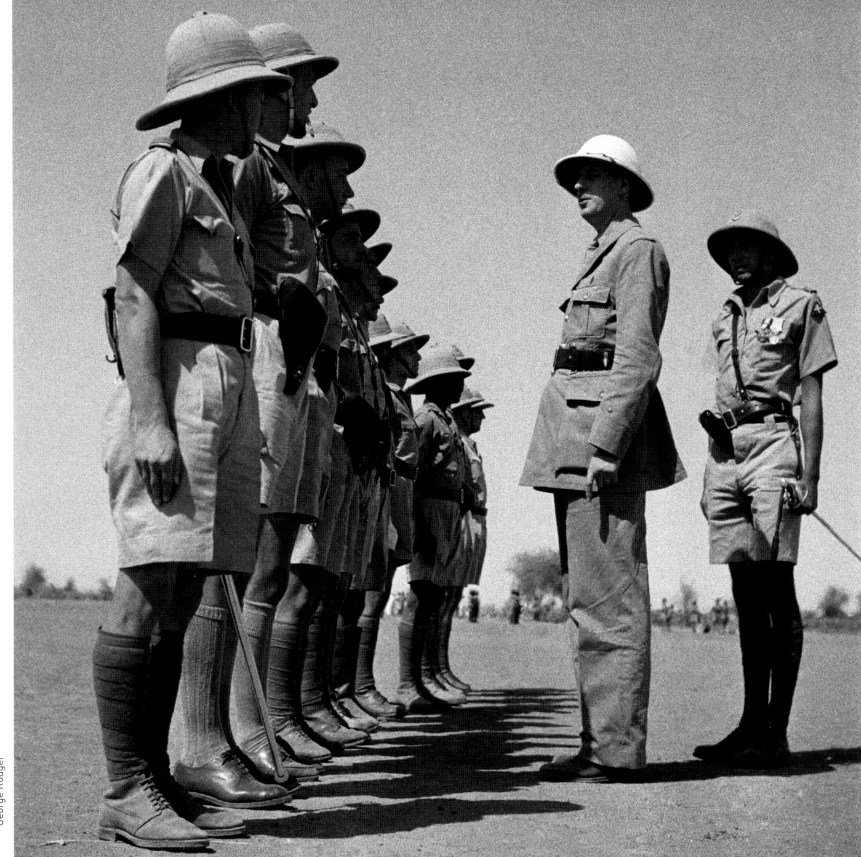

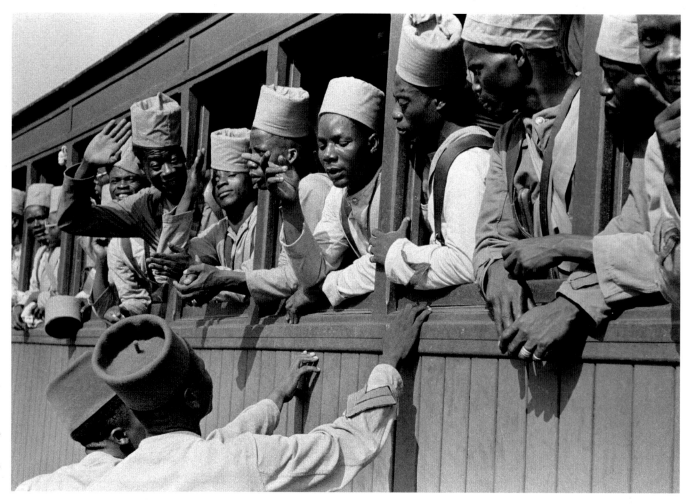

George Rodger

Africa

CAMEROON, SENEGALESE TIRAILLEURS

Senegalese troops leaving Douala to join the Leclerc Column stationed in Chad, at Fort-Lamy. It is hard to imagine that these young people were headed to the front with any awareness of what modern war was really about. The attitude on the platform was not one of resignation, but rather the exhilaration of adventure.

CHAD, GENERAL DE LARMINAT AND COLONEL LECLERC

As they fought alongside the British in Eritrea, the Free French tried to carry out their own offensives. Led by Leclerc, the first Gaullist offensive involved taking the Italian base of Kufra, in Libya. After crossing 1,250 miles (2,000 kilometers) of desert, the small troop managed to force the enemy garrison to surrender. On the facing page is General de Larminat, governor, and Colonel Leclerc.

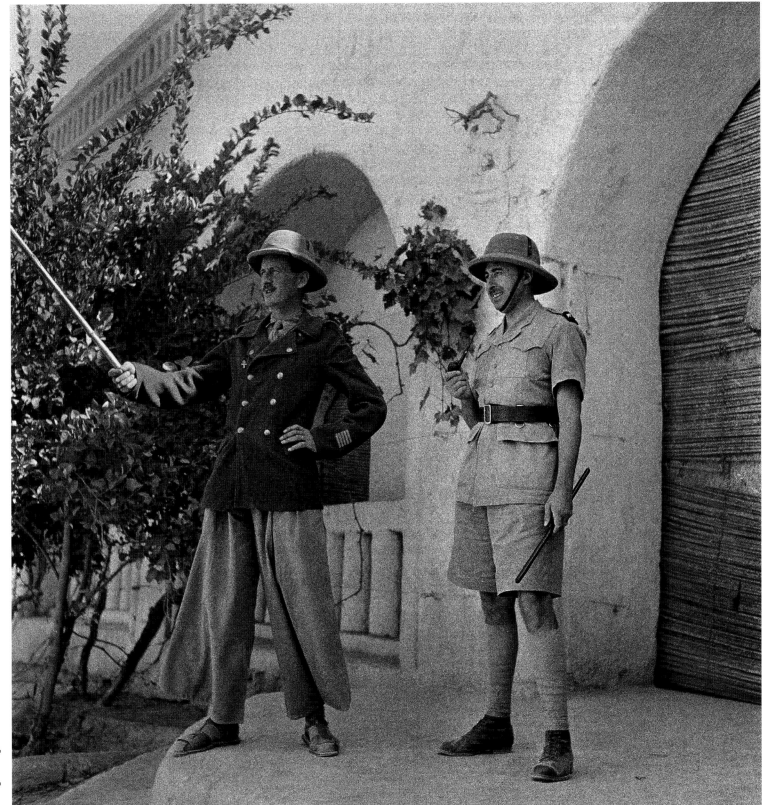

23

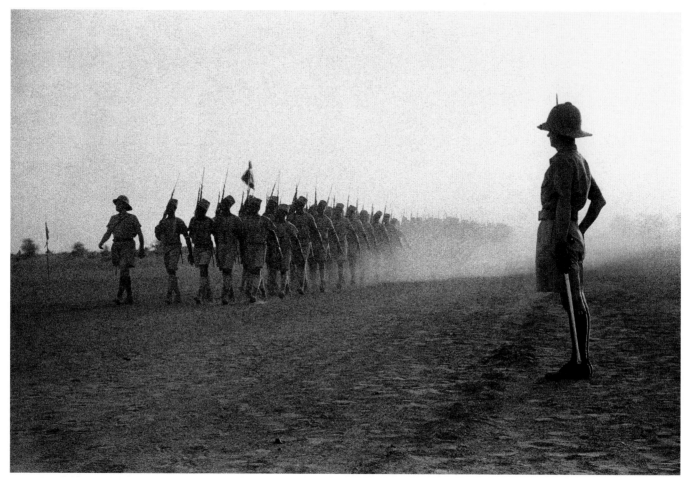

East Africa

SUDAN, PARADE IN AL-FASHIR

An African unit of Free French parades in the dust of the British training camp of Al-Fashir, before leaving for the front in Eritrea. In perfect alignment, with spotless uniforms, and marching in rhythm, the soldiers carry their rifles with bayonets on their shoulders and hold their unit's flag high, as a French officer in a colonial helmet looks on.

ERITREA, FORT UMBERTO

Created in Brazzaville in the autumn of 1940 by the head of the Free French, the Brigade Française d'Orient (BFO) assisted the British forces in East Africa in early 1941. On February 18, under a blazing sun and on uneven terrain, the BFO, commanded by Colonel Monclar, participated in the capture of Fort Umberto in Eritrea.

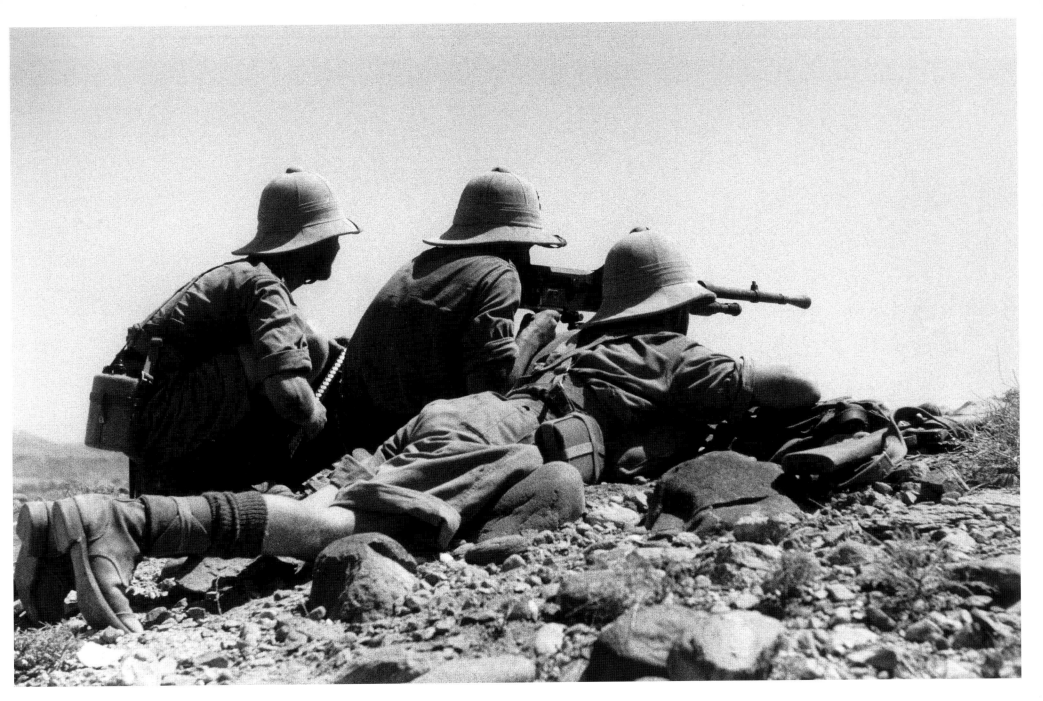

George Rodger

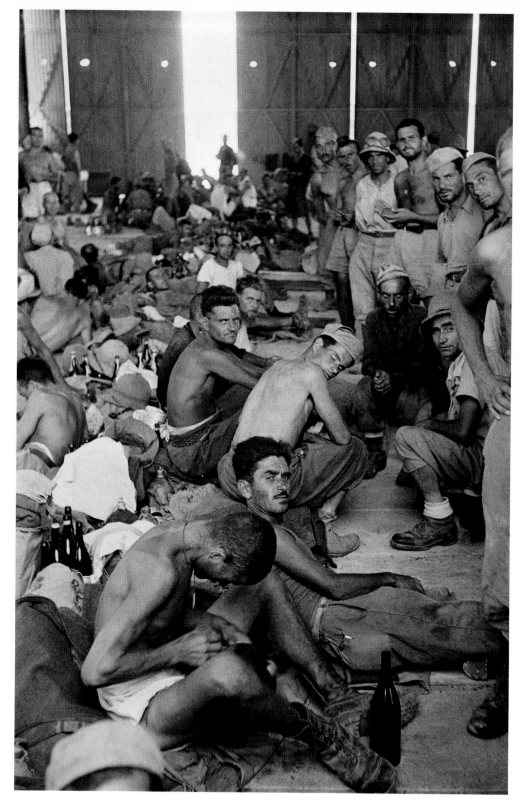

East Africa

ERITREA, ASMARA, AND MASSAWA, APRIL 1941

After the victory at Keren, in Eritrea, Allied forces took Asmara, then, on April 8, the large naval base of Massawa, on the Red Sea, where they captured 40,000 Italians.

George Rodger

ETHIOPIA, THE RETURN OF THE KING OF KINGS, MAY 1941

The two hundred and twenty-fifth descendant of the Queen of Sheba and King Solomon, the negus, the last emperor of Abyssinia, took refuge in England after Mussolini's troops invaded his country. After the defeat of the fascist army in April 1941, he made a triumphal return to Addis Ababa a month later. The eyes of the King of Kings emanate deep sadness and profound disillusionment. Not only because while he was in exile he lost his two sons-in-law, shot by the Italians, and his daughter, who died in a Roman jail, but also because this religious man, who had a great respect for human life, saw "civilized" soldiers use gas to overcome the resistance of "Abyssinian savages."

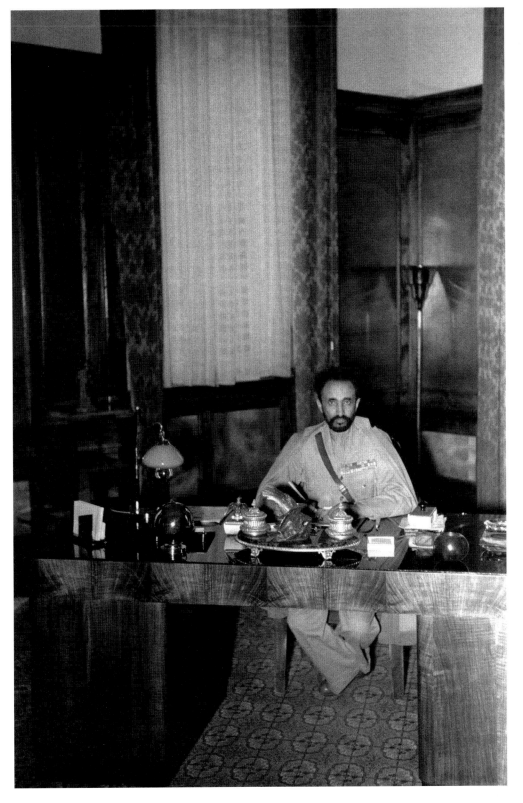

George Rodger

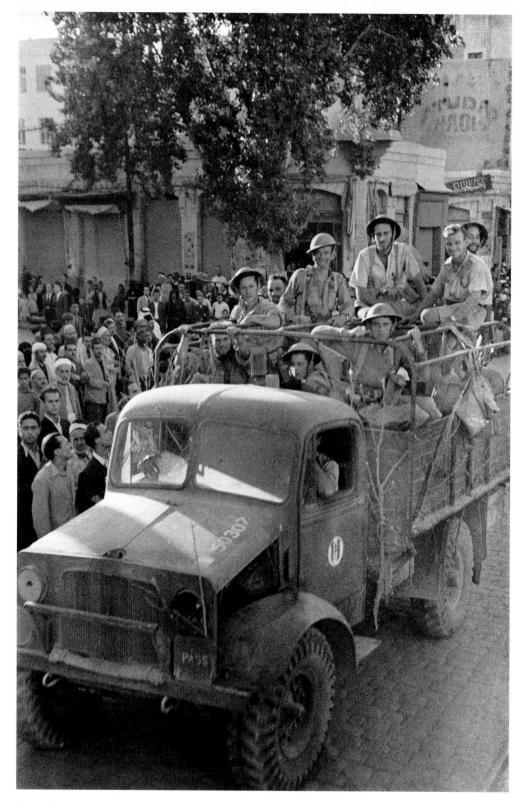

The Levant

SYRIA, LIBERATION OF DAMASCUS, JUNE 21, 1941

Believing that the policy of military collaboration carried out by Admiral Darlan threatened Britain's interests in the Middle East, English and Gaullist troops invaded Syria, which was defended by an army faithful to Pétain. The fighting ended as the Free French forces took Damascus and then paraded through the streets of the capital.

ACRE, JULY 14, 1941

An armistice between the British, Gaullists, and Vichy French was signed in Acre on July 14, 1941. Generals Catroux and Legentilhomme are seen here leaving the signing ceremony. They were somewhat concerned that France, under pressure from London, had granted independence to Syria and Lebanon, where a certain amount of nationalist agitation had appeared: according to de Gaulle, these were "hopes impossible to satisfy fairly . . . in this transitional period."

George Rodger

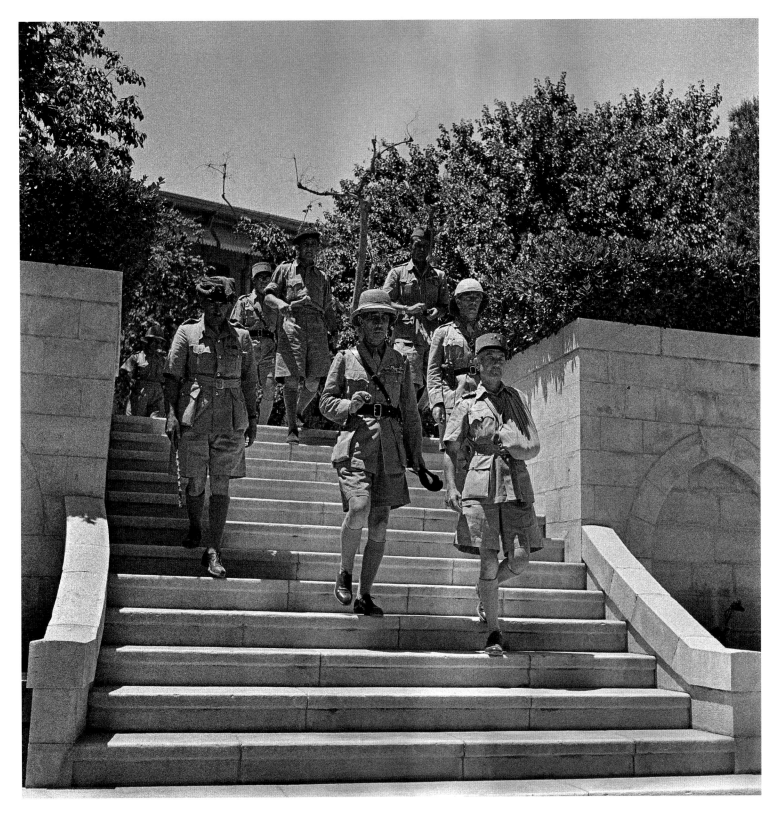

George Rodger

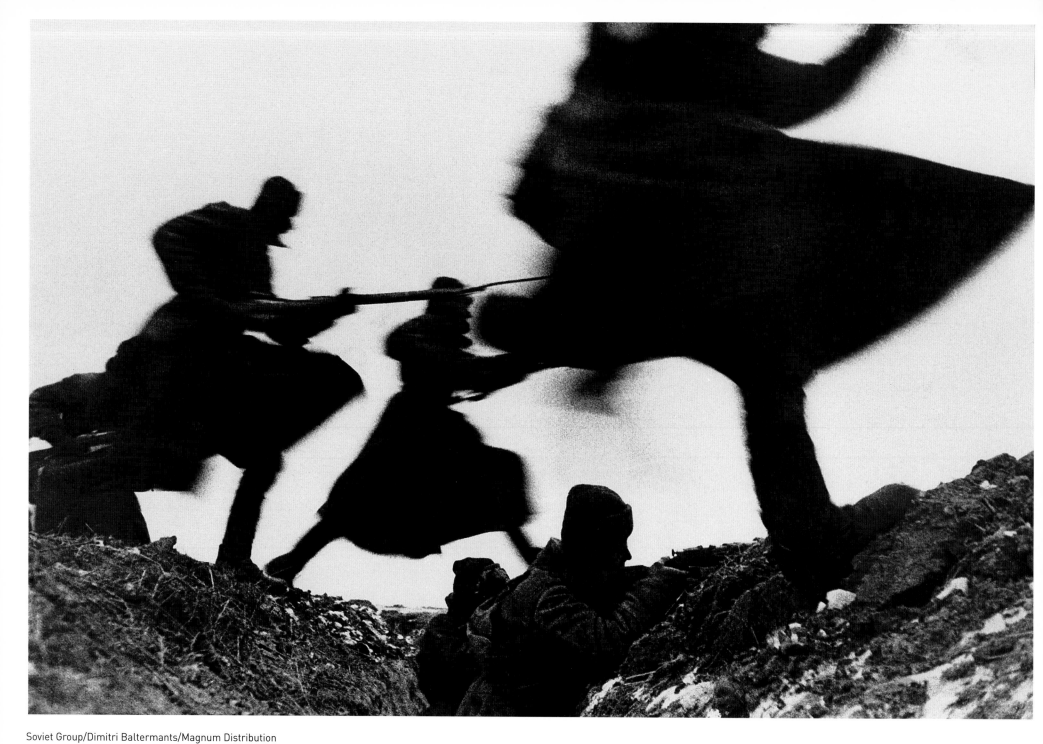

Soviet Group/Dimitri Baltermants/Magnum Distribution

USSR

THE ATTACK!

This is one of the most emblematic photos of the Second World War and the perfect example of a moment of life frozen on film. Dimitri Baltermants, an official photographer for the Soviet government, working for the daily *Izvestia* and the Red Army newspaper, managed to catch the brief moment when infantrymen, with bayonets on their barrels, rushed ahead to attack the enemy while other soldiers, in the trench, covered their advance. Determination, bravery, and a disregard for danger are all evoked in this famous photo.

MOSCOW, MILITARY REVIEW IN RED SQUARE

A traditional military parade in Red Square, Moscow, in early November 1941, to celebrate the anniversary of the Revolution. Under the snow, soldiers carrying rifles on their shoulders march in front of civilian and military authorities lined up on a stand built above Lenin's mausoleum, at the foot of the Kremlin's wall. This photo exudes an impression of strength and confidence that is intended to reassure the Russian people—even as their country is in the midst of a catastrophe and Nazi troops are camping in the suburbs of Moscow. Published the following day in daily newspapers, this propaganda photo was intended to help maintain moral.

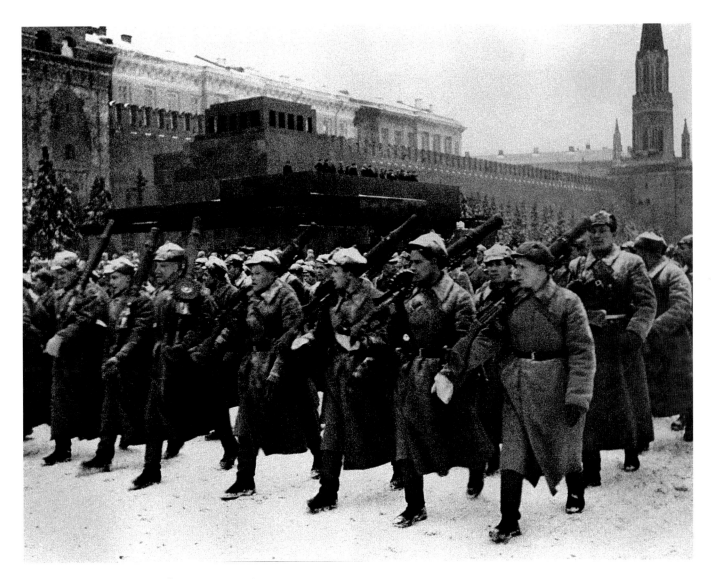

Soviet Group/Alexander Ustinov/Magnum Distribution

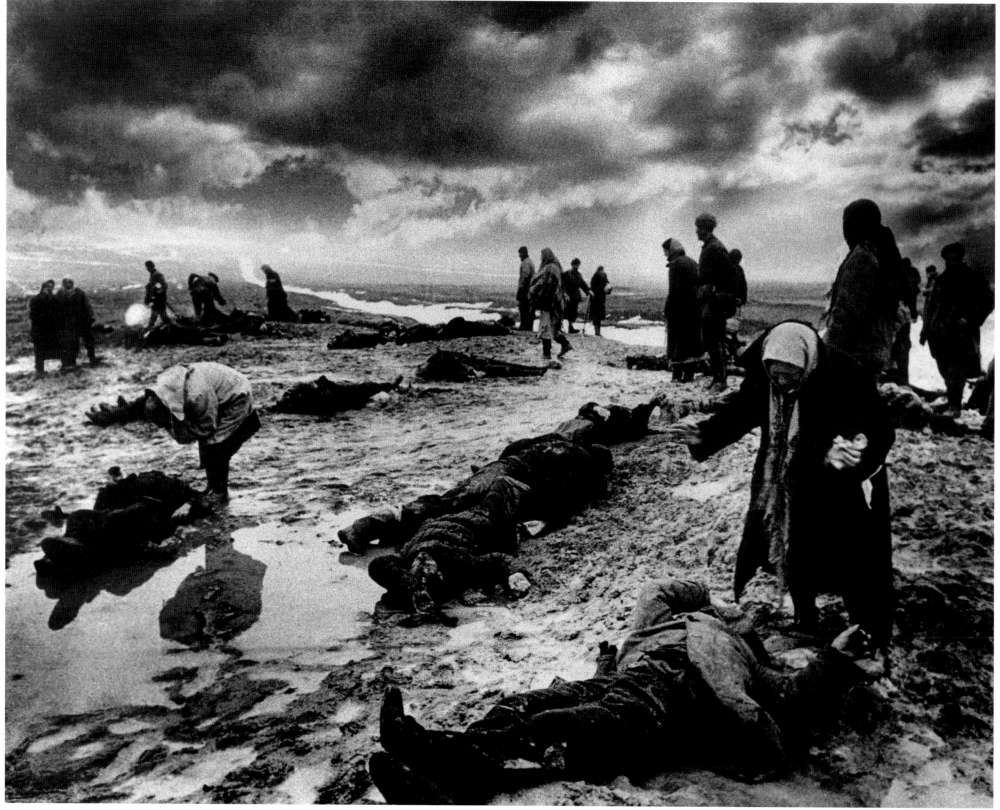

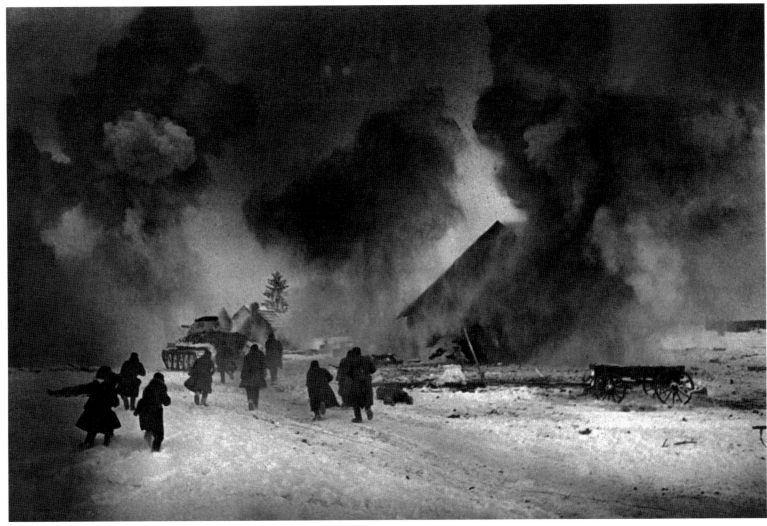

USSR

NAZI MASSACRE IN CRIMEA

This photograph has a rare emotional force and is one of the military images of World War II that has been seen around the world. Under a threatening sky, this picture, retouched to accentuate its dramatic intensity, shows Russian women of the town of Kerch, Crimea, leaning over corpses lying in the mud after the thaw. They are looking for relatives brutally murdered by the Einsatzgruppen (SS intervention groups). The publication of such an atrocious photo in newspapers could only strengthen the patriotism of the Soviet people and increase international public awareness of their suffering.

BREACH IN THE SIEGE OF LENINGRAD

Anatoly Garanin, official war correspondent for a Soviet magazine, *Frontovaya Illyustratsia*, here shows a small group of soldiers behind a tank attempting to open a breach in a defensive perimeter that the Nazis had established around Leningrad.

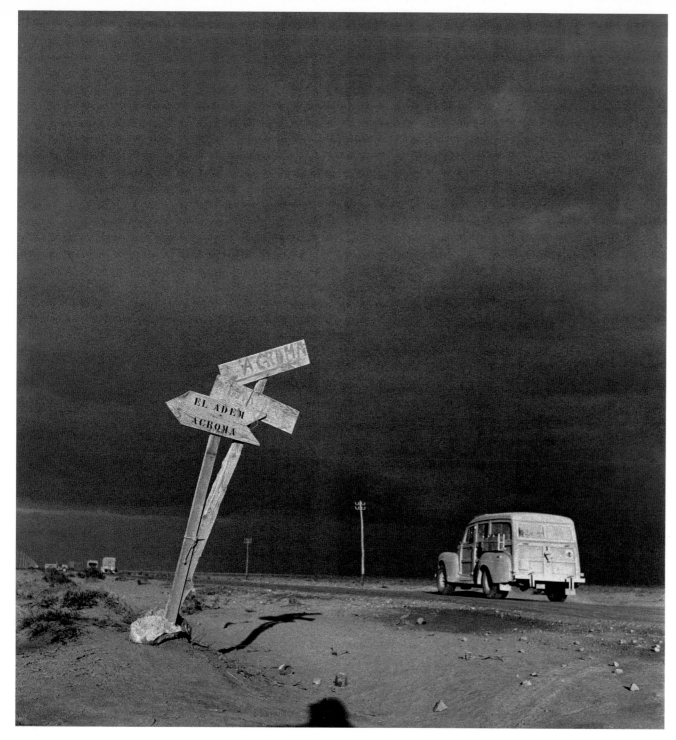

George Rodger

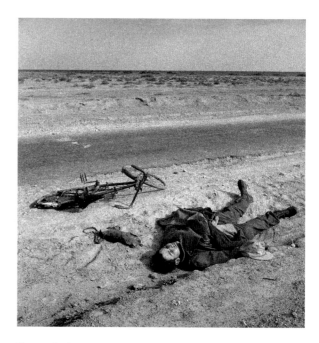

George Rodger

East Africa

LIBYA, DESERT ROUTE

A column of British military vehicles drives toward Tobrouk to liberate the fort that had been surrounded by enemy forces since April 1941. A straight track marked by a handful of rickety signposts: this was the inhospitable desert of Cyrenaica.

EGYPT, DEATH IN THE DESERT

In a barren desert, with no trees, no shade, no water, no homes, no people, and hardly any roads, a dead soldier lies near his bicycle. A dead body in a dead landscape.

EGYPT, DESERT GRAVE

A soldier stands in silent remembrance before the grave of an RAF lieutenant who was shot down by anti-aircraft fire on June 14, 1941, and buried by the Afrika Korps in the middle of the desert, near his plane. This picture shows an honorable war, very different from that which took place on the Russian Front. Here, there were no summary executions and no deportations. In this wide-open space, as empty as the sea and as fascinating as that endless body of water, the war still seems to obey a code.

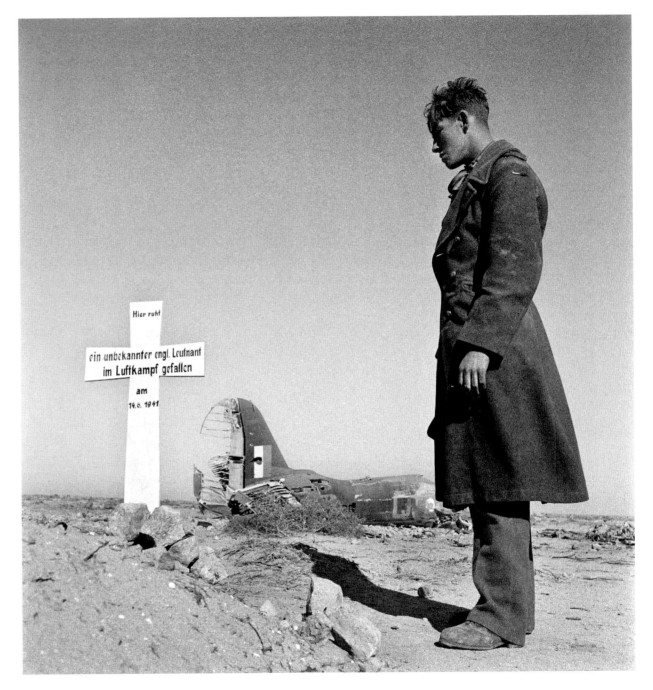

George Rodger

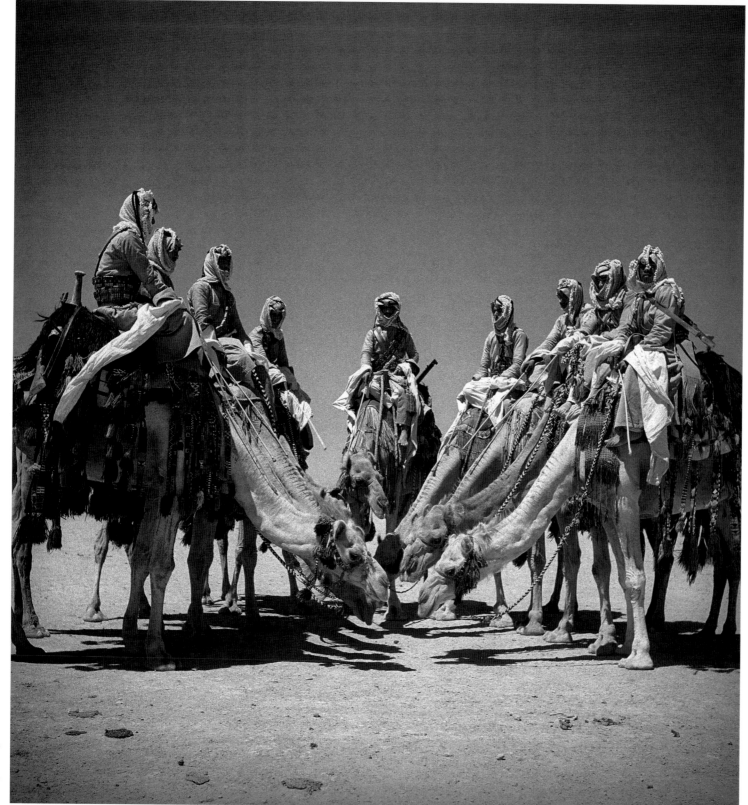

George Rodger

TRANSJORDAN, SONS OF THE DESERT

The magnificence and refinement of these camel harnesses is in stark contrast to the barrenness of the surrounding desert. Created after the First World War, in Transjordan, then under British mandate, the Arab Legion, made up of Bedouin volunteers under the command of British officers, was originally charged with policing the desert, ending intertribal conflicts and preventing the theft of livestock.

BEDOUIN OF THE ARAB LEGION

Initially responsible for maintaining order in the desert of the Emirate of Transjordan, the Arab Legion soon became the official army of the Hashemite state. Armed with old rifles and swords, these Bedouins—rugged and loyal soldiers—together with their mounts, which could cross the wide-open arid spaces and sand dunes that were off limits to vehicles, helped reestablish a pro-British government in Iraq in 1941, and participated in the invasions of Syria and Iran.

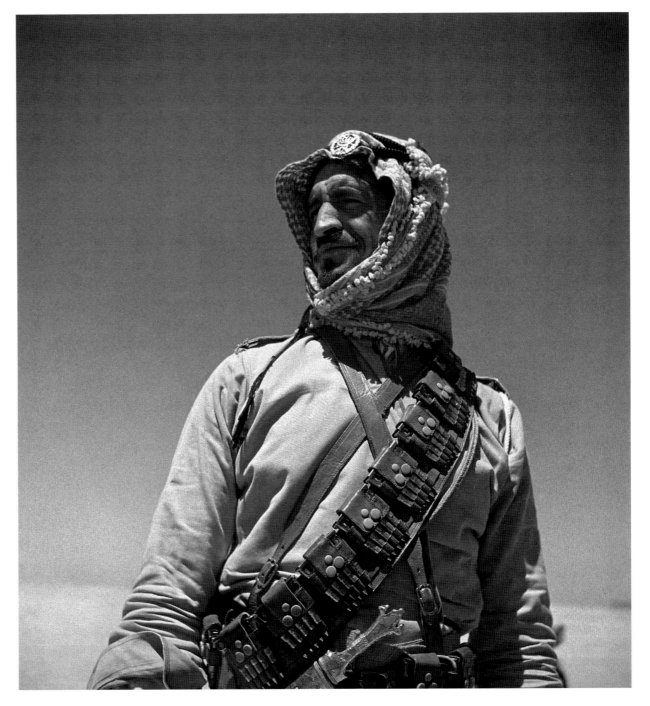

George Rodger

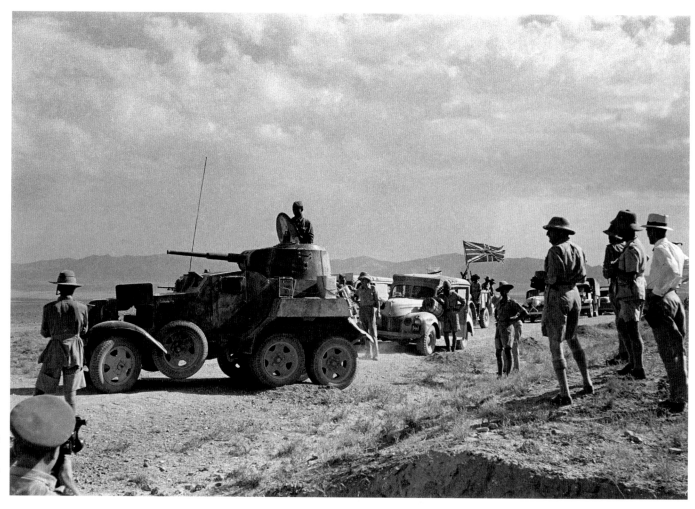

George Rodger

Iran

BRITISH MILITARY CONVOY AWAITING THE ARRIVAL OF THE SOVIET DELEGATION

After Germany invaded the USSR, London and Moscow put pressure on the shah of Iran to accept that the Allies could transport military convoys to the USSR via a new 938-mile (1,500-kilometer) railway. Built by German engineers, it stretched from the ports of the Persian Gulf to those of the Caspian Sea, via Tehran.

MEETING AT KAZVIN, AUGUST 31, 1941

Faced by the shah's refusal to cooperate, the British and Soviets invaded Iran. The two military forces met west of Tehran, at Kazvin, on August 31. The supply route known as the Persian Corridor became widely used, starting in 1943, after the Mediterranean Sea was cleared for navigation. The Russians would receive more than 7 million tons of equipment by this supply route.

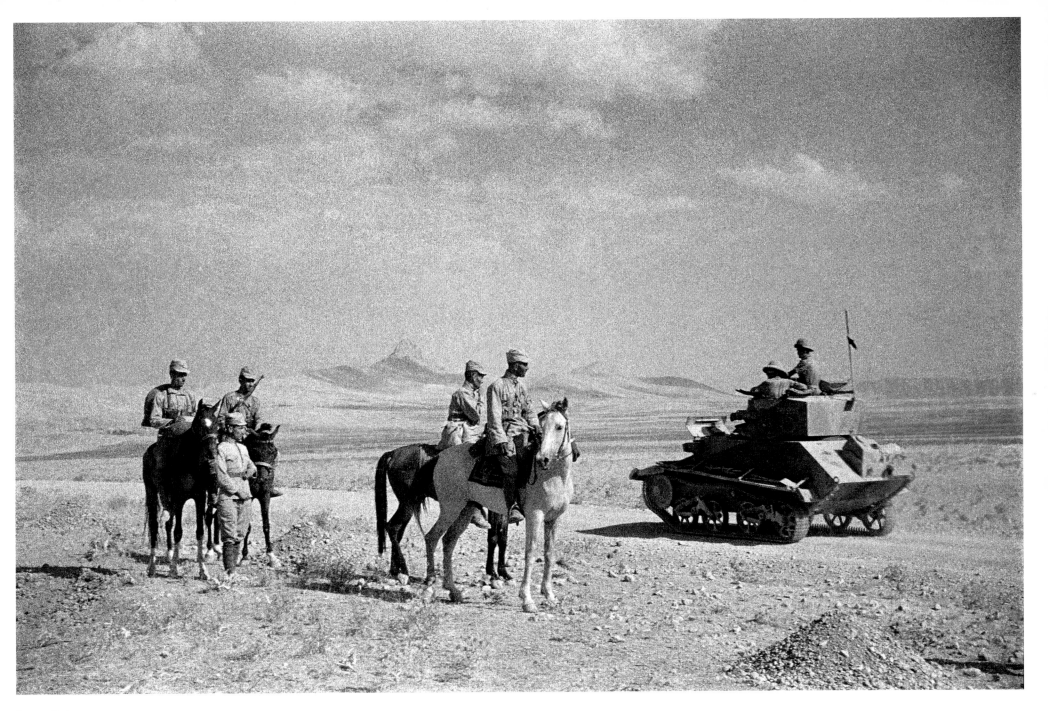

George Rodger

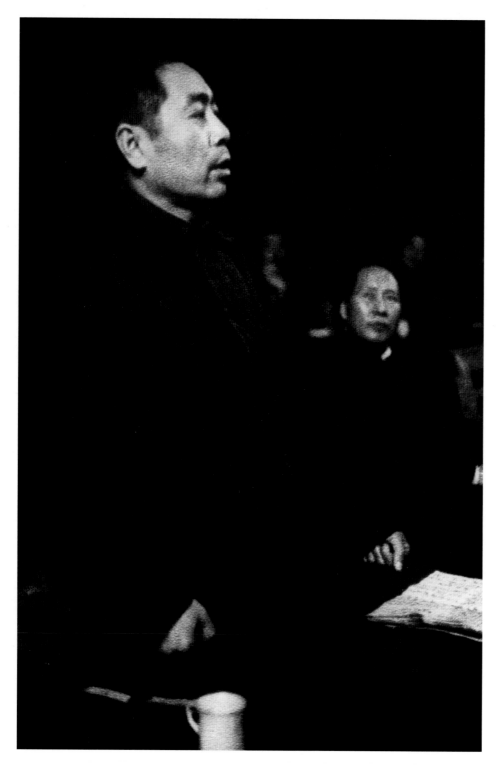

Wu Yinxian/Magnum Distribution

China

ZHOU ENLAI IN YAN'AN

Portrait of Zhou Enlai, Mao's ambassador to the Kuomintang government in Chongqing. After studying in Japan, France, Germany, and Moscow, Zhou Enlai joined Mao, took part in the Long March, and played a major role in negotiations with Chiang Kai-shek during the creation of the United Front.

PEASANTS HOEING THE LAND

An eternal tableau: men hoeing the nourishing earth. It was taken by Wu Yinxian, a Chinese photographer who was born in 1900 and died in 1994, and shows soldiers of the People's Liberation Army, which was renamed the Eighth Route Army during the United Front period, clearing new land around the territorial base of Yan'an, in the heart of Communist China.

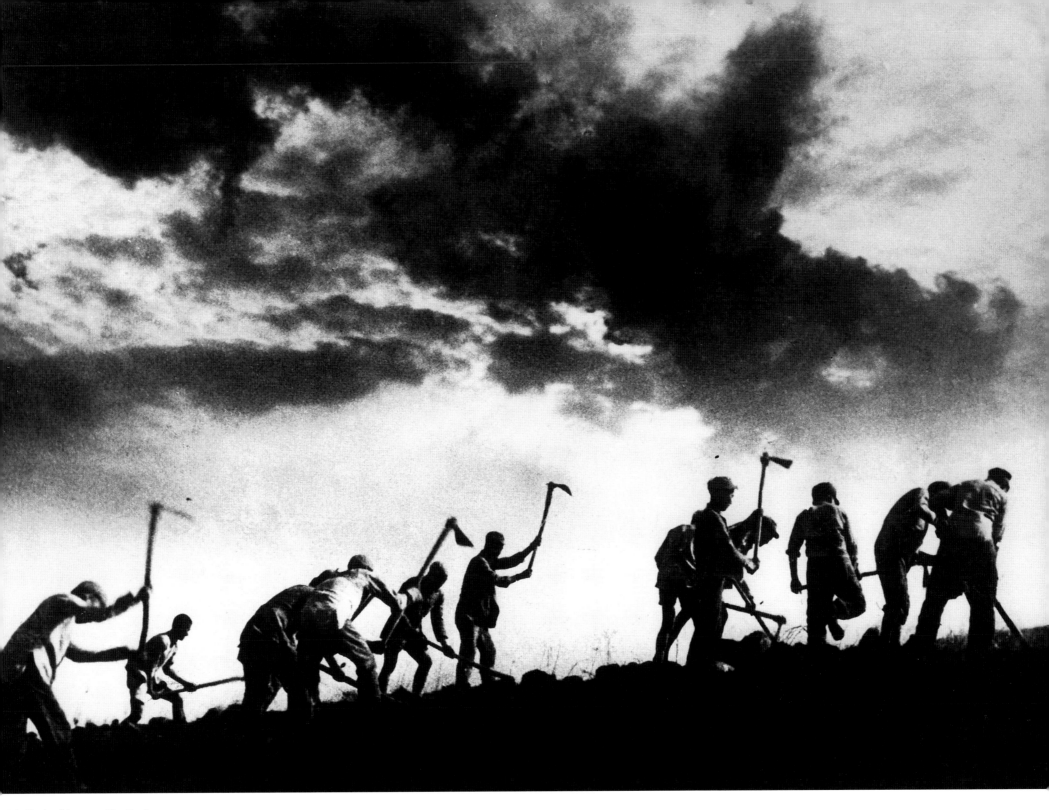

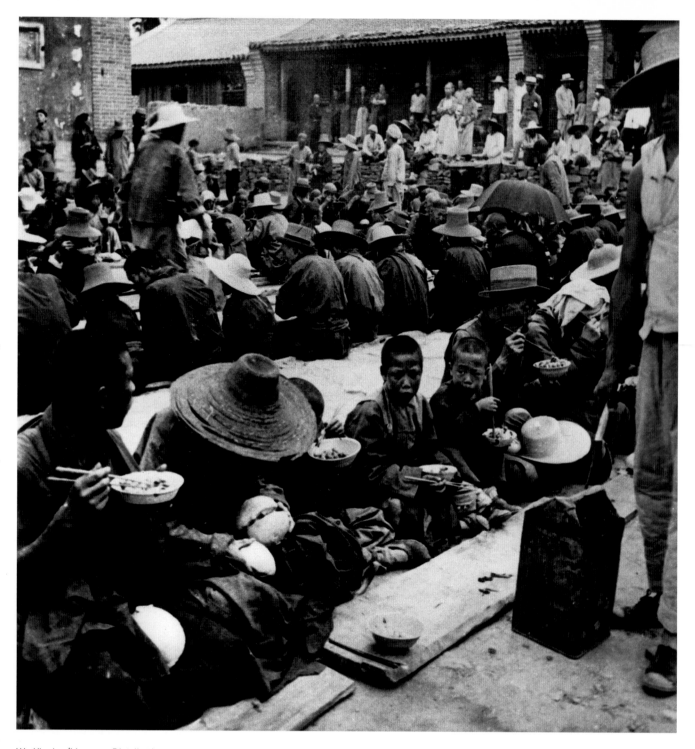

Wu Yinxian/Magnum Distribution

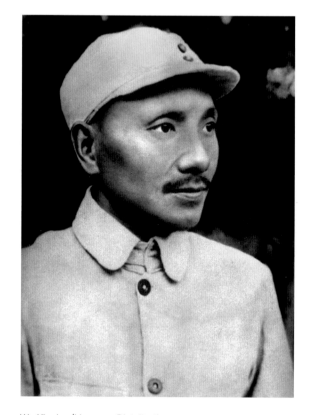

Wu Yinxian/Magnum Distribution

China

SHAANXI, RICE BOWL

A meal provided by the party. Linking itself to the peasant population that had suffered the exactions of large landowners for centuries was one of the pillars of Mao's strategy, the other being the defense of the fatherland against Japanese invaders. Symbolizing resistance against the enemy and protection of the weakest, the Chinese Communist Party had no trouble getting the country's peasants to join the revolution.

SHAANXI, DENG XIAOPING

A close-up of one of the leading figures of Chinese Communism, Deng Xiaoping, who discovered Marxism and became a Communist activist when he was working in the Renault factory in Boulogne-Billancourt, near Paris. Here, he is wearing the austere battle-dress of political commissar.

MAKING IRON IN THE COUNTRY

A long belt, as used in the workshops of old, turns a bellows that blows air into the foot of a small blast furnace. Filled with coke and iron ore from a wicker basket, this country ironworks produced cast iron and steel that was used to make plows. Requiring just a small investment, it allowed Chinese peasants to take advantage of local deposits, avoiding the transportation of raw materials. These country workshops led to an improvement in living conditions in the Chinese countryside.

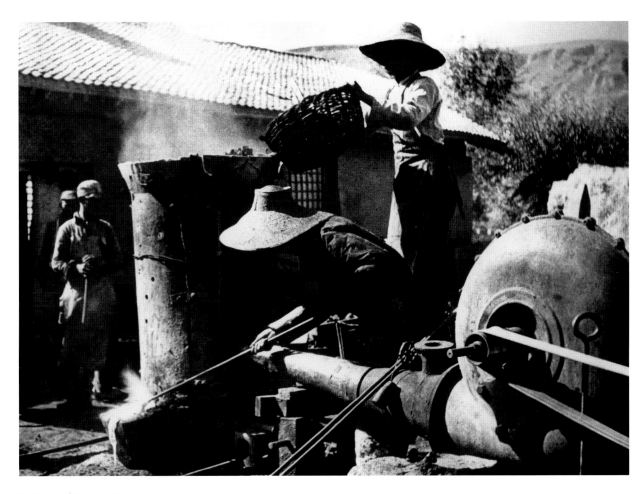

Wu Yinxian/Magnum Distribution

1942 The Axis reaches its apogee

It was in 1942 that the Axis attained its maximum extent. Following a series of brilliant victories, Germany and Japan had overrun immense tracts of land, in Europe as well as in Asia. From the autumn, however, storm clouds begun to gather and the Axis was to suffer a succession of setbacks in the Pacific and Africa, as well as on the Russian front.

At the beginning of the year, the Japanese, implementing their plans for conquest, had seized the Philippines, Indonesia, and Burma, thus cutting off the only route for American military aid to reach Nationalist China, since they had already blockaded the coast.

In spring, at the Communist territorial base at Shaanxi, Mao Zedong, all the while engaged in a guerrilla war against the Japanese invader, attended a major symposium, at which he defined the mission of the intellectuals and artists who had joined the Yan'an Academy to fight for the revolution. And woe betide anyone who dared criticize the lack of democracy in the Communist Party.

Meanwhile, in the Middle East, in the mandates of Syria and Lebanon, two states that in June 1941 had passed into the authority of Free France, nationalists claimed the independence promised them by Churchill and, imprudently, by General Catroux. To calm the unrest in August and September, de Gaulle made a visit to the Levant States.

By the autumn, in North Africa, Montgomery was back on the offensive against the troops of Rommel at El Alamein, harrying them as far as Tunisia. At the same time, Anglo-American forces opened a second front, not in Europe where the Wehrmacht was still too powerful, but in Africa, where the probability of carrying the day seemed more likely. With Montgomery pushing in on one side and Eisenhower's Americans on the other, the German army in Africa was well and truly wedged in.

It was, however, on the Eastern Front at Stalingrad that the Reich was to undergo its most crushing setback. In a courageous departure, in November the Red Army initiated a major offensive with the aim of skirting around and encircling the German army. The following month, in polar temperatures, furious slaughter unfolded in the city, in its streets and houses. One month on and the German Sixth Army surrendered. The myth of the invincible Wehrmacht evaporated. The situation had changed and now luck in battle began favoring the Allies.

Facing page: USSR, THE CALL OF THE MOTHERLAND

A moving picture centered on the affectionate kiss a mother gives her son as he sets off to join the partisan brigades engaged in the guerrilla war. It was a perilous mission indeed and the mother, standing in the small family garden next to the *isba*, or log hut, knows this all too well. With his gun over his shoulder and his haversack on his back, the new partisan is awaited by the recruiting agent, probably the local party representative, holding his mount. To destroy the enemy, to carry out one's mission without a murmur, to ferret out traitors, and never to reveal a single name under torture—that was the oath of the partisan. "If I betray this sacred oath, let me be struck down dead!"

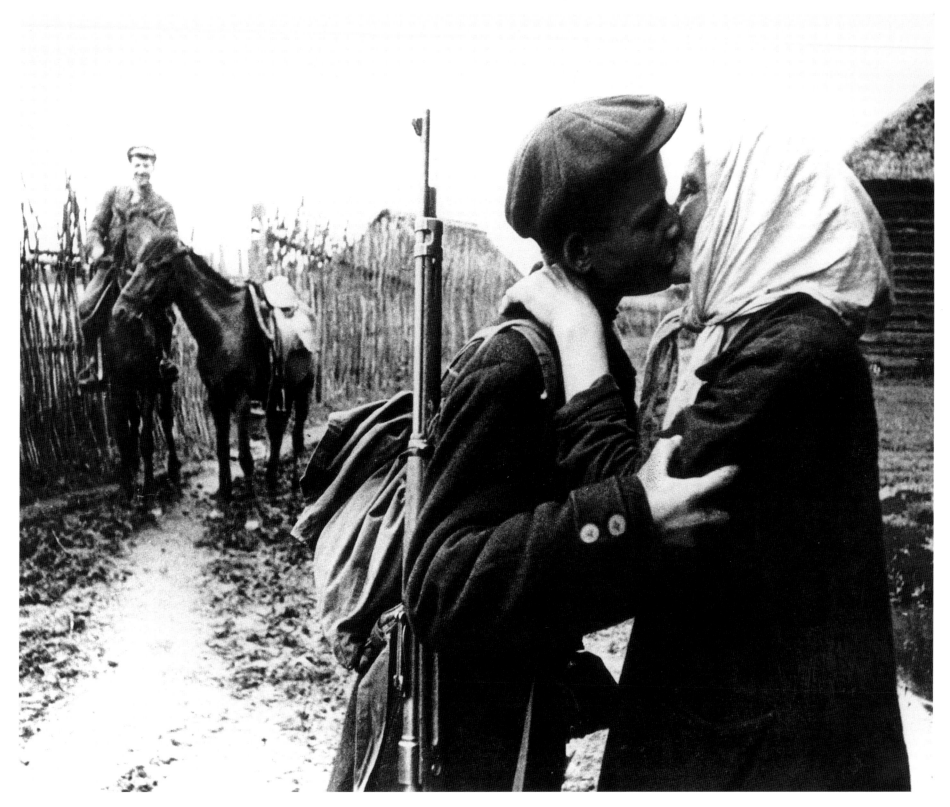

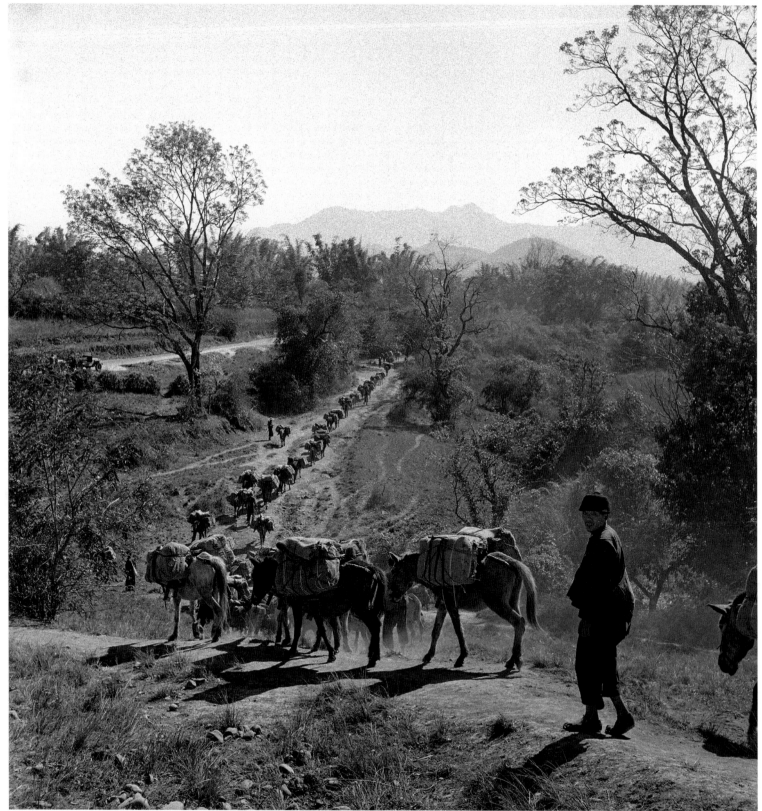

George Rodger

Burma

MULE CONVOY ON THE BURMESE ROAD

Stretching as far as the eye can see, this convoy of mules testifies to President Roosevelt's determination to help the China of Chiang Kai-shek to take the fight to the Japanese aggressor by providing it with a significant quantity of military matériel. By threatening to resume engagements with modern, American-made armaments, Nationalist China thus forced Japan to maintain a large force in this theater of operations.

American supplies were unloaded in the port of Rangoon (Yangon), before being conveyed by rail to the terminus at Lashio, 500 miles (800 kilometers) to the north. From there the matériel was transported over more than 625 miles (1,000 kilometers) on trucks and on mule-back, to Kunming, the capital of Yunnan, the Chinese province on the Burmese border. Over some sections the American convoys followed the same tracks that Marco Polo had walked in the thirteenth century.

CHINESE WOMAN ON A BUILDING SITE

After the imperial army's capture of Rangoon in March 1942, the Americans—deprived of its use—had to unload their matériel in the port of Calcutta, from where the cargoes were taken by train to Ledo in Assam. To link Ledo with Lashio, the Americans started laying a new, 375-mile (600-kilometer) long road through the inhospitable jungle; this was completed only in the spring of 1945.

Meanwhile, it was the US air force which, thanks to the establishment of an airlift above the Himalayas (known as "The Hump"), was charged with supplying China. In undertaking this enormous task (roadways and airfields), the government could call upon an inexhaustible supply of manpower. Equipped with tools dating from ancient times, armies of "coolies", as in the imperial era, were called upon to perform miracles.

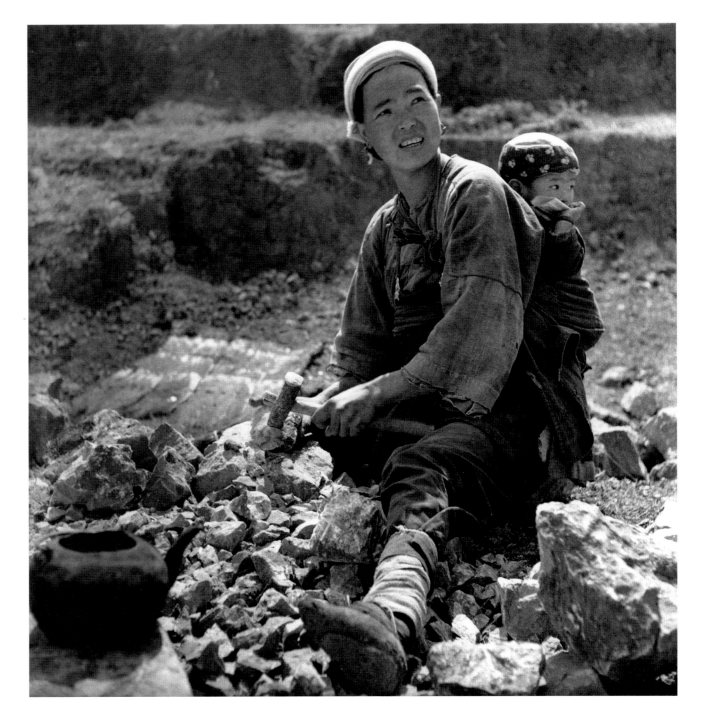

George Rodger

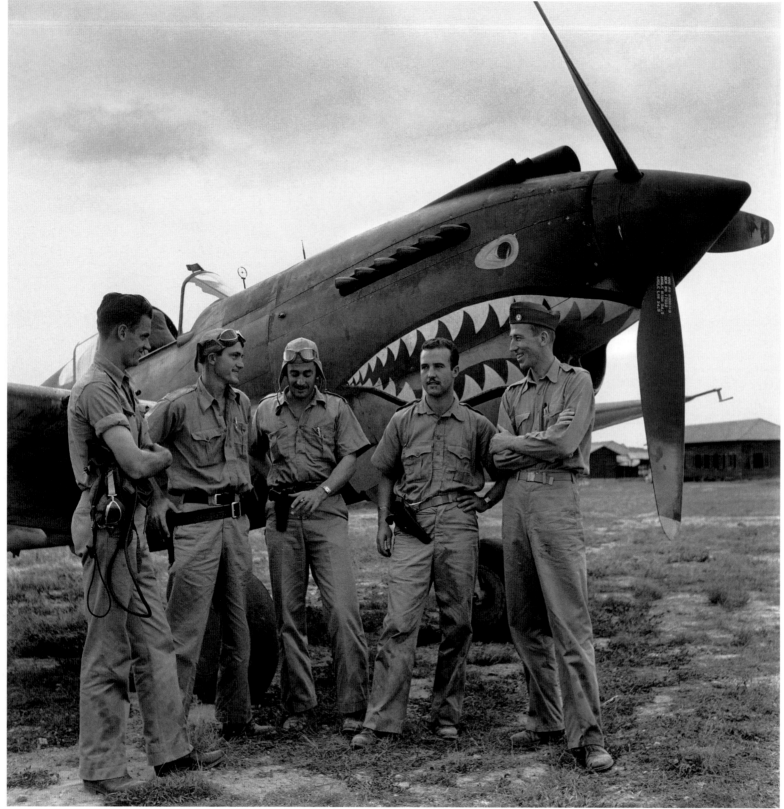

George Rodger

Burma

THE FLYING TIGERS

The Flying Tigers were American pilots who, from 1940, volunteered to fly with the Chinese air force. Like their Chinese counterparts, the Americans decorated their fighters with sharks' heads with gaping jaws. In spite of their bravery, the Flying Tigers, who had promised President Roosevelt that they would make the Japanese eat dust, could not prevent the imperial army capturing Rangoon on March 9, 1942.

KUMAONI SOLDIERS

Motionless in his foxhole and frowning gravely, this Kumaoni soldier, engaged in the British army, has his eyes fixed on the Japanese on the opposite bank of the Sittang River to the north of Rangoon (Yangon). Living in Nepal in the foothills of the Himalayas, and belonging to the Kumaoni ethnic group, these soldiers are splendid fighting men in the tradition of the Gurkhas. Resistant, brave, wily, and loyal, and handling their *khurchi* (a kind of curved saber) with consummate skill, the Kumaoni served in an Indian division of the British army.

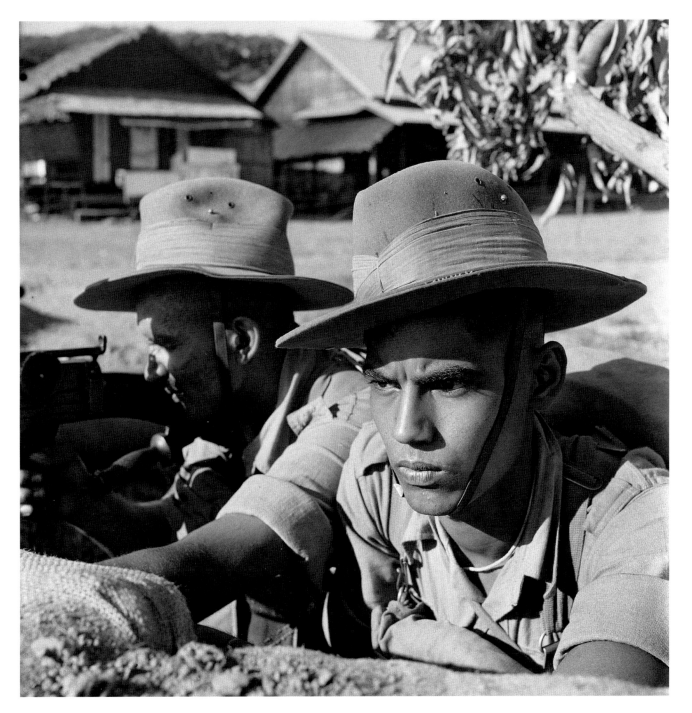

George Rodger

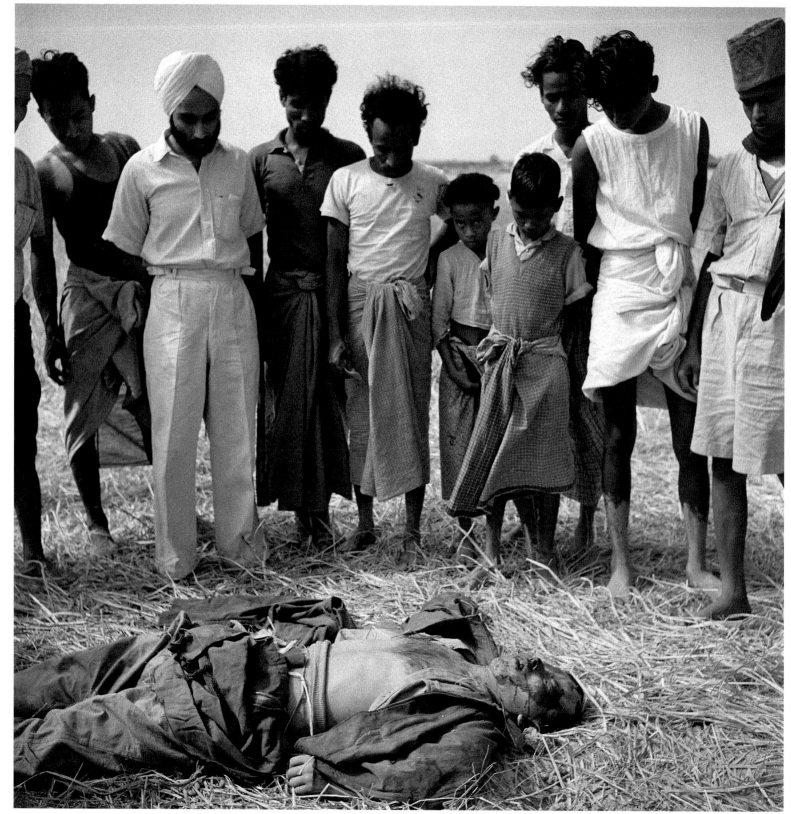

50

Burma

JAPANESE AIRMAN BROUGHT DOWN BY THE FLYING TIGERS

With grave expressions and heads lowered, these observers are silent and questioning in the face of death. If showing an enemy corpse—even including his face—was acceptable in the Allied press, conversely all photographs of dead American soldiers would fall foul of the censor until the end of 1943.

CHIANG KAI-SHEK, HIS WIFE, AND THE AMERICAN GENERAL STILWELL

A photo taken in Chiang's headquarters at the elegant spa town of Maymyo, in the mountains of Burma to the east of Mandalay, once frequented by British officers. In spite of appearances, this was no happy threesome, and relations with Chiang Kai-shek, whom General Stilwell had nicknamed "Peanut," did not take long to deteriorate. Stilwell (himself known as "Vinegar Joe" due to his grumpiness) recounts in his book how "Peanut" never sent a word of thanks to Roosevelt for the money lent by the United States, making only desultory efforts to break the Japanese blockade, and that all in all China contributed little to the American war effort against the enemy.

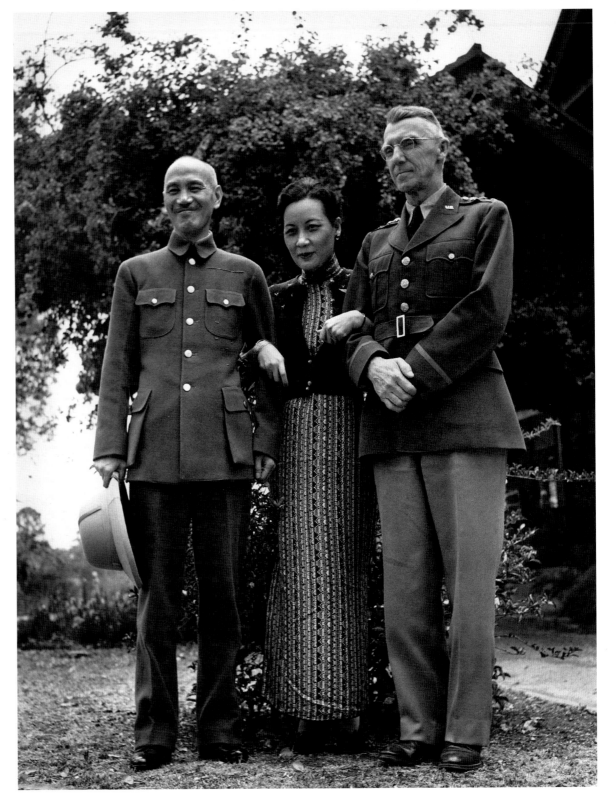

George Rodger

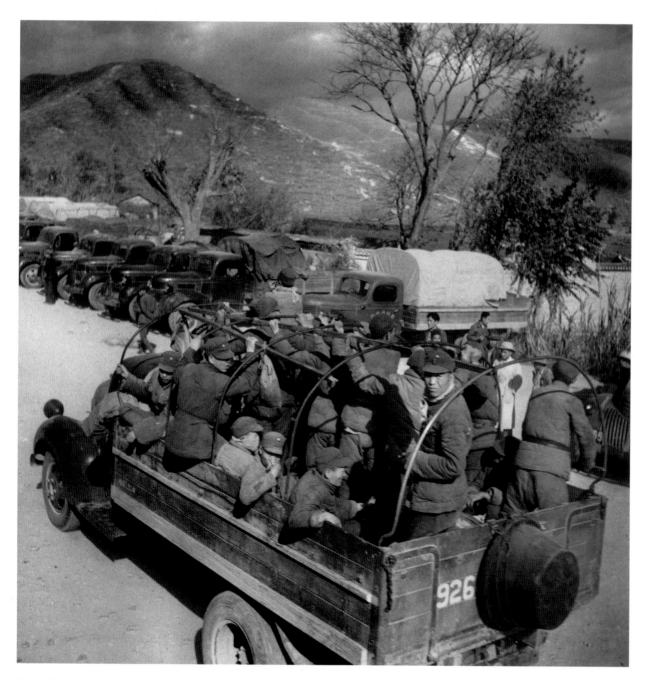

George Rodger

Burma

CHINA, CHINESE TROOPS AT BAOSHAN (YUNNAN)

In order to fend off the Japanese attack on Burma, the Chinese government, in agreement with the British authorities, expedited many contingents of soldiers and a significant amount of weaponry to the mountainous region of Baoshan, not far from the Burmese border. In spite of the assistance given the British by both Chinese armies, nothing could prevent the Japanese offensive, starting out from Rangoon (Yangon) at the beginning of March and heading north. By the end of April, retrenchment had become inevitable: British troops withdrew to India, with the rump of the Chinese armies retiring to the Yunnan mountains.

BURMA, CHINESE WOUNDED IN BURMESE TERRITORY

With their arms in slings and haggard faces, these Chinese soldiers show just how bloody the battle attempting to block the Japanese advance into Burma became, due to the actions of the Japanese air force. Thousands of Chinese soldiers were to be taken prisoner during a campaign in which Chiang's forces, systematically refusing to be subjected to British command, fought separately.

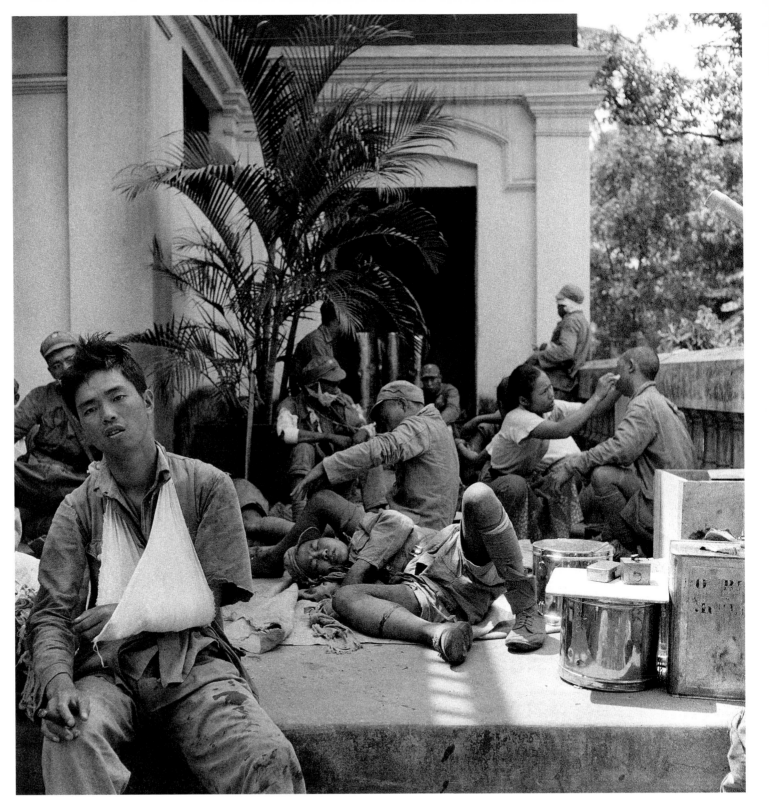

George Rodger

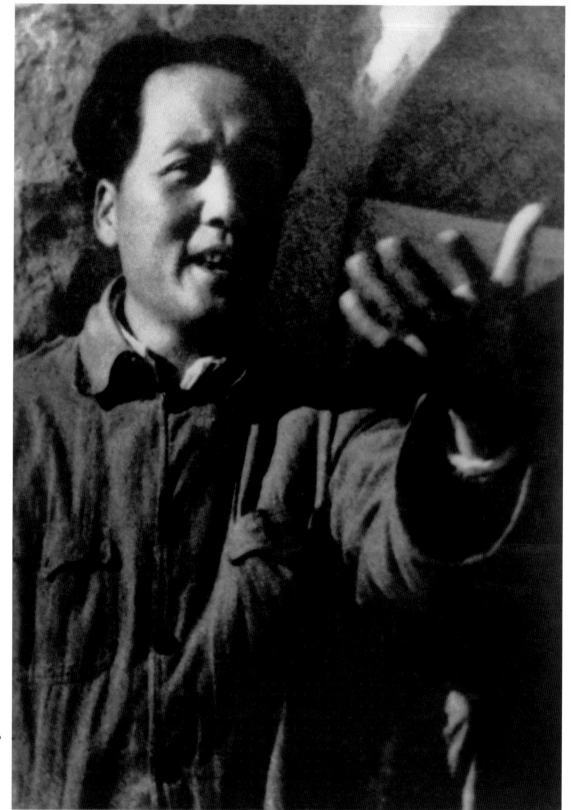

China

THE DUTY OF THE "CULTURAL ARMY"

Mao seems to be making a gesture welcoming the various intellectuals and artists who assembled in May 1942 at the city of Yan'an for a symposium devoted to the place of art and literature in the revolution.

In the eyes of the head of the Chinese Communist Party, alongside the regular army, intellectuals, too, were to be enrolled into a "cultural army," with the mission to educate people and win over hearts and minds. The pen is one front, Mao suggested, just as the gun is another.

CHINA, FIRST RECTIFICATION CAMPAIGN, MAY 1942

In contrast with the preceding photo, this one shows Mao in serious mood, dressed entirely in black, standing in front of a troglodyte dwelling. Following the symposium held the previous month, he is addressing members of the party convened in extraordinary session to try the journalist and writer, Wang Shiwei. Beguiled by propaganda, Wang had traveled to Yan'an but was quickly disappointed by the life he saw there. He did not hesitate to dispatch articles to the newspapers in which he explained how the society he had discovered at the Red base was very much at odds with the ideals of justice and equality proclaimed by the party. Refusing to retract his accusations, in June 1942 Wang was condemned to life imprisonment "for calumny, Trotskyist ideas, and subversion." Five years later, he was executed in atrocious conditions on Mao's personal orders. This show trial, soon followed by other arrests and interrogations, proved to be just the first campaign designed to humiliate intellectuals in Communist China.

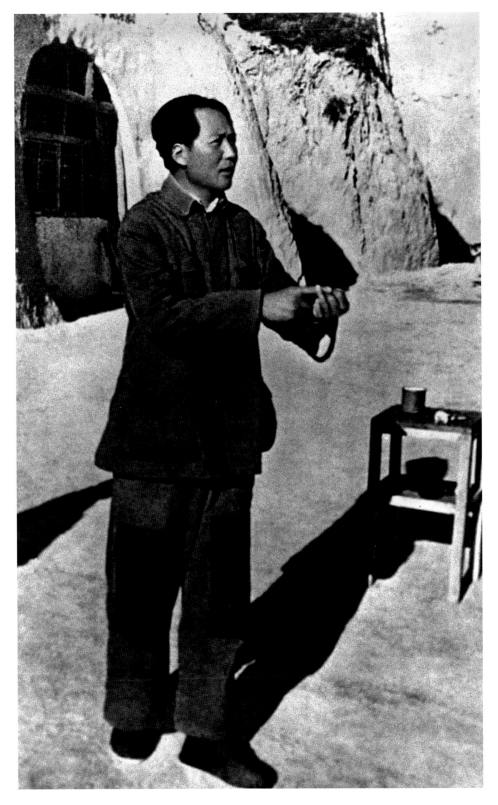

Wu Yinxian/Magnum Distribution

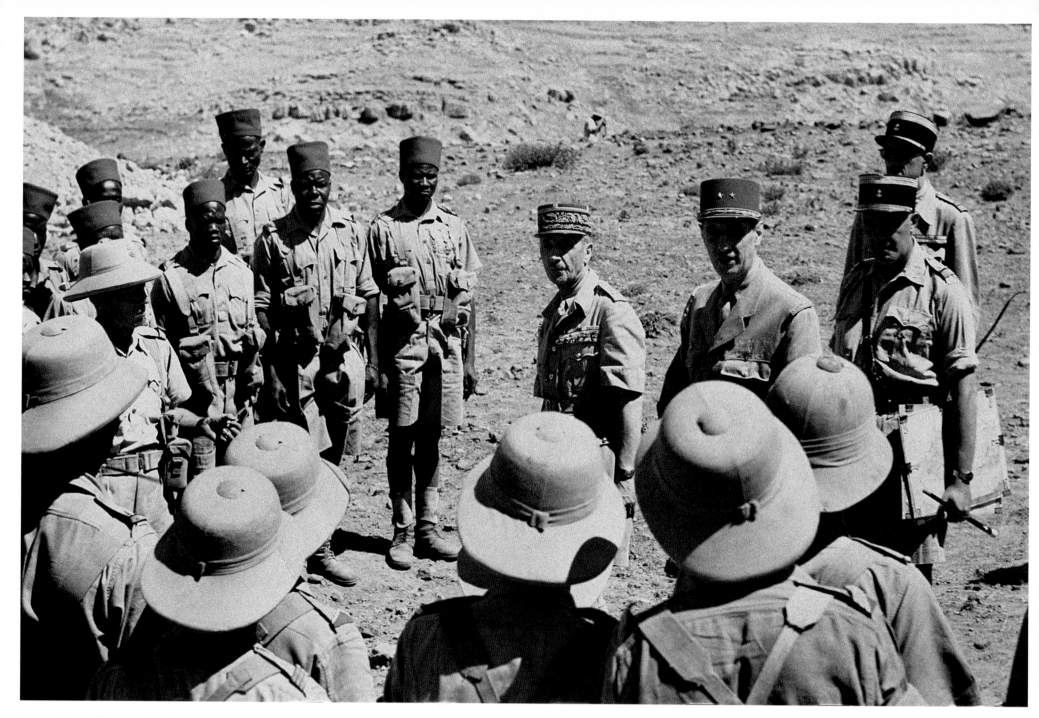

Barbey Collection/Magnum Distribution

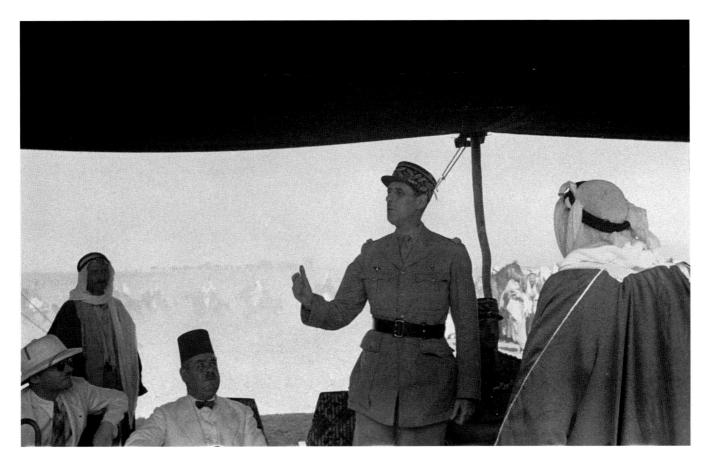

Barbey Collection/Magnum Distribution

The Near East

LEBANON, DE GAULLE AT BIKFAYA

Accompanied by General Catroux, the French high commissioner to the Levant States, de Gaulle reviews a detachment of Senegalese riflemen in Bikfaya. Hailing from Chad, the regiment had been dispatched to Lebanon to maintain law and order in the face of demands by the nationalist Phalangist Party. The Muslim riflemen wear the *chechia* (a cylindrical cap), together with English equipment (gaiters and cartridge pouches). The non-Muslim soldiers in the foreground sport English-style pith helmets instead.

SYRIA, DE GAULLE WITH THE DRUZE

In August 1942, aware of the need to adopt "a new stance in keeping with the evolution and force of events" in the Levant States (as described in de Gaulle's war memoirs), while refusing any radical change of status "before the sun of peace rises to shine once again on the world," de Gaulle stopped off in Syria at the Mount Al-Duruz. There, in mountains which had always been a hotbed of rebellion against the French presence, de Gaulle outlined to the Druze dignitaries what he dubbed "independence in the long term."

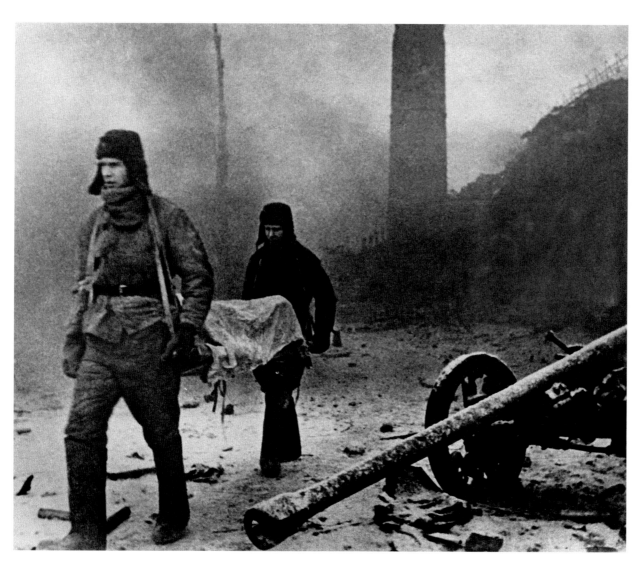

Soviet Group/Georgi Zelma/Magnum Distribution

USSR

STALINGRAD, EVACUATION OF A CASUALTY

This snapshot, taken by Soviet photographer Georgi Zelma, a war correspondent of *Izvestia* and (like Baltermants) an "eye of the nation," might have been retouched—as so many others were—to bring out certain contrasts. The photo shows the grim everyday reality of the war in Stalingrad on the banks of the Volga at the end of 1942. A wheel-mounted anti-tank gun, half-destroyed concrete walls, a factory chimney, rubble on the ground, and, in the center, in a light that is heavy with dust, two sturdy fellows from the Red Army, wearing gloves and caps with earflaps, carry a casualty on a stretcher to the underground infirmary.

STALINGRAD , RUSSIAN TANK OFFENSIVE

The spearhead of the Red Army, a phalanx of armored tanks (here T-34s, recently produced in arms factories that had been transferred to the Urals) mount a night offensive against positions occupied by the German Sixth Army commanded by General von Paulus. Looking like cheap fireworks, rocket flares allow the pilots of these armored monsters to see where they are going.

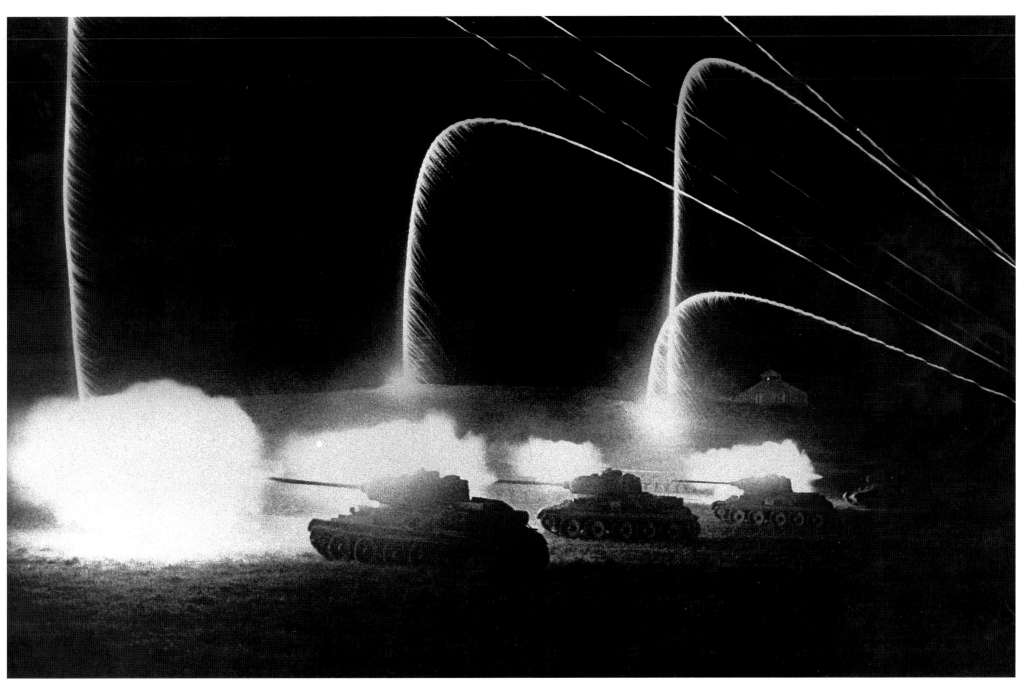

Soviet Group/Dimitri Baltermants/Magnum Distribution

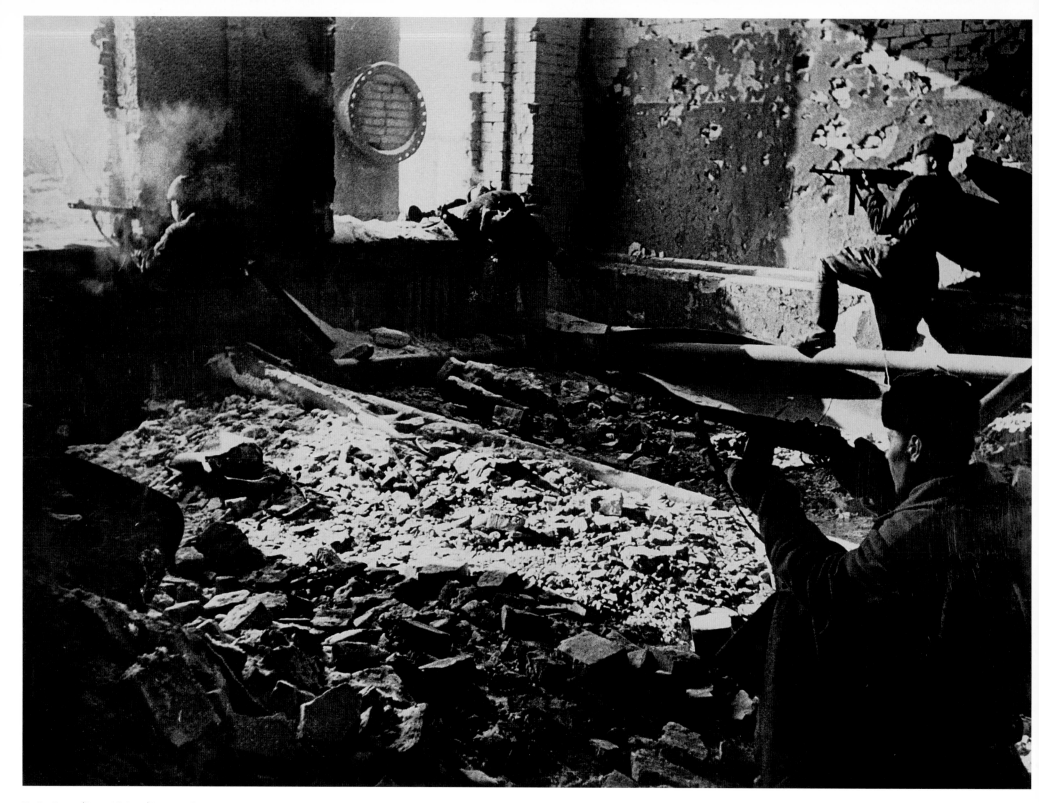

Soviet Group/Georgi Zelma/Magnum Distribution

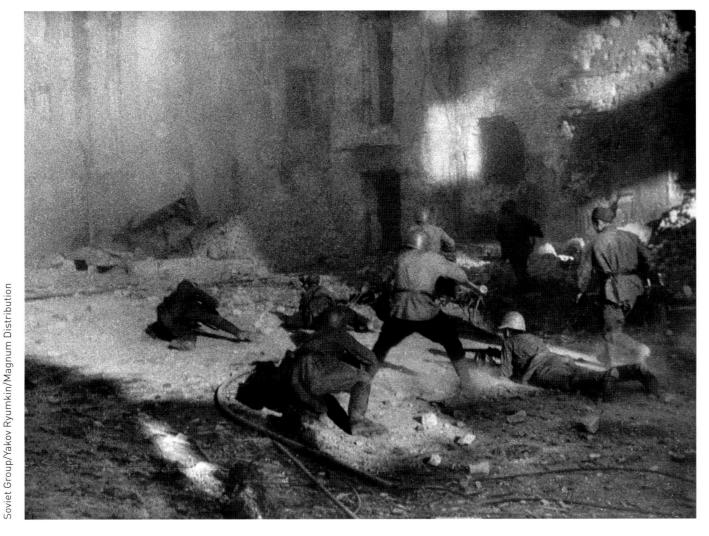

USSR

STALINGRAD, SNIPER COMBAT

Bullet holes in the walls, a heap of rubble on the ground—this is a hellish vision of Stalingrad. Extremely costly, these confrontations—waged inside houses and factories—lasted throughout late 1942 and into early 1943. By the end of January, this interminable and furious sniper war was drawing to a close. The ground being frozen hard, Khrushchev noted, tens of thousands of German corpses lay about awaiting burial. They were to be incinerated later on gigantic bonfires fueled by railway sleepers.

LENINGRAD, STREET FIGHTING

In Leningrad, the city of the revolution, besieged, bombarded, and starving, where the wounds of the combatants were sewn up with safety pins, a ray of light on a wall brings a glimmer of hope.

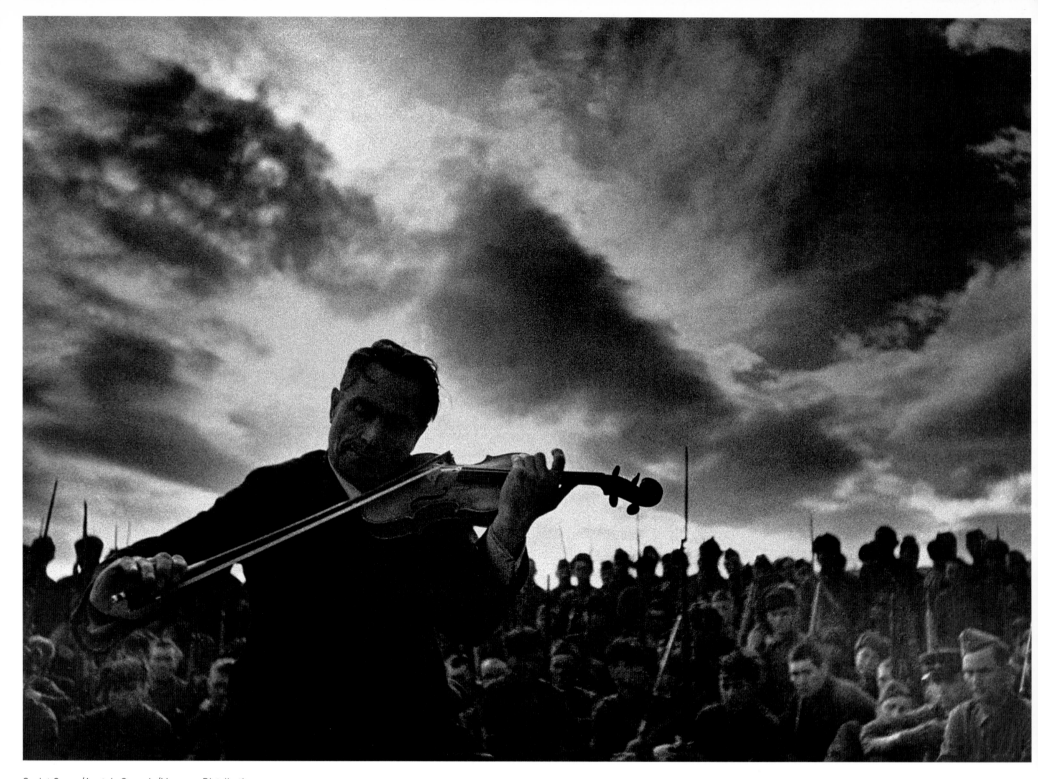

Soviet Group/Anatoly Garanin/Magnum Distribution

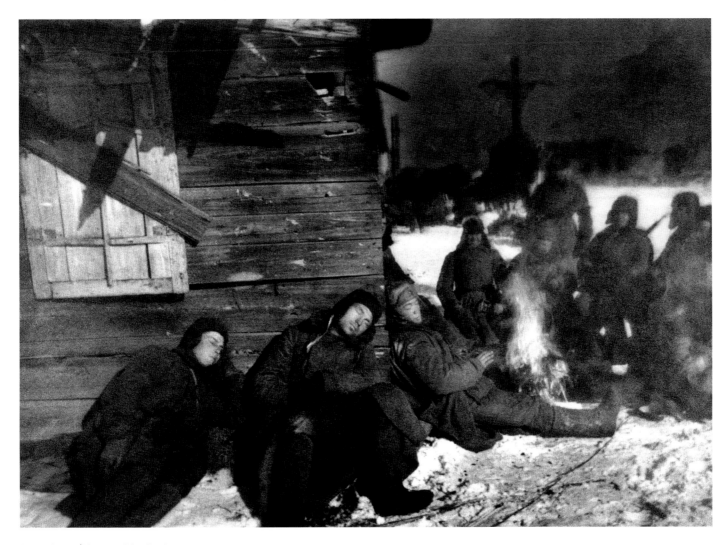

Soviet Group/Magnum Distribution

USSR

SOUTHERN FRONT, VIOLINIST

A first-rate violonist, a professor from the Academy of Moscow no less, has arrived to exhort the Slav heart of the "Red Archers" to battle. To maintain morale and keep the love of the motherland and the hatred of fascism burning among the troops—this was the artist's mission.

STALINGRAD, THE HEROES REST

Is it dawn or twilight? In a wan light, a huddle of warmly dressed Red Army soldiers gathers around a fire at the foot of an *isba*. Seated on ground covered with grubby snow, they take a quick rest between attacks.

1943 Hope changes sides

In the course of the third spring of the conflict, the tide of the war begun to turn. The die was cast: the balance of power was shifting and the initiative was—from now on—to be with the Allies. It began in Africa, with the victory at El Alamein in the autumn of 1942. This was followed three months later on the Eastern Front by the still more resounding triumph at Stalingrad. In 1943, this strategic turning point was to be confirmed in every theater of operations, bringing a revival of hope among the Allies. This was even true in Poland where, in January 1943, condemned to a grisly death, the Jewish population of the Warsaw Ghetto rose up against its Nazi torturers in one last desperate act of heroism.

Far from these atrocities, the Americans, having disembarked on the coasts of Morocco and Algeria, were advancing to join up with Montgomery's British who had set out from Egypt. Together, they straddled the *jebels* and deserts and drove back the German–Italian armies to Tunisia; these forces capitulated to the Allies in May 1943. After Stalingrad, this was known as "Tunisgrad."

Two months later, Anglo–American forces made landfall in Sicily, liberating the island and forcing Mussolini to step down. From their springboard in Sicily, in September the Allies disembarked on the coast of the Italian peninsula, south of Naples, not far from Vesuvius, obtaining the capitulation of the country, which then changed sides.

On the Pacific Front, the US Navy task forces, veritable mobile air bases floating in the midst of the ocean and escorted by vast flotillas of cruisers and destroyers, advanced or rather leapt from island to island ("island-hopping").

After the US Navy had taken Guadalcanal in the hostile jungle, following a dogged and bloody battle, the strongly defended Japanese naval and air base of Rabaul in New Britain soon fell in its turn. The murderous assault on the Tarawa atoll towards the end of the year (November 1943) foreshadowed the later events on Omaha Beach in Normandy.

In the Far East, Chiang Kai-shek persisted in his wait-and-see policy with regard to the Japanese invader, itself all too busy repelling wave after wave of American attacks in the Pacific. In the Communist territorial base at Shaanxi, Mao Zedong continued to harass the occupier, all the while defending his positions against repeated raids by the Kuomintang Nationalists.

Facing page: ITALY, LIRI-CASSINO VALLEY, REFUGEES

Regaining their village after the battle, these Italian countrywomen show dignity and pride as well as considerable grace. The women's proud demeanor is accentuated by the low-angle viewpoint.

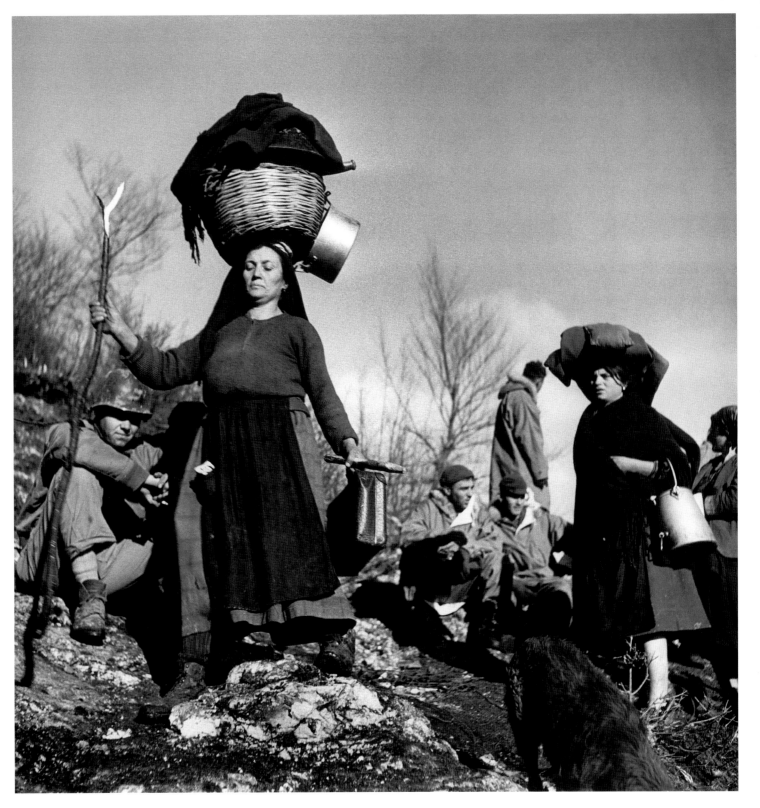

Robert Capa

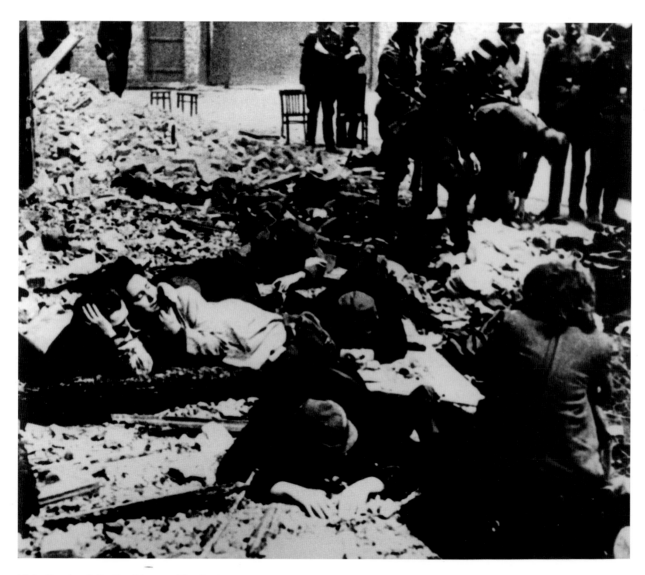

Micha Bar-Am Collection/Magnum Distribution

Poland

WARSAW, THE GHETTO UPRISING

In German-occupied Poland (the General Government), Germany lost no time reconstituting the Polish ghettos, into which it promptly herded the Jewish population. In Warsaw, approximately 400,000 Jews were forced to live in a restricted area, which the Gestapo fenced off with high walls. From 1942, death from "natural" causes was accelerated by a systematic policy of extermination in the death camps. Thus, 300,000 Jews from the Warsaw Ghetto vanished in the second half of 1942, the record number of deportees being attained in July, with 70,000 in a single week. When, on April 19, 1943, the German police, reinforced by SS units, came to take delivery of a fresh quota, it encountered resistance from Jews, who courageously took up arms against their would-be murderers. The historian Martin Gilbert records the words of a survivor, who recalls that for a whole month "one saw, for the first time, Germans crawling off to escape Jewish bullets; the screams of the wounded Germans occasioned us immense joy."

WARSAW, JEWS BEING DEPORTED FROM THE GHETTO, APRIL 19–MAY 16, 1943

The future looked more than bleak for the Jews in the Ghetto. Deprived of external help, on May 16 the resistance in the Ghetto stopped issuing official military statements and the insurrectionists emerged from their underground shelters. Six thousand of them had already perished in the fires lit among the houses by the occupier and seven thousand had been killed in the fighting. As for the sixty thousand survivors, such as the ones in this photograph, they were marched off to forced labor camps or to the death camp at Treblinka, east of the capital.

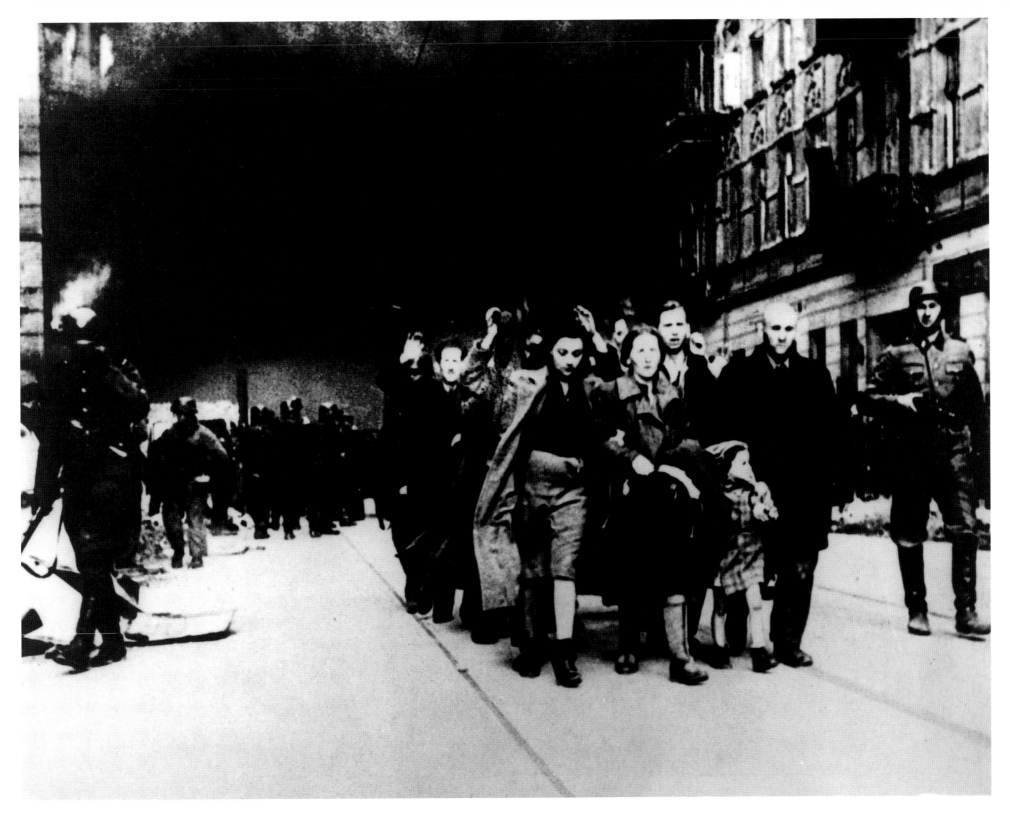

Micha Bar-Am Collection/Magnum Distribution

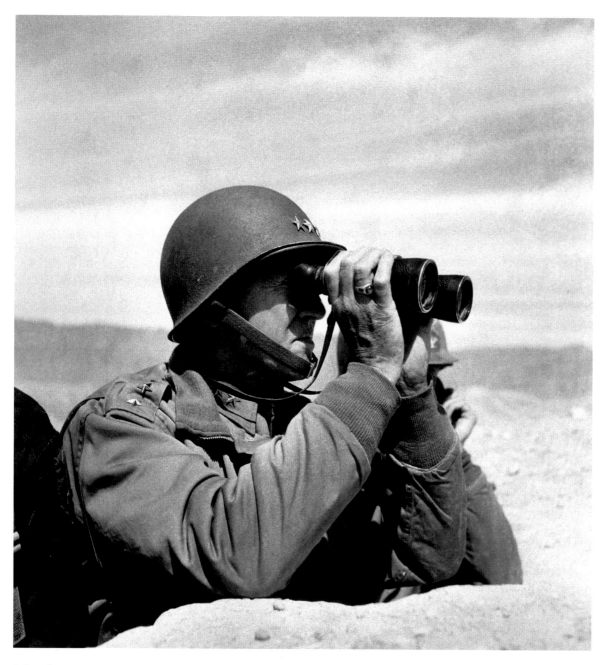

Robert Capa

Tunisia

GENERAL GEORGE PATTON

A splendid portrait of the most famous strategist in the American army, observing the armored units of the Second US Army Corps being deployed during the offensive at El-Guettar through a pair of binoculars. After the unit's debacle at the Kasserine Pass in February, it was Patton whom General Eisenhower entrusted with restoring order in the ranks.

AMERICAN SOLDIERS AMONG THE MOUNTAINS OF TUNISIA

Arid hills, prey even in spring to a burning wind from the nearby Sahara, a stony land strewn with tufts of thornbushes grazed by the herds of the nomads—such is the image of the relatively low-lying mountains of Tunisia. Having suffered a serious reverse at the Kasserine Pass in February 1943, one month later the American high command launched a successful offensive against Rommel's forces in the direction of Gafsa and El-Guettar.

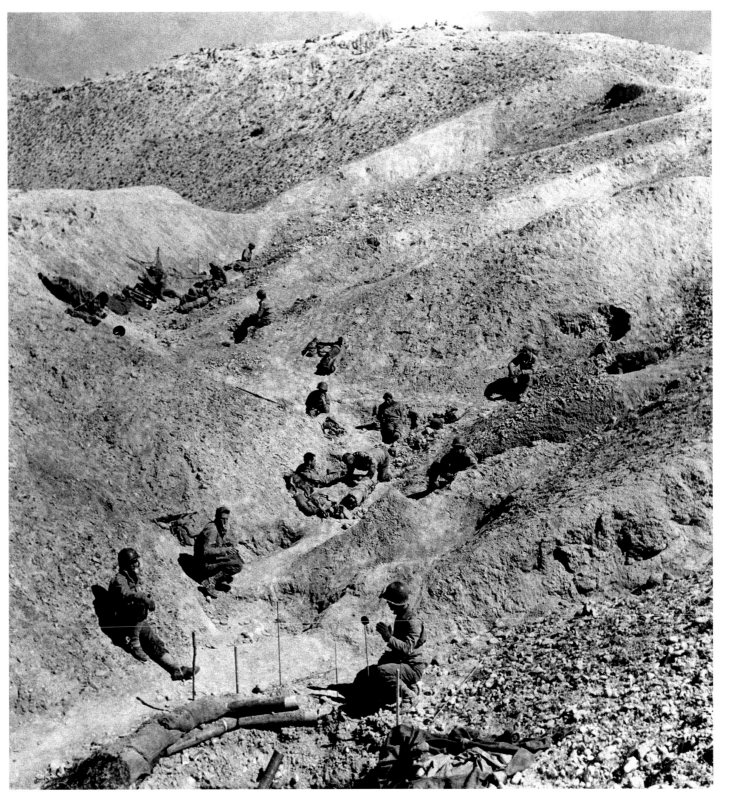

Robert Capa

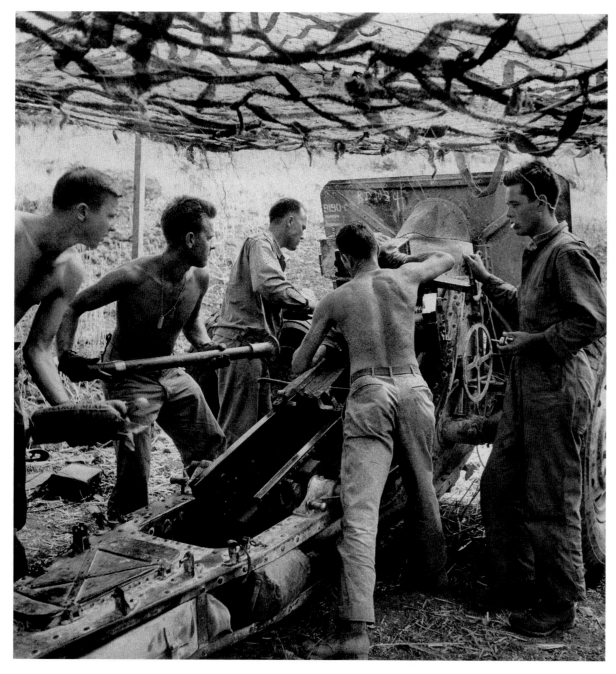

Robert Capa

Tunisia

THE VICTORY AT EL-GUETTAR, MARCH 23, 1943

Concealed under a thick net of camouflage, the enormous gun is shown in the heat of the action. Firing off blazing salvoes against Rommel's tanks, which had already been slowed down by a vast minefield, the combined efforts of the land artillery and the ground-attack aircraft in the valley of El-Guettar completely scuppered the German operations.

AMERICAN FIGHTER PILOT

The photo makes this pilot—sitting in the cockpit of his plane, complete with helmet and goggles and preparing to take off for a fresh sortie—look very heroic. The fuselage is emblazoned with his strike rate: nine swastikas, one for each plane shot down. Mustang, Lightning, and Spitfire planes all played a major role during the offensive at El-Guettar, the first American victory on African soil.

GENERAL OMAR BRADLEY

Devoid of the class and brilliance of Patton, Bradley, as this photographic portrait suggests, was a modest, understated, hardworking man. Ernie Pyle, the celebrated American war correspondent, in his work *Brave Men*, offers an account of an officer with simple tastes who neither smoked nor drank. He concludes his description by saying that Bradley came over as a "schoolteacher rather than a soldier."

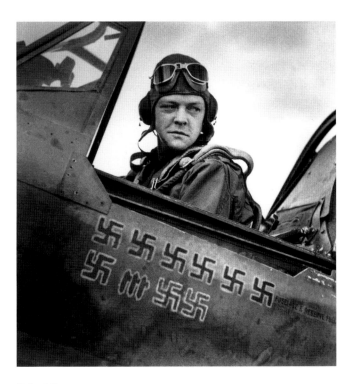

Robert Capa

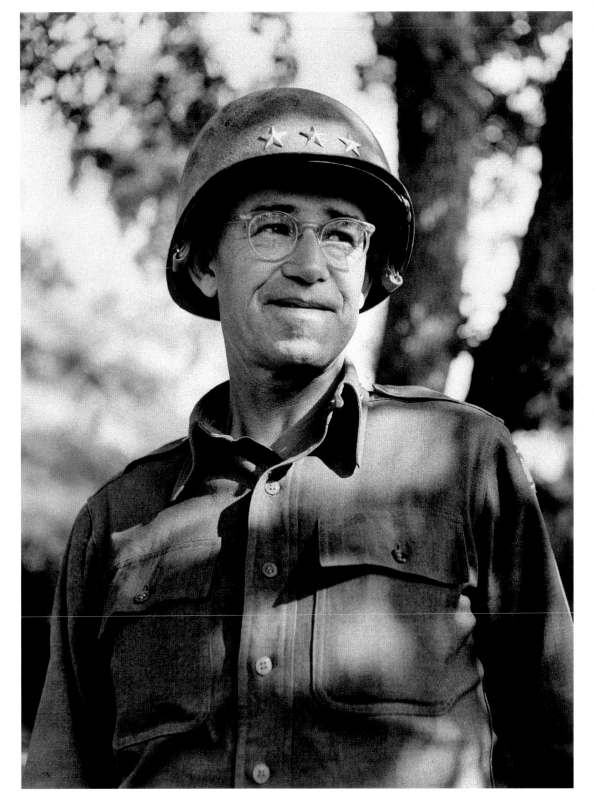

Robert Capa

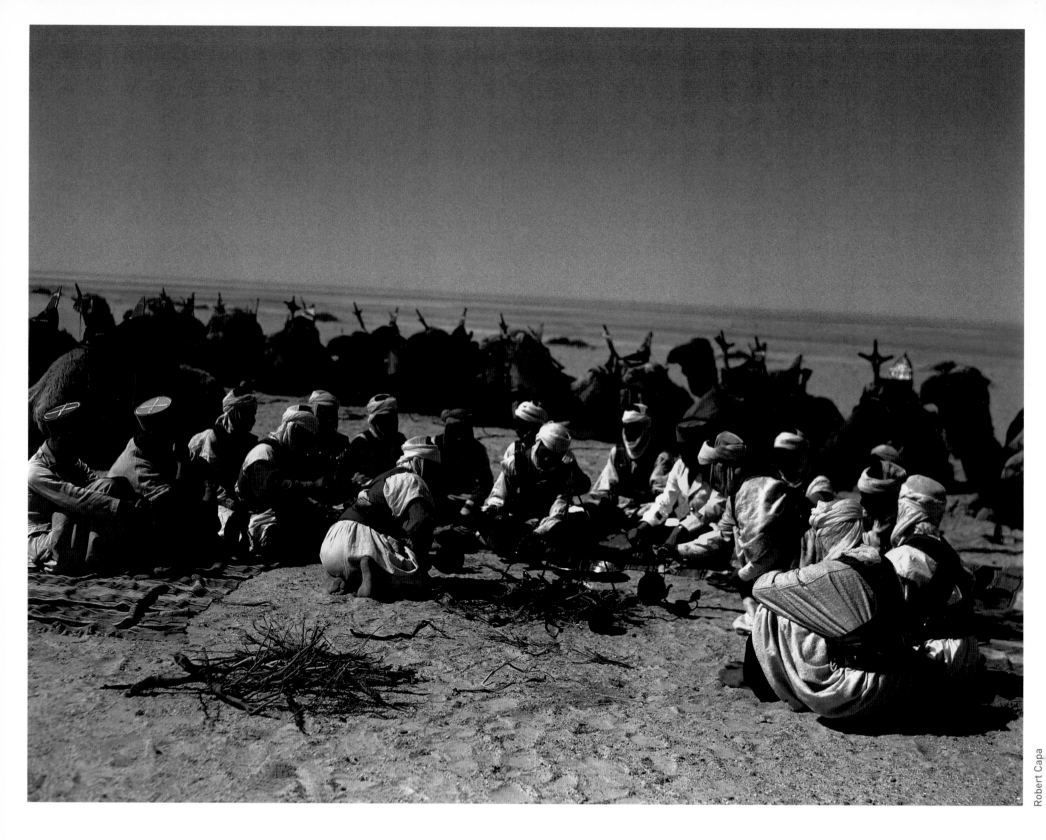

Tunisia

MEHARISTS DRINKING TEA

Recruited among the Bedouin tribes of the Sahara, the Meharists were volunteer soldiers who, complete with their mounts, were engaged in the French army. Suited to the country and with immense reserves of stamina, the *meharis* (camels) were, unlike horses, able to cross the shifting sands of the dunes and were employed on reconnaissance missions. Here a detachment of Meharists take tea before rejoining the battlefield. "Sweet and strong," as the caption reads, the tea required an hour's preparation and two hours to be drunk, thus affording a good rest for the mounts visible in the background.

MEHARISTS IN BATTLE

In the desert, the tiniest wrinkle can be used as a hiding place. Under their French officers, the indigenous troops, living with their camels, had a military life that was comprised of an amalgam of French army rules and regulations (the uniforms worn and weapons carried) with local customs. As formerly with the dragoons, the Meharists approached the battlefield mounted but fought on foot.

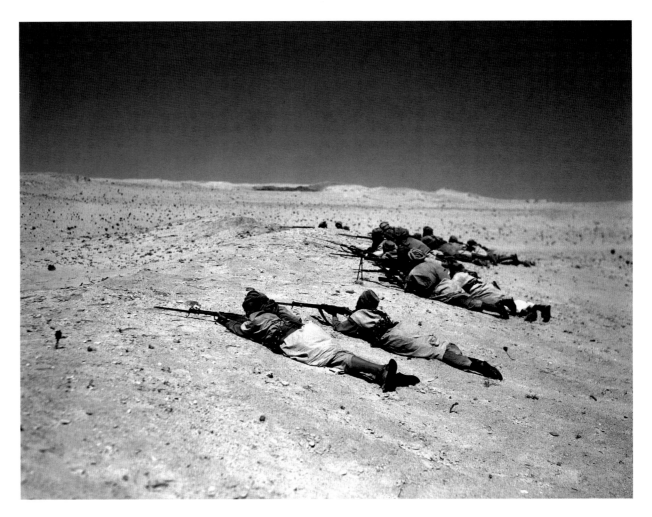

Robert Capa

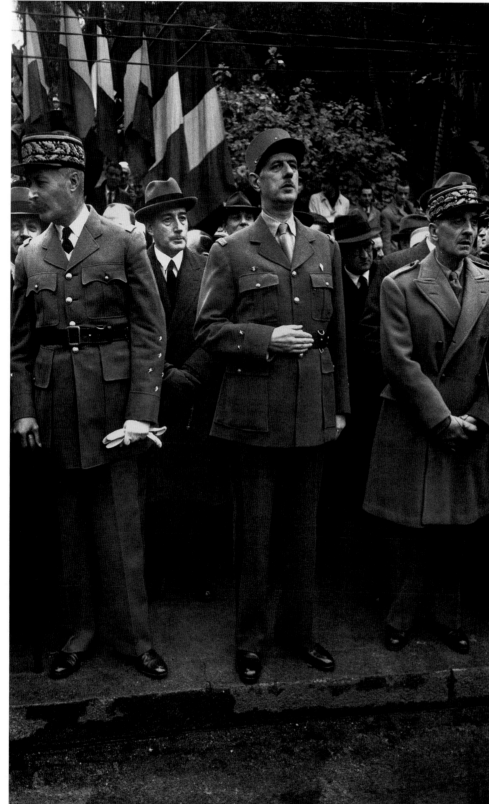

Robert Capa

Algeria

ALGIERS, DE GAULLE, NOVEMBER 11, 1943

Standing tall and proud, towering above the rest of the assembly, clearly visible against a backdrop of tricolor flags, General de Gaulle, with General Giraud to the right, and General Catroux to the left, presides over the ceremony of the twenty-fifth anniversary of the Armistice of 1918 in Algiers. In his speech, the president of the French Committee of National Liberation—in other words, the head of the French government—denounced both collaboration and cowardice. "Once again singing the love song of France," as he writes in his memoirs, he felt proud to be able to hail both the Resistance at home and the forces of Free France abroad.

ALGIERS, A PROCESSION OF SENEGALESE TROOPS, NOVEMBER 11, 1943

Turning his lens on a contingent of Senegalese troops flanked by two officers at the November 11 ceremony, the photographer wants to pay tribute to the many African soldiers in the French army. Wearing American uniforms and shouldering Lebel rifles, since the beginning of 1941 these indigenous battalions had taken part in all the operations in which Free France was engaged: Kufra, Eritrea, the defense of the fort at El Alamein, Tunisia, and—later—Italy.

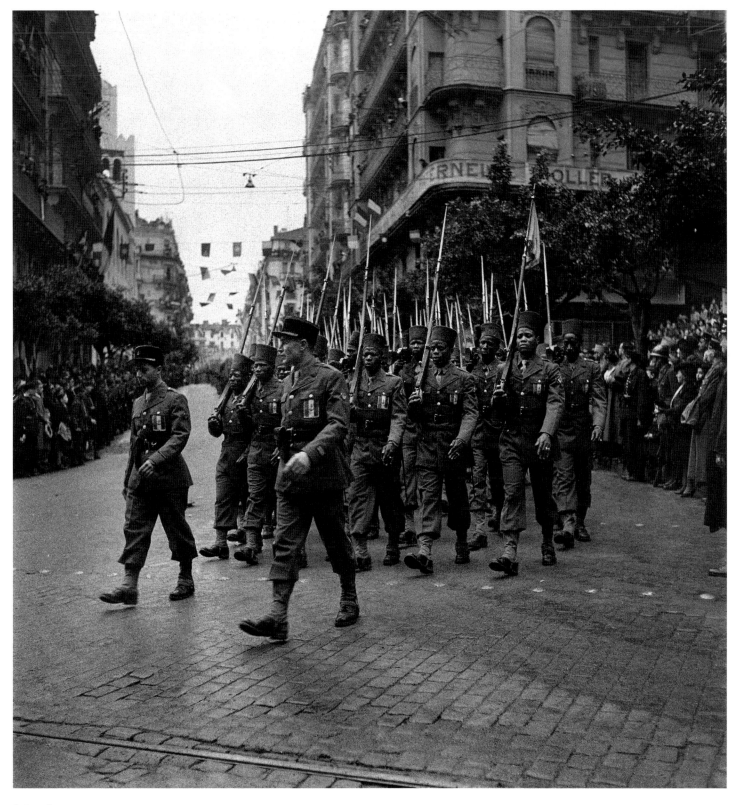

Robert Capa

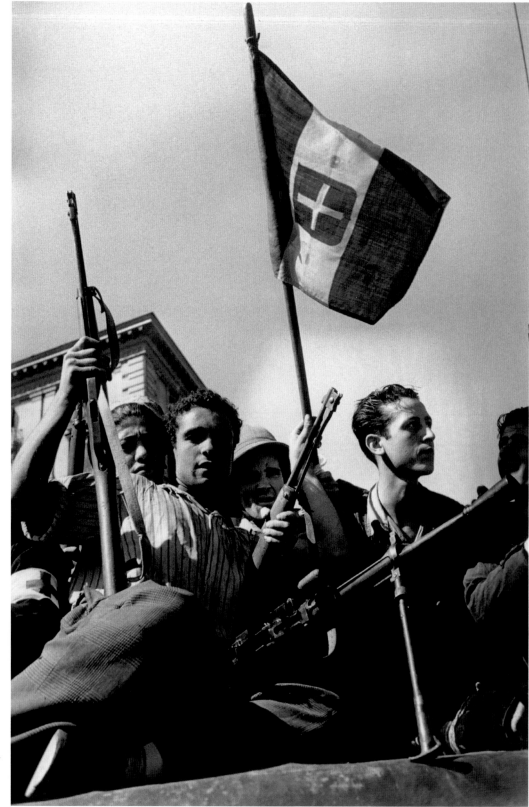

Sicily

PALERMO, THE ARMY OF THE SHADOWS

Emerging from hiding as soon as the success of Allied landings on the Sicilian coastline became known, bands of antifascist resistance fighters sparked insurrections all over the island. Here, in Palermo, a posse of clandestine troops brandishes the flag of the Italian monarchy as American troops enter the city. Three days later, on July 25, the Gran Consiglio del Fascismo announced the resignation of Mussolini, and King Victor Emmanuel III handed power over to Marshal Badoglio.

PALERMO, MONREALE LIBERATED, JULY 22, 1943

In Monreale, near Palermo, a crowd bars the road to the military vehicles and gives a delirious reception to its liberators. It is true that many Italian-American soldiers must have had cousins in Sicily. As for the Mafia, it was entirely on the side of the Americans.

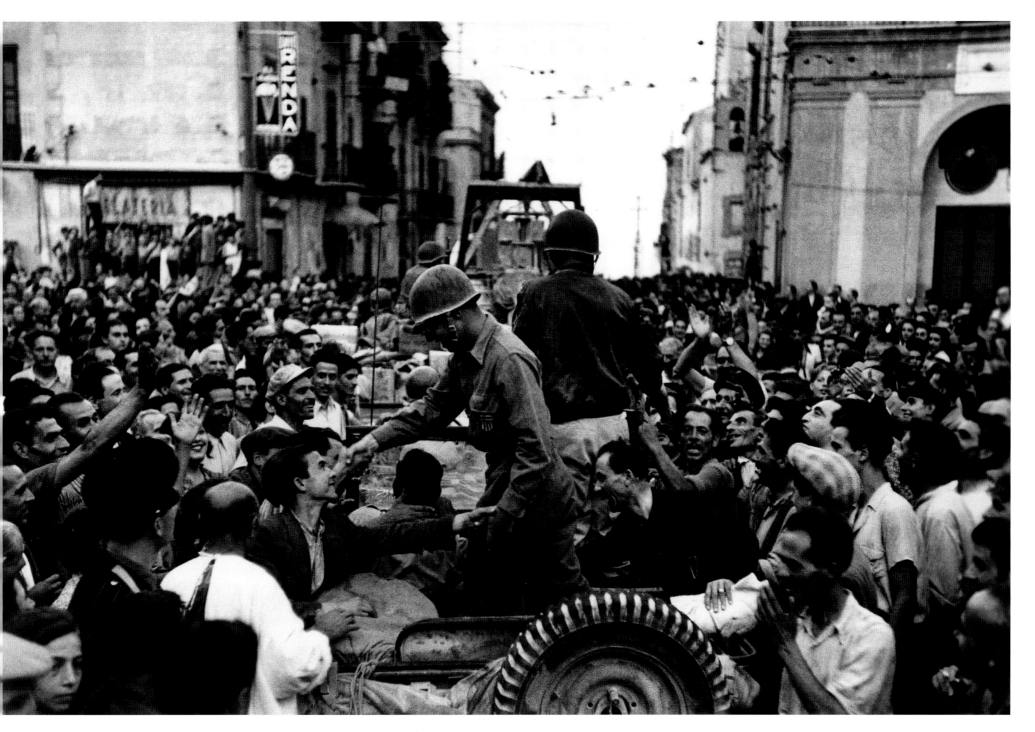

Robert Capa

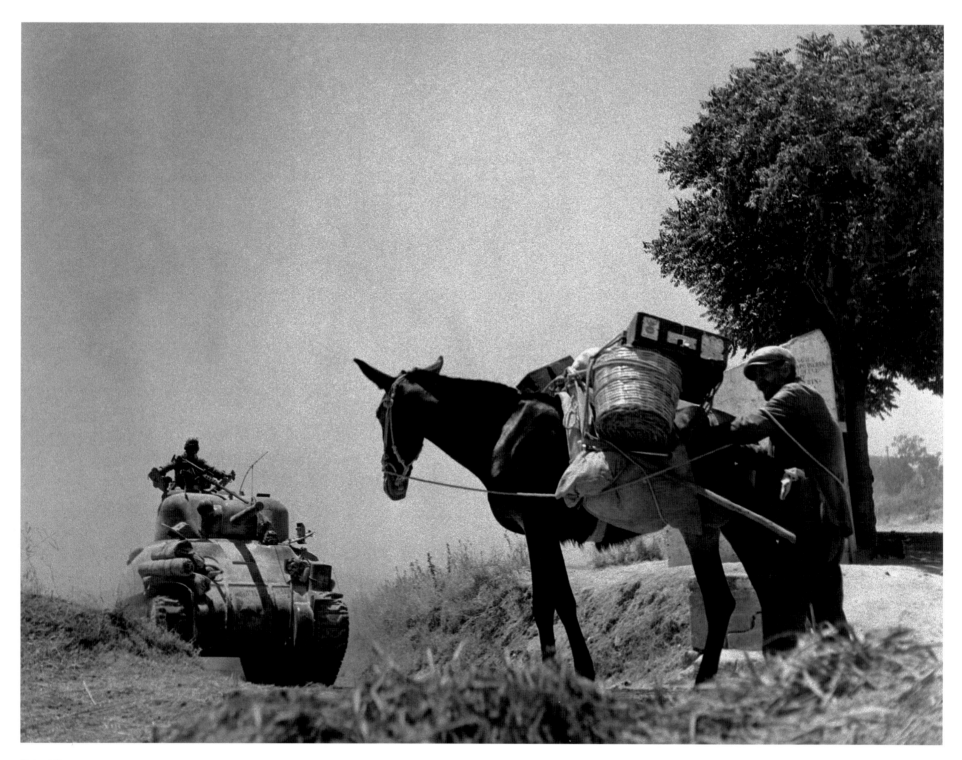

Robert Capa

Sicily

TROINA, THE MONSTER AND THE MULE

An encounter that affords a wonderful example of counterpoint. On the one side, an unseeing, mechanical, armorplated monster arriving from the direction of Palermo, and on the other, fleeing the village of Troina, a mule with a packsaddle—for millennia the companion of the Sicilian peasant at work among the olive groves or vineyards. It was here, in these hills in the center of the island, that the German high command had reckoned they could block the advance of the American tanks and so allow the bulk of the troops of the Wehrmacht to cross the Strait of Messina and take refuge on the Italian mainland.

TROINA, WOUNDED CHILD, AUGUST 6, 1943

An important crossroads and a stronghold surrounded by hills and located in the heart of the island, Troina saw the lengthiest and toughest battle in the whole Sicilian campaign. Frequently bombarded by artillery from both sides, and by the US Air Force, the suffering of the inhabitants of the town was enormous, as shown in this photo. Taken in Troina in August 6, the day the town was liberated, it shows a Sicilian couple with their wounded child, their eyes full of reproach. Here, it is the Americans who seem to be wreaking the destruction.

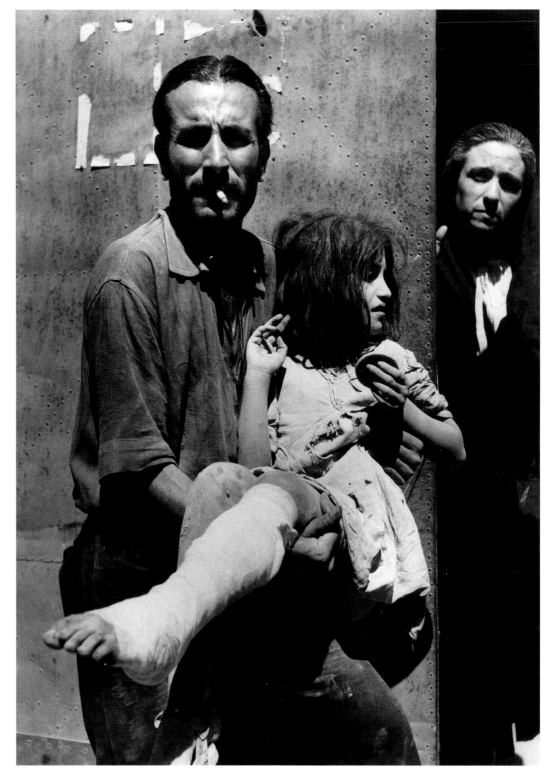

Robert Capa

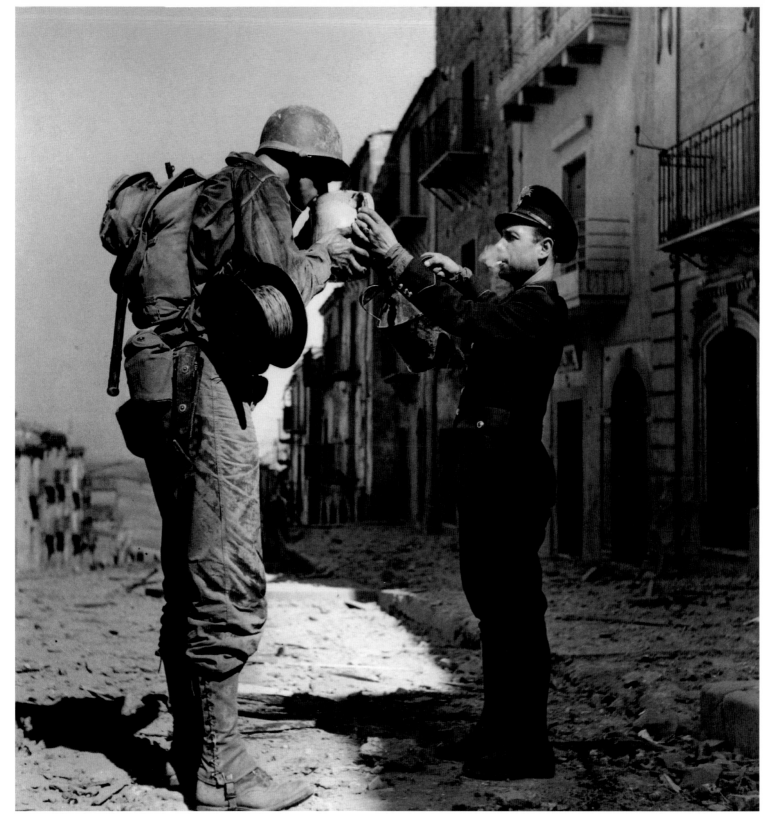

Robert Capa

Sicily

SICILIAN POLICEMAN
AND AMERICAN SOLDIER IN TROINA

A scene in the town of Troina showing an American soldier and a Sicilian police officer, dressed in a black uniform, swapping a cigarette for some water in a street covered with rubble. Although officially Rome still formed part of the Axis, the Italian people greeted the Americans more as liberators than as invaders.

GERMAN PRISONERS

For this group of fifteen or so German soldiers belonging to the Fifteenth Panzergrenadier Division, the war is over. After transfer to North Africa, the men would have been sent to camps in Great Britain, Canada, or the United States. In Sicily, the Germans and Italians lost some 29,000 killed or wounded with 140,000 prisoners taken. In spite of the mines laid by the Allies, the German command succeeded against all odds in evacuating more than 100,000 men and 10,000 vehicles from the island.

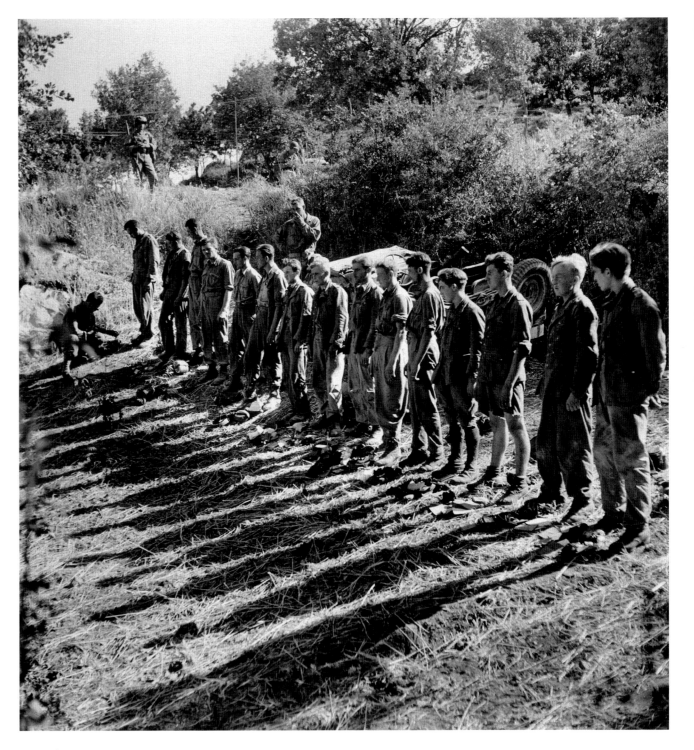

Robert Capa

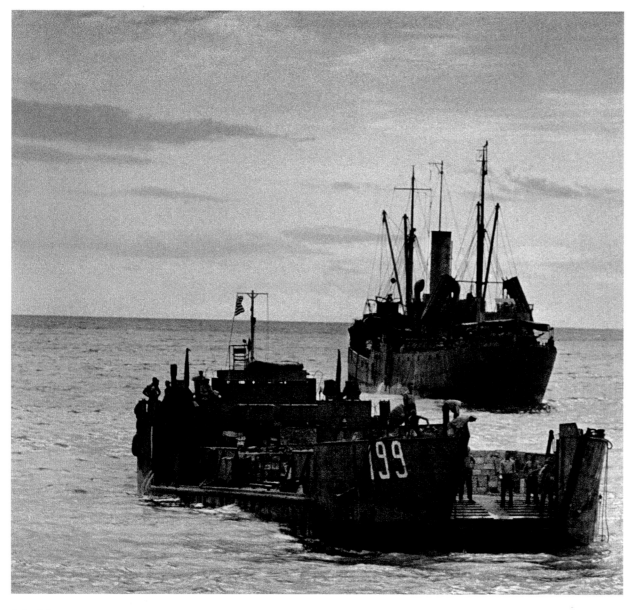

Robert Capa

Italy

OPERATION AVALANCHE, SEPTEMBER 9–10, 1943

Once the Sicilian campaign had been successfully completed, in the night of September 9 to 10, Allied forces starting out from Oran, Bizerte, and Palermo disembarked on the coast of the Italian mainland in the Salerno region. Operation Avalanche had begun. The chief objective of these landings was to capture the port of Naples, located around 30 miles (50 kilometers) north. On September 3, a few days before the launch of Avalanche, Italy had secretly signed an armistice and signaled its intention to come over to the Allied camp. By September 11, as the Italian naval fleet sailed to the Allied naval base on Malta, the bridgehead at Salerno was about 12 miles (20 kilometers) deep and had a perimeter of some 44 miles (70 kilometers).

THE LIBERATION OF NAPLES, OCTOBER 1, 1943

Saluting their arrival by raising their right arm beneath an Italian flag, a crowd in Naples greets the Americans with same enthusiasm as the Sicilians—in spite of Naples being the most heavily bombarded city in all Italy. Prior to falling back, though, the Germans had carried out the systematic demolition of the harbor installations in the largest city in southern Italy—destruction which was to be seen again nine months later in Cherbourg—which was bad news for the liberators.

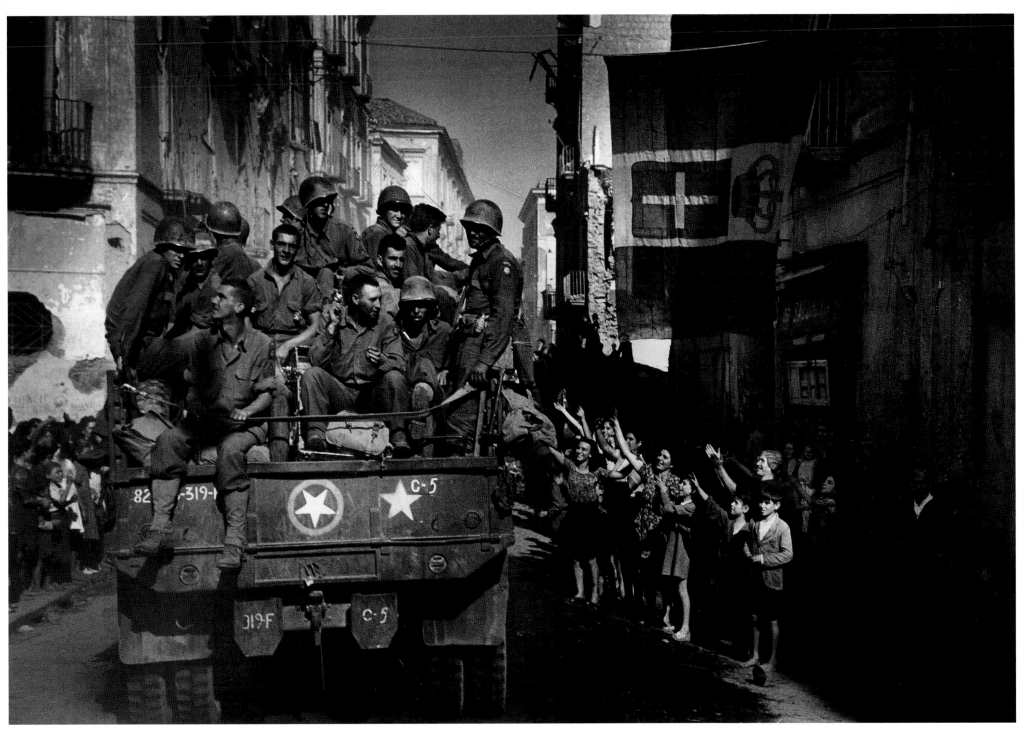

Robert Capa

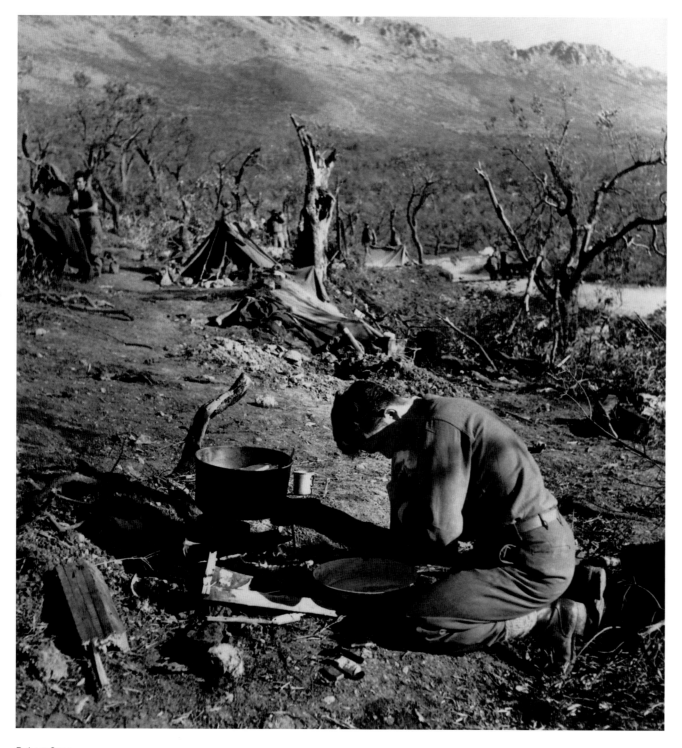

Robert Capa

Italy

LIRI VALLEY, AMERICAN CAMP, DECEMBER 1943

Faced with the severity of the Italian winter and with the stalemate reached in the military operation to take Monte Cassino, the American high command decided to suspend further offensives. Isolated atop the mountain, the soldiers of the Forty-Fifth US Infantry Division were forced to return to a state of nature, living in tents and cooking over bonfires, deep in the Liri Valley.

MONTE CASSINO, GENERALS HAVING A SNACK, DECEMBER 1943

In the center, wearing a beret, is General Juin and, on the far left, General Theodore Roosevelt Junior. Arriving in Italy in November 1943, the French Expeditionary Corps took a sector of the front in between the Americans and the British.

MONTE PANTANO, MOROCCAN GOUMIER IN THE SECOND INFANTRY DIVISION

After the Saharan Meharists, here we have a Moroccan Goumier on the Italian front with, on his shoulder, the crescent and the five-pointed star symbolizing the five pillars of Islam. The dress of these infantrymen from the Berber mountain tribes was formed of a curious blend of military garb and indigenous clothing, such as the djellaba, a kind of striped cloak woven from thick wool. Hardy, straightforward country folk who scorned death and had a reputation for giving no quarter, they were excellent combatants who specialized in night raids, terrorizing the enemy.

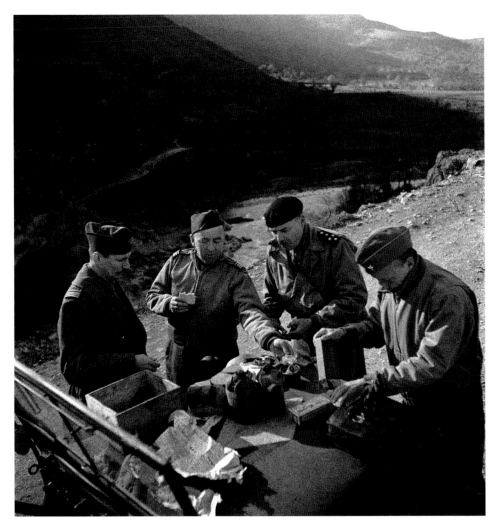

Robert Capa

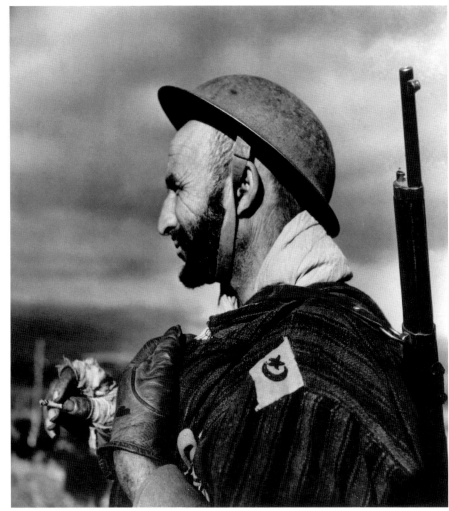

Robert Capa

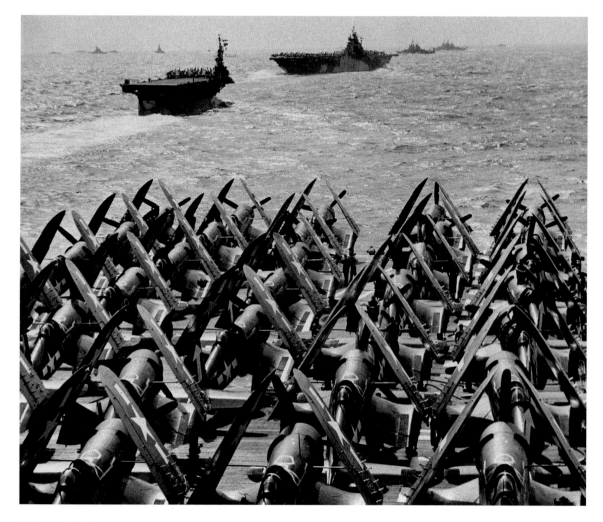

W. Eugene Smith

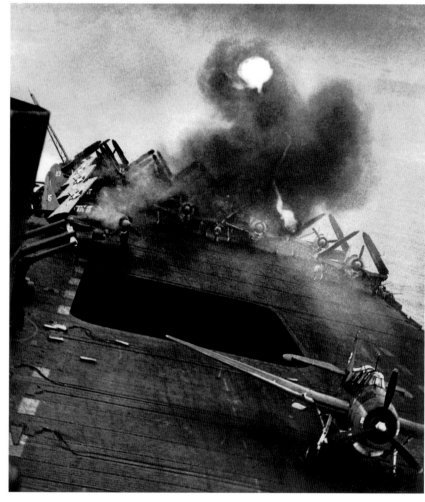

W. Eugene Smith

The Pacific

AIRCRAFT CARRIER, THE USS *BUNKER HILL*

Like great birds with folded wings lining up perfectly on the flight deck of the American aircraft carrier *Bunker Hill*, which plied the Pacific as part of a task force—this is what an air and sea fleet looks like at rest. Launched in 1942, the *Bunker Hill* (27,000 tons, a crew of 2,600, with space for 90 to 100 planes), following its intervention at Rabaul, also took part in the bombardment of Tarawa.

THE JAPANESE COUNTERATTACK

Explosions, planes on fire, thick smoke—the photograph conveys perfectly the violence of a Japanese counter attack on the flight deck of the *Bunker Hill*. The Japanese riposte followed a significant American air raid on the base at Rabaul on the island of New Britain.

THE AIRCRAFT CARRIER, THE USS *SARATOGA*

Although they must have seen it a hundred times, for this large audience standing, as if at the theater, on several tiers, the delicate maneuver of a plane (here, a Hellcat) coming onto the flight deck still constituted an interesting spectacle. After landing on a surface in motion, the plane, with its wings folded up, taxies onto a large platform serving as an elevator that descends down to the lower bridge where the craft can be maintained and parked up.

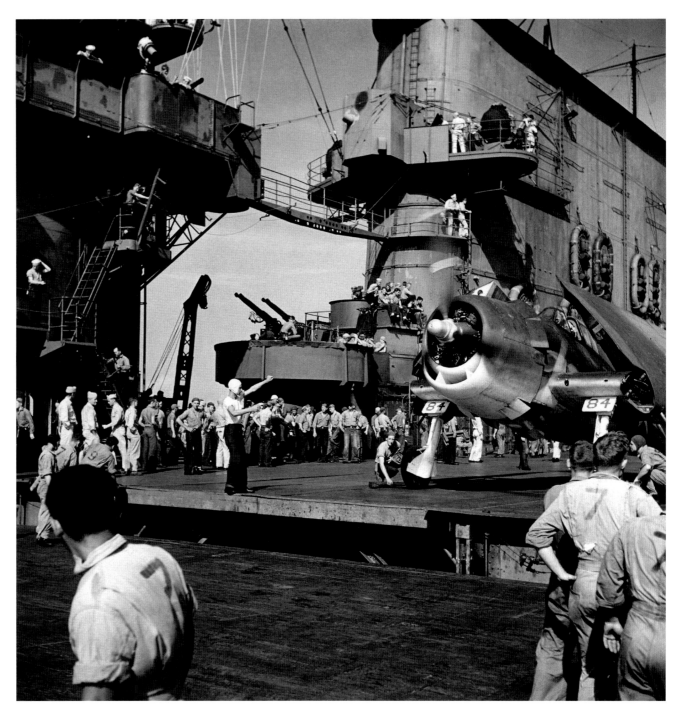

Wayne Miller

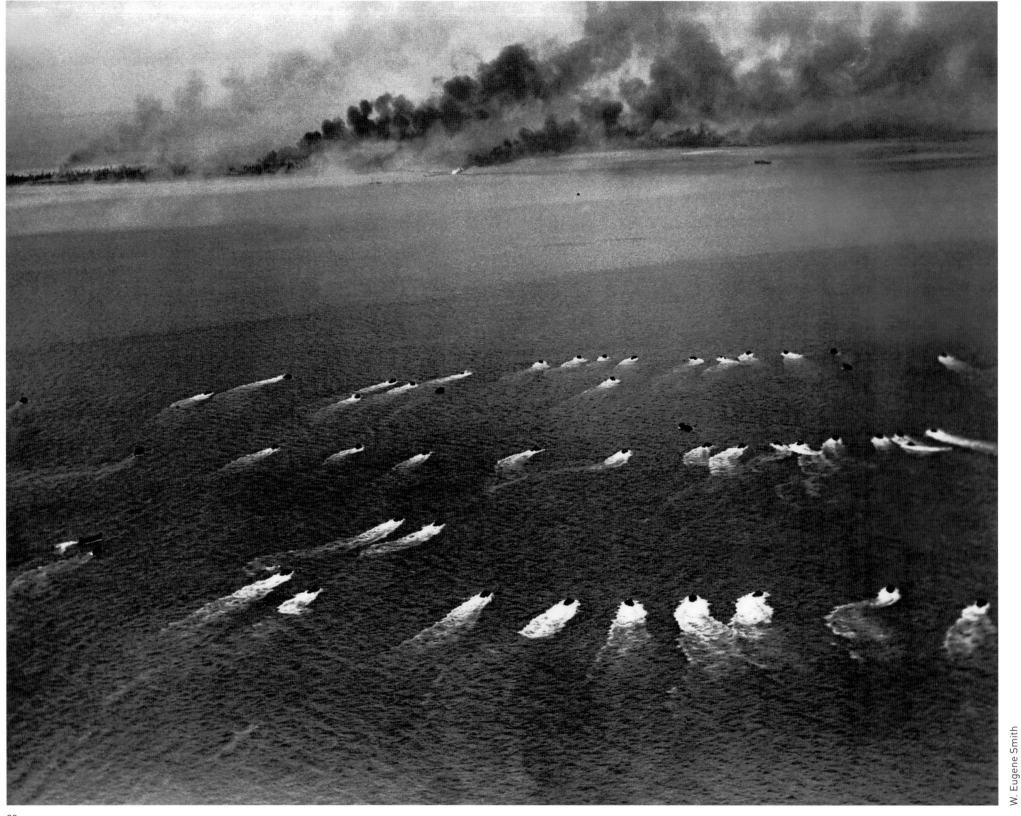

W. Eugene Smith

The Pacific

ATTACK ON TARAWA ATOLL, NOVEMBER 1943

The black fumes on the horizon are a result of the atoll's defenses being battered by the great naval guns and bombed from the air. In the foreground, making the most of the thick smokescreen and the dazed condition of the defenders following the ceaseless bombardment, wave after wave of landing craft and attack barges speed towards the shore of the atoll.

FIGHTING ON TARAWA

Placed atop a hillock and marked by a ring of stakes cut from coconut palms, the Japanese defensive position, ripped apart by air raids and the naval bombardment, put up little resistance to the land attack by the navy, if one can judge by the debris scattered over the ground. The vertical orientation of the photograph makes the eye shift constantly from the corpse in the foreground to the fortification on the knoll. After a brutal engagement lasting three days, the island at last fell into the hands of the Americans, who lost 3,100 killed, wounded, or missing in action. Out of the 4,700 Japanese soldiers, only 17 surrendered; all the others either fought to the death or committed suicide.

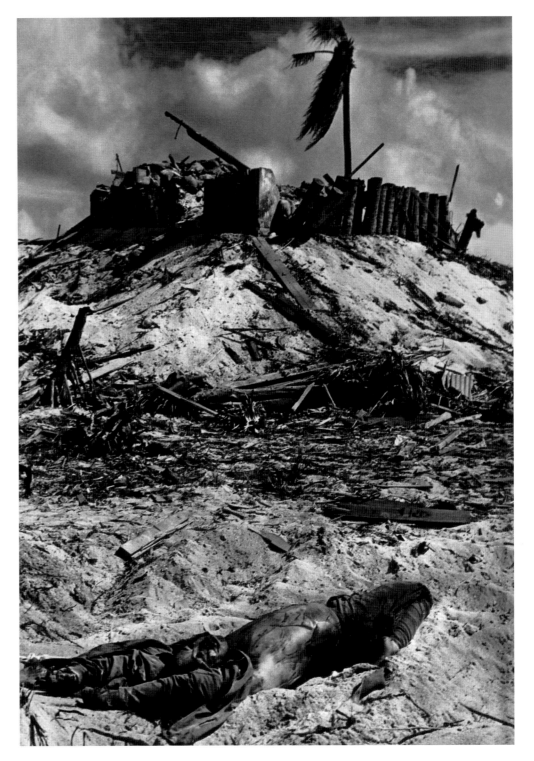

W. Eugene Smith

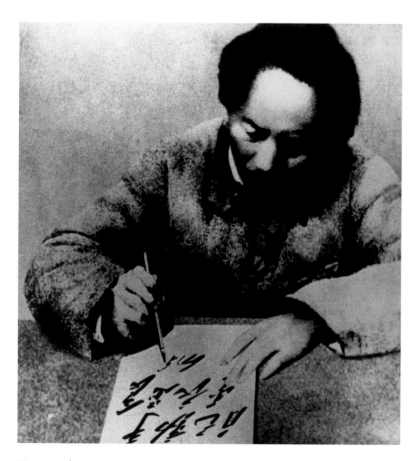

Wu Yinxian/Magnum Distribution

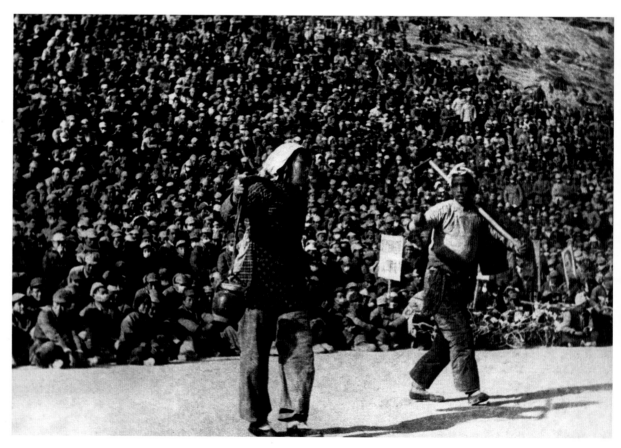

Wu Yinxian/Magnum Distribution

China

MAO TSE-DUNG, THE CALLIGRAPHER

Mao applying himself to the art of penmanship. A rather strange portrait of the Communist leader taken in 1943 by the photographer Wu Yinxian on the shoot of a propaganda film about the epic of the Long March (1934–35). This forced migration led the Communists—threatened by encirclement and extermination by the army of Chiang Kai-shek—to make their way to the remote province of Shaanxi.

Mao, who had attended the relatively advanced First Provincial Normal School and worked for a brief time as a librarian, had quite a taste for intellectual pursuits. He is seen here, with his receding hairline and a brush in his hand, leaning over a sheet of paper covered with characters writing out one of his favorite slogans: "Work with your own hands."

By 1943 the Japanese army had been occupying half China's territory for some six years and, in the face of this mortal danger, the two adversaries, Mao and Chiang, tried to present the invader with a "united front." During this pause in the revolutionary struggle and in the implementation of his plans for land reform, Mao immersed himself in the history and culture of his country.

YAN'AN, MUSICAL DRAMA

In Yan'an, the Communist Academy fostered the performing arts, in particular popular theater with its songs, dances, and mime. It became a convenient vehicle for the dissemination of party propaganda.

YAN'AN, LIU SHAOQI

A student with Mao at the normal school in Hunan, Liu Shaoqi came back to China after a stint in Moscow to join Mao, becoming one of his closest friends and apparently his designated successor.

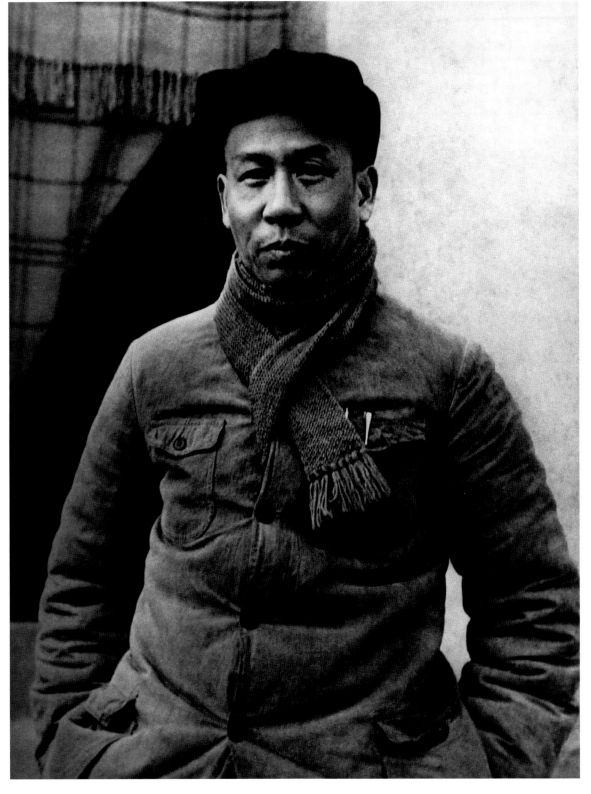

Wu Yinxian/Magnum Distribution

1944 The Axis powers in retreat

In the Mediterranean, as in the English Channel and the Pacific, events in 1944 confirmed the general retreat of the Axis powers that had started in 1943 on the Eastern Front with the Battle of Kursk; in North Africa with the capitulation of Tunis; in Sicily with the liberation of the island; in mainland Italy with the disembarkation at Salerno; and in the Pacific with the operations at Guadalcanal, Rabaul, and Tarawa.

On the Italian mainland, after getting bogged down along the Gustav Line, a solid defensive position backing against the uplands of the Apennines, the Allied armies, reinforced by the troops landed at Anzio, were—by January—on the march again, capturing the stronghold of Monte Cassino in May and charging on for Rome, reaching it on June 4. The first European capital to be liberated by the Allies, even this major event in 1944 was soon overshadowed by the success of an operation that took place two days later in the

English Channel along the Normandy coast. For the first time, the Allies were to undertake a large-scale amphibian operation along a shoreline strongly fortified and stubbornly defended by the Wehrmacht. Involving vast forces (navy, air force, a campaign to lull the German command into a false sense of security, artificial harbors, etc.), Operation Overlord, the code name for the invasion of the Normandy coast, was eventually successful. In the following weeks, the Americans took Cherbourg, and then, one month later, Avranches; whereas on the other flank the British, having seized Caen, pushed in the direction of Falaise, thus hemming in the German Seventh Army.

On August 20, hardly had the Normandy campaign finished than the vanguard of Patton's army, having crossed the Seine downstream from Paris at Mantes and, a few days later, upstream at Troyes, was heading in the direction of the Siegfried Line. At the same time,

the Resistance emerged from the shadows, sparking a wholesale insurrection in Paris that ended with the liberation of the capital and a great patriotic parade down the Champs-Élysées led by General de Gaulle, head of the provisional government. On the Pacific Front, successfully implementing the strategy of "island hopping," the American command was making giant strides towards Japan itself. In succession, at the end of vicious fighting, it seized the Gilbert, Marshall, Caroline, and, finally, the Marianna Islands. The first breach in the outer defensive perimeter of Japan, the loss of the island of Saipan (in July), located around 1,500 miles (2,500 kilometers) from Tokyo, combined with crushing defeat of the imperial fleet in the Leyte Gulf (the Philippines, in October), unambiguously demonstrated to the Japanese political and military authorities that the end was nigh.

Facing page: NORMANDY, OPERATION OVERLORD, OMAHA BEACH, JUNE 6

An iconic image of the operation to secure Allied landings on the Normandy coast. At dawn on June 6, in a gray light that blurs the line between sky and sea, on Omaha Beach, an American soldier crawls through the water.

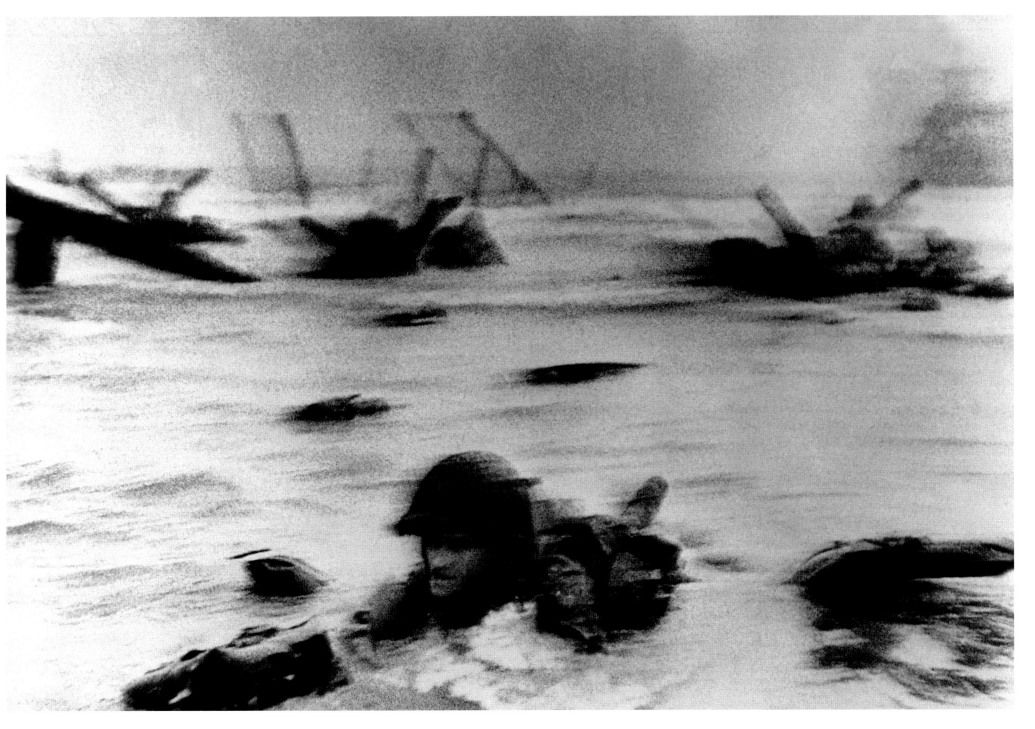

Robert Capa

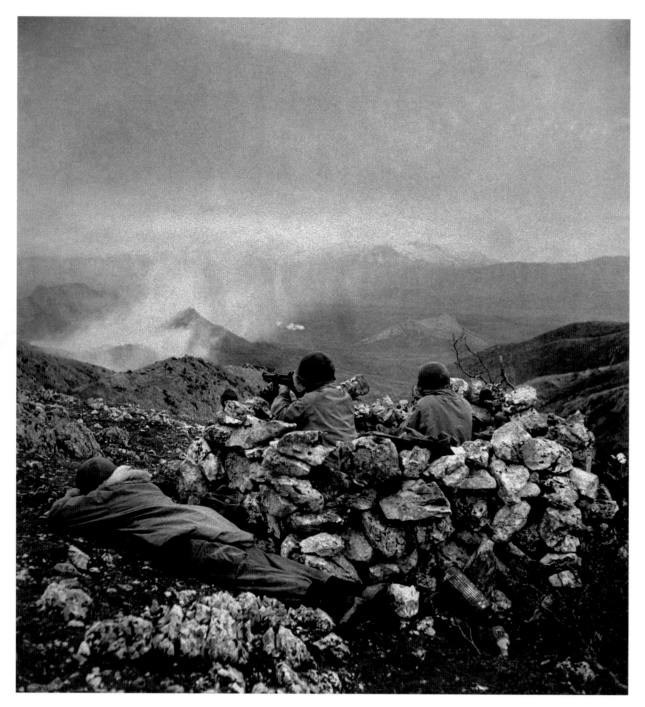

Robert Capa

Italy

LIRI VALLEY, JANUARY 4

So as to break the deadlock at Monte Cassino, which is strategically located at the entrance to the Liri Valley, a bastion blocking the advance of the Allies to Rome some 95 miles (150 kilometers) away, the American command called upon its First Special Service Forces, a crack unit comprising some 2,000 highly trained men. A mix of parachutists and rangers, the elite soldiers seen in this photograph succeeded in dislodging the Germans from Monte Radicosa, but not from Monte Cassino. The harsh winter that then gripped the Apennines forestalled all military operations over the following days.

MONTE PANTANO, MULE CONVOY

A rugged landscape, steep paths, and the intense cold made supplying the troops especially onerous. Here, a line of mules led by troops of the French Expeditionary Force bring provisions to the soldiers of the Thirty-Fourth US Infantry Division (Red Bull), observing a section of the Gustav Line in the uplands.

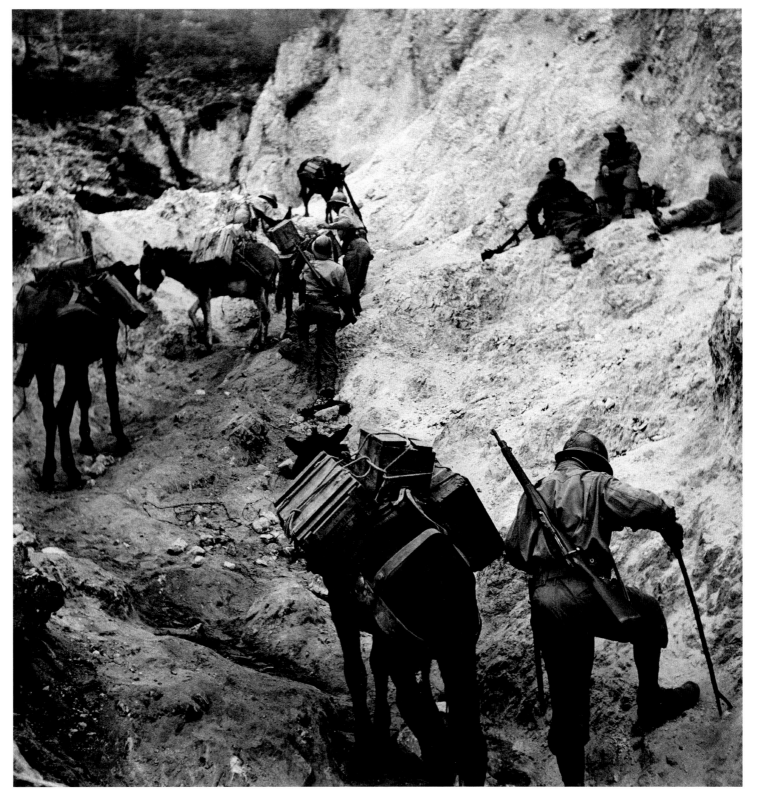

Robert Capa

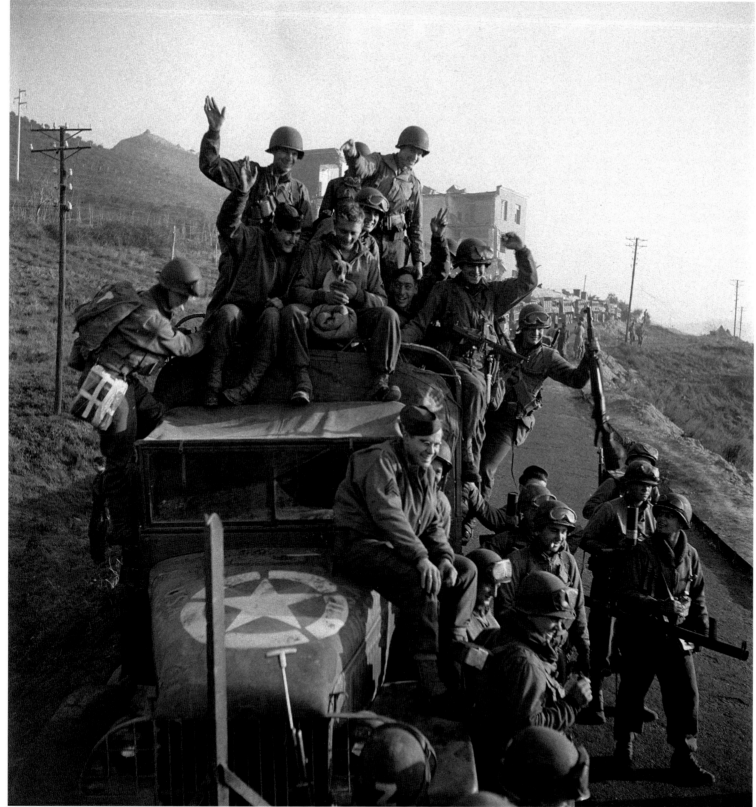

Robert Capa

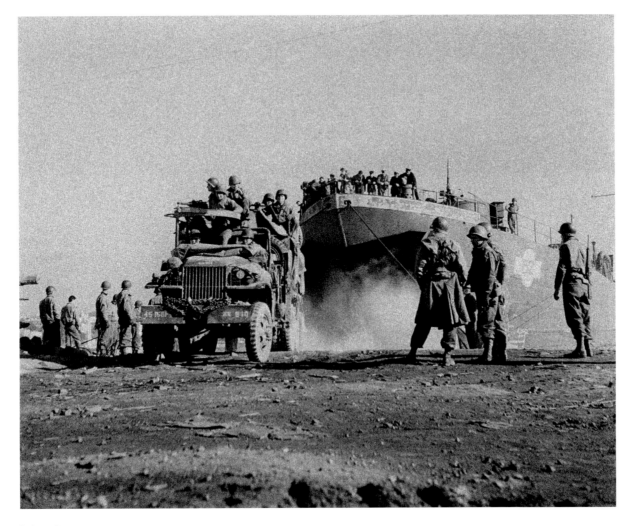

Robert Capa

Italy

DISEMBARKING AT ANZIO, JANUARY 22, 1944

American troops, advancing cheerfully towards the interior on the sunlit morning of January 22, after disembarking without hindrance on the beaches of Anzio-Nettuno, situated well behind the Gustav Line.

DISEMBARKING AT ANZIO, JANUARY 22, 1944

Thanks to the element of total surprise, the American attack on Anzio was a success and, in 24 hours, 35,000 men and a little more than 3,000 vehicles were unloaded. Losses for the whole day amounted to 13 killed and approximately 150 wounded or unaccounted for. The response, however, was not long in coming and the Germans fighting "with sacred hatred," as Hitler's orders couched it, were soon tying up the Allies at their bridgehead.

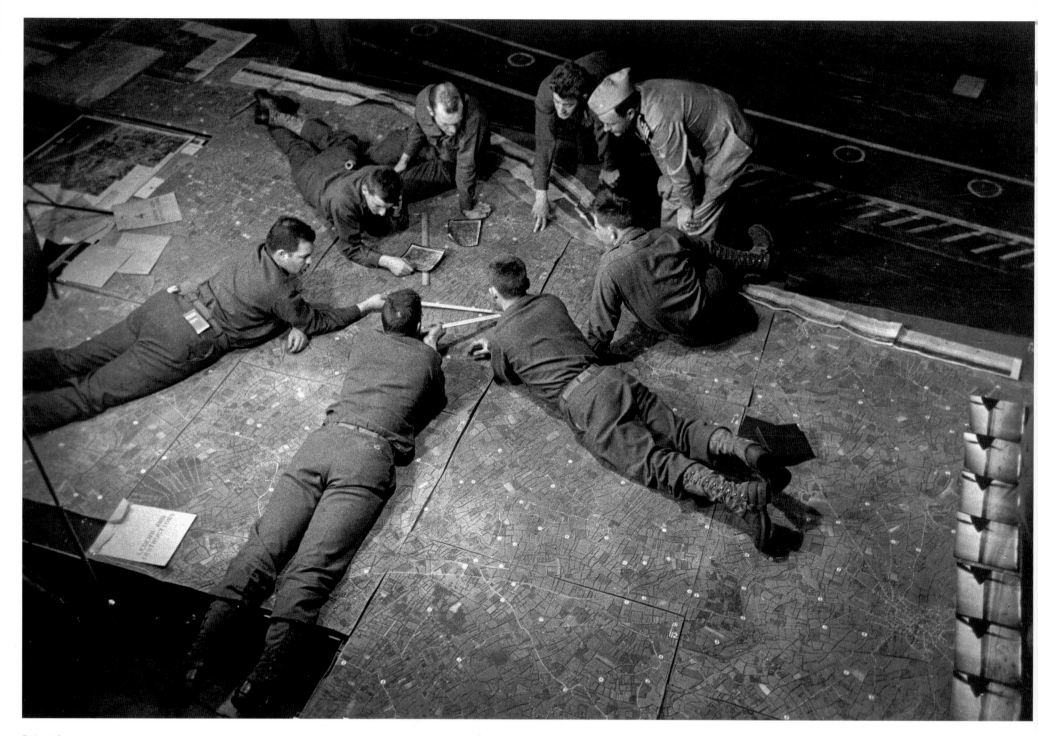

Robert Capa

Great Britain

WEYMOUTH, EARLY JUNE

American officers, on board a transport ship at anchor in the pool at Weymouth Port, lie stretched out on a composite of large aerial photographs so as to observe the terrain just to the rear of Omaha Beach. Aerial photography provided more than three-quarters of the reconnaissance information necessary for preparing Operation Overlord.

WEYMOUTH, EARLY JUNE,
UNLOADING THE TROOPS

Large transport vessels and landing craft with a ramp at the bow, riding off Weymouth. In Operation Overlord, the Allied navies were responsible for clearing mines from the Channel, transporting the troops, neutralizing German defenses, and keeping the task force supplied.

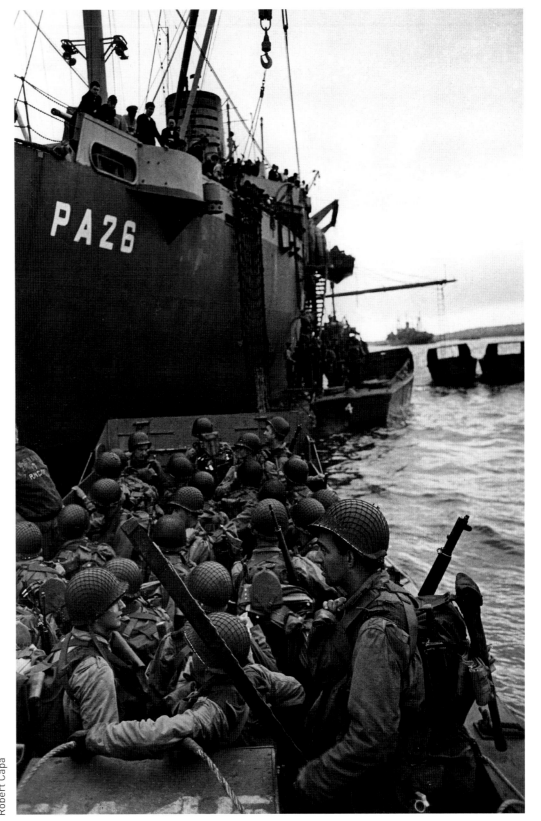

Robert Capa

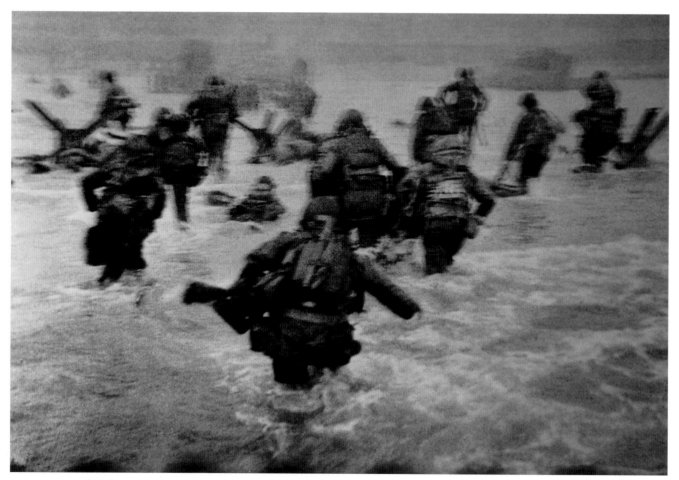

Robert Capa

France

NORMANDY, OMAHA BEACH, JUNE 6

An emblematic photograph of American soldiers, in the first wave of the assault, advancing towards Omaha Beach which is strewn with obstacles, at dawn on June 6.

NORMANDY, OMAHA BEACH, JUNE 6

In the early morning on D-Day, amid the first waves of the assault: in the background one can faintly make out the escarpment over Omaha Beach, half hidden by a cloud of dust raised by the intense naval bombardment that preceded the landing.

At the edge of the sands, men standing, bending over, or stretched out in the water, try to protect themselves from the machine-gun bullets and shrapnel. Some shelter near defenses made up of bits of rails welded together at the middle, while others advance behind the occasional amphibious tank, some still sporting their floatation skirt, and with funnels through which the engines took in air during the long sea crossing. As at the atoll of Tarawa in the Pacific, the first hours on Omaha proved hell on earth for the American infantry.

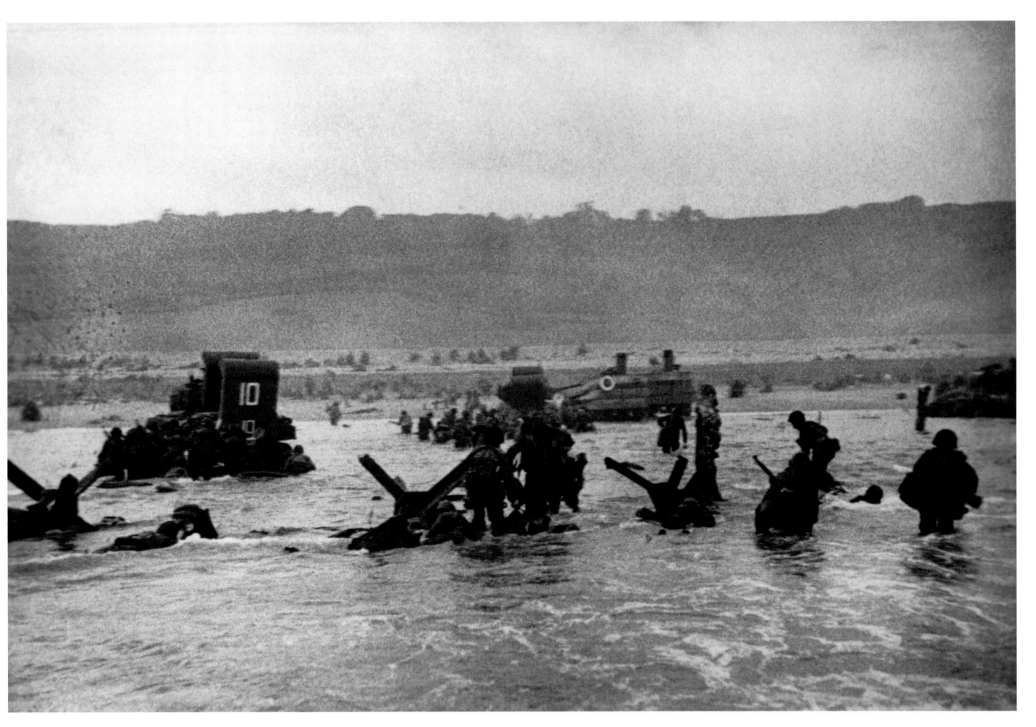

Robert Capa

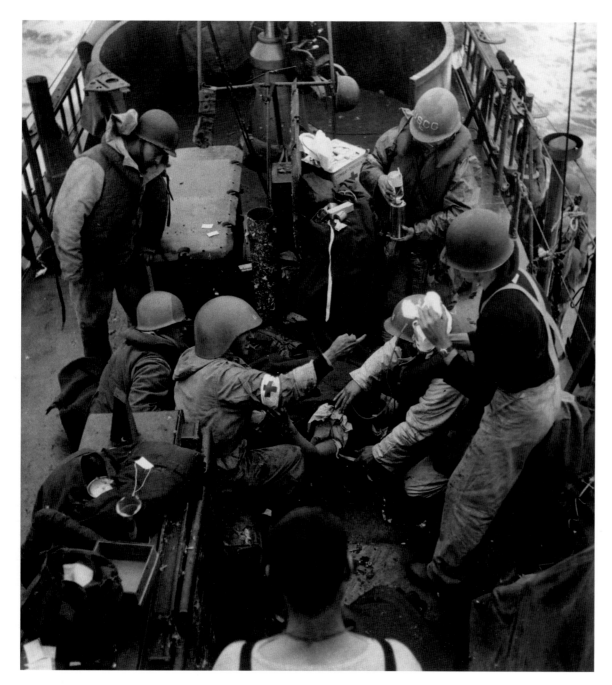

Robert Capa

France

NORMANDY, OFF OMAHA BEACH

First aid being given to men wounded at Omaha Beach by a member of the medical department wearing a US Navy helmet on board a landing craft. The most severely injured were then loaded onto one of the transport ships that shuttled back and forth between the Normandy coast and England, to be looked after in hospitals requisitioned by the military.

NORMANDY, OMAHA BEACH, JUNE

Laid side by side, like the boats stranded along the beach, dead American soldiers—their faces covered from prying eyes by a blanket—await burial in a cemetery inshore.

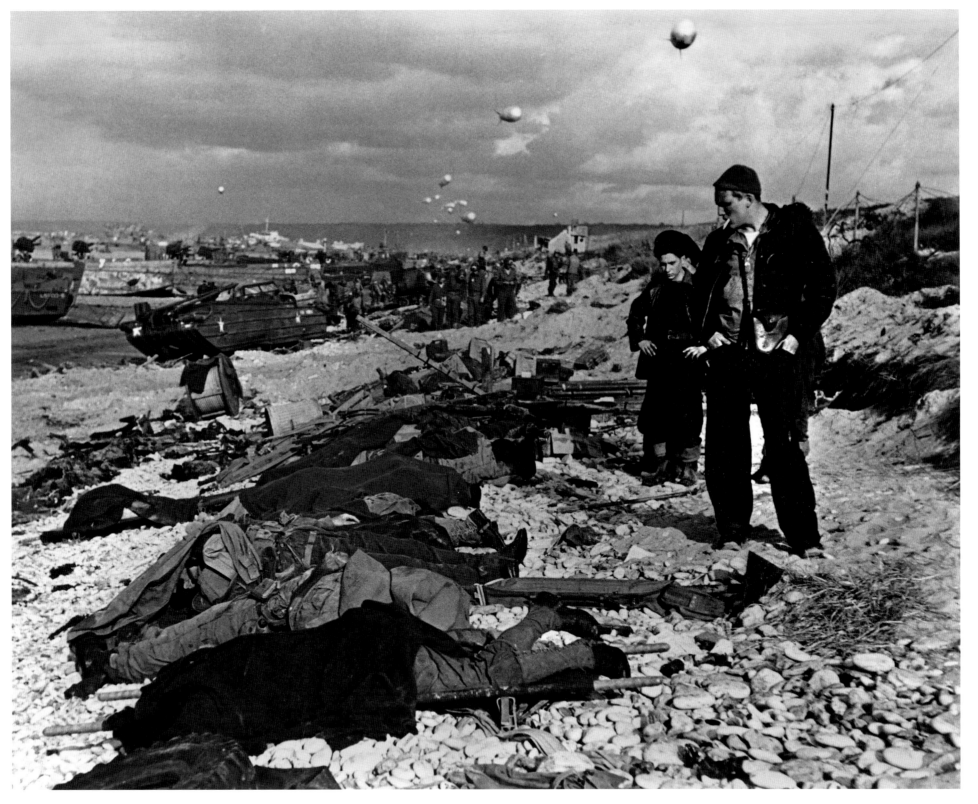

Robert Capa

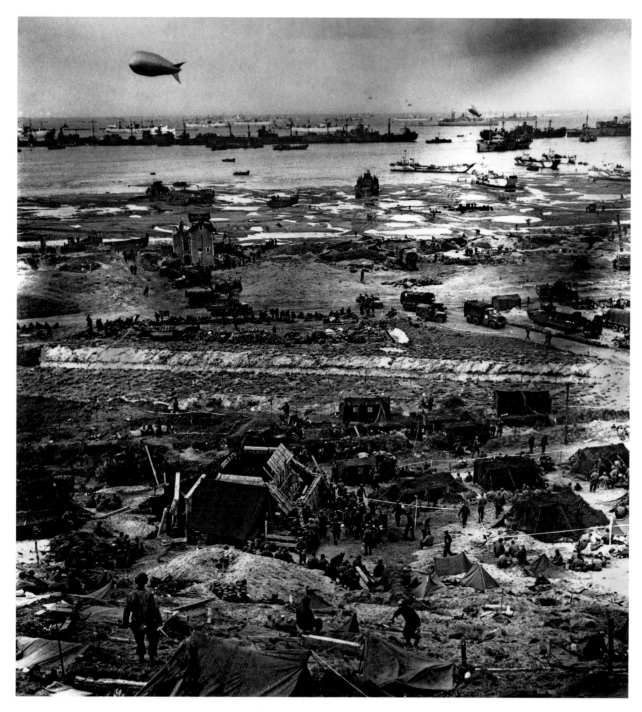

Robert Capa

France

NORMANDY, OMAHA BEACH AT LOW TIDE, JUNE

The morning of June 6, with its images of the beach littered with hundreds of piles and rails driven into the sand, seems a long time ago. Activity is now intense, as much offshore—where the construction of an artificial harbor begins with the laying of a line of old boats as a barrier—as on the beach. Landing craft specialized in tank transport lie beached at low tide, while a camp has been established next to the shore and truck convoys make their way inland. In the center of the photograph are the remains of an old anti-tank ditch, dug by the defenders, now filled in.

NORMANDY, OMAHA BEACH, GERMAN PRISONER

A German prisoner with a tired and worn face, probably belonging to the 352 Division, a unit which, before being reformed in France, had already fought on the Russian Front. Equipped with modern armaments, these well-trained men put up stout resistance against the American attack, continuing their efforts as the US troops headed for Saint-Lô.

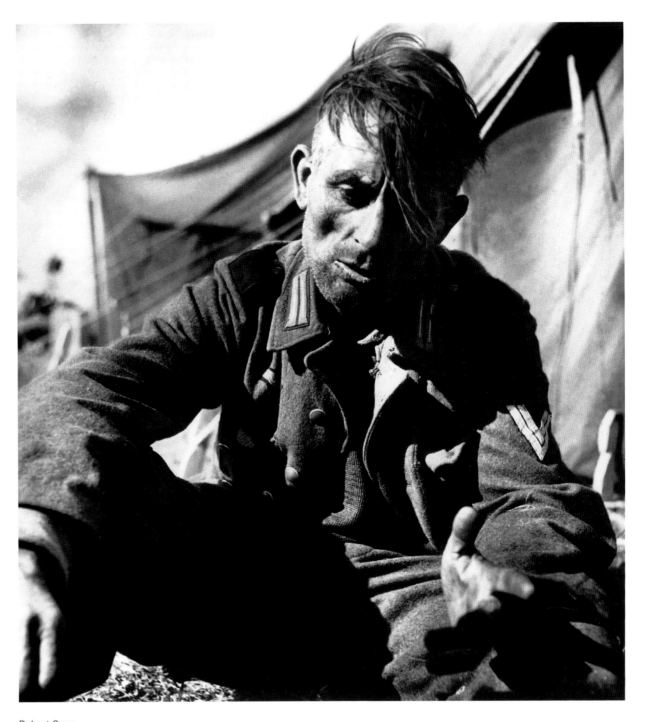

Robert Capa

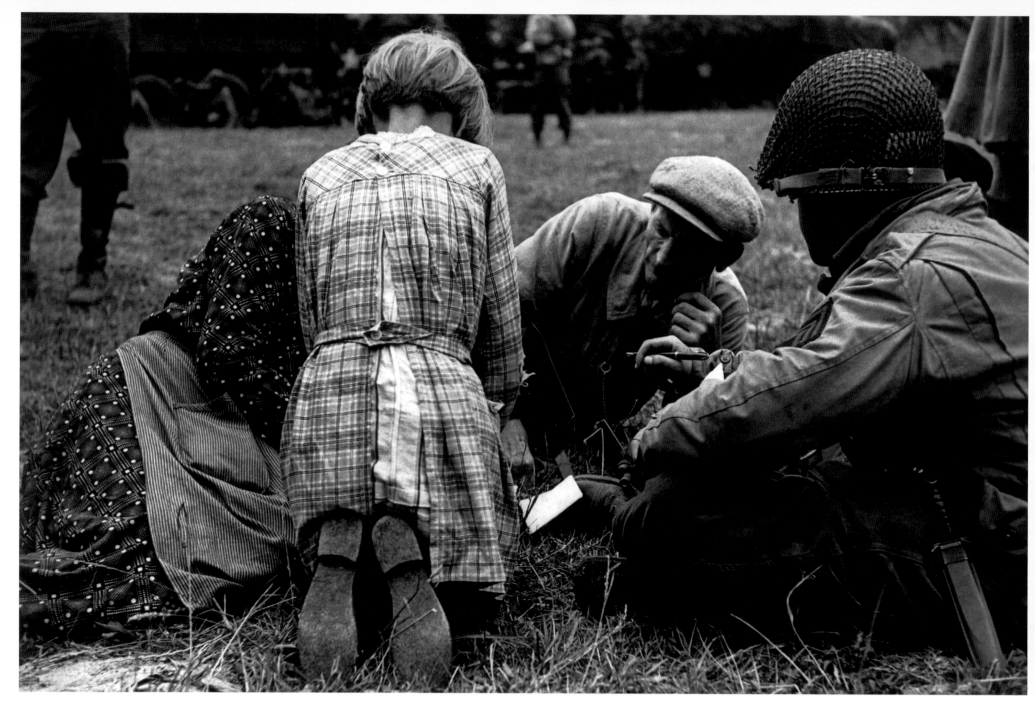

Robert Capa

France

NORMANDY, COLLEVILLE-SUR-MER, JUNE

A child wearing a smock, a mother lying in the grass wearing a long dress and a striped gray apron with a large pocket, and a farmer sporting a cap and with a sizable watch on a chain in the fob pocket of his jacket—here we have a splendid example of 1940s fashion in the Normandy countryside. The man appears to be providing the American soldier with information.

BATTLE OF NORMANDY, CELEBRATION OF MASS ON THE BEACH

Bareheaded, kneeling reverently on the sand, those lucky enough to escape the hell of Omaha Beach are offered Communion on the beach by a military chaplain. Visible too are the barrage balloons protecting the shore from attack from any low-flying German planes and, to the extreme right, the slope overlooking the seashore.

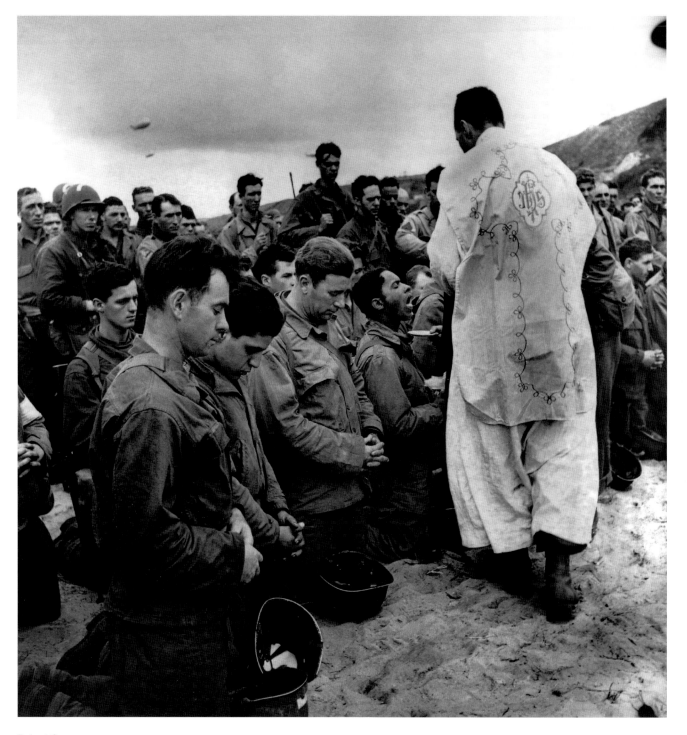

Robert Capa

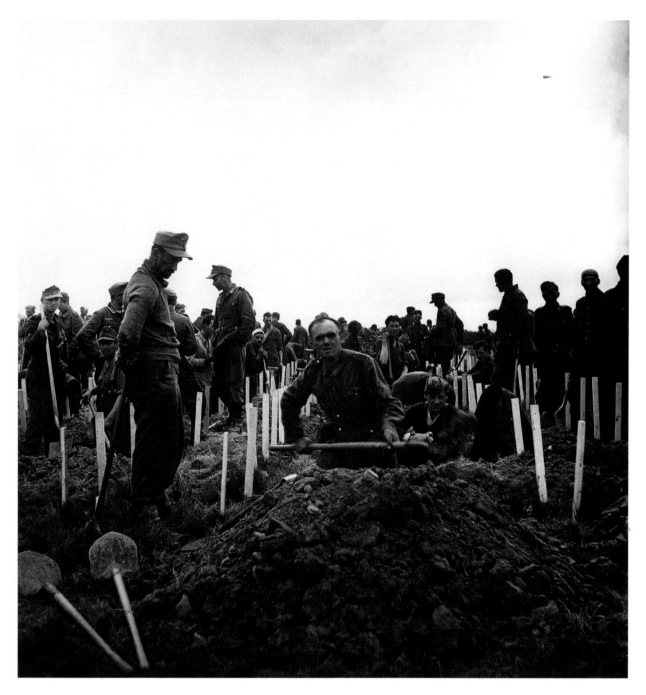

Robert Capa

France

NORMANDY CAMPAIGN,
SAINT-LAURENT-SUR-MER, JUNE 1944

German prisoners digging graves in the commune of Saint-Laurent, one of three that constitute Omaha Beach. In the years following the war, those buried in these provisional graveyards would be transferred to the huge American cemetery at Colleville-sur-Mer.

REFUGEES, NORMANDY CAMPAIGN,
PONT-L'ABBÉ, JUNE 15

Houses destroyed, walls on the point of collapse, piles of rubble, hanging electric cables—the combat that raged between American parachutists and German paratroopers in the area around Pont-l'Abbé utterly destroyed part of the village. One can only imagine the anguish of the refugees on reentering their village, from which they had been urgently evacuated only shortly before the attack.

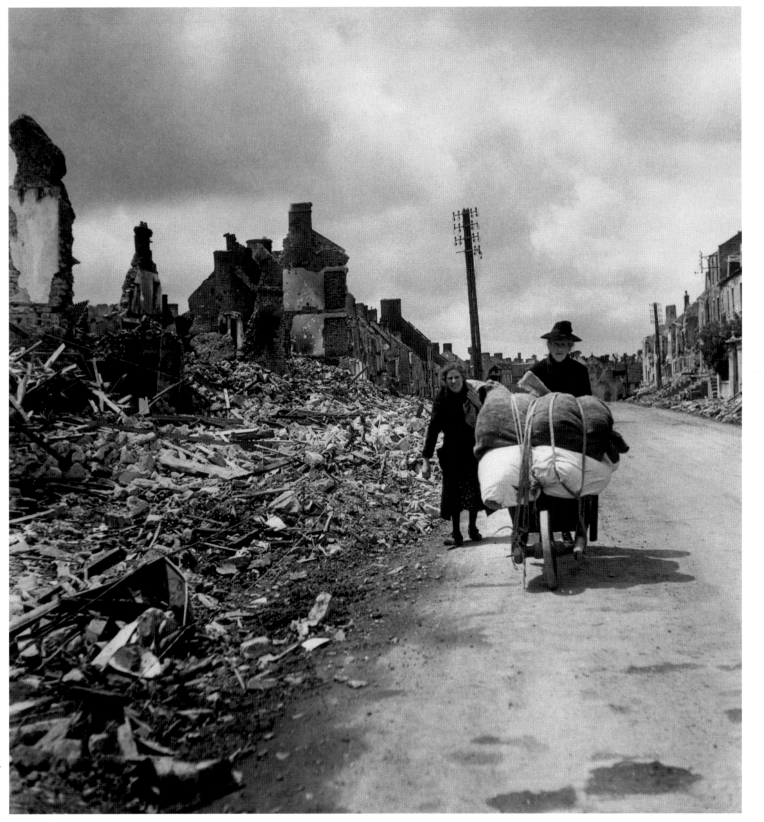

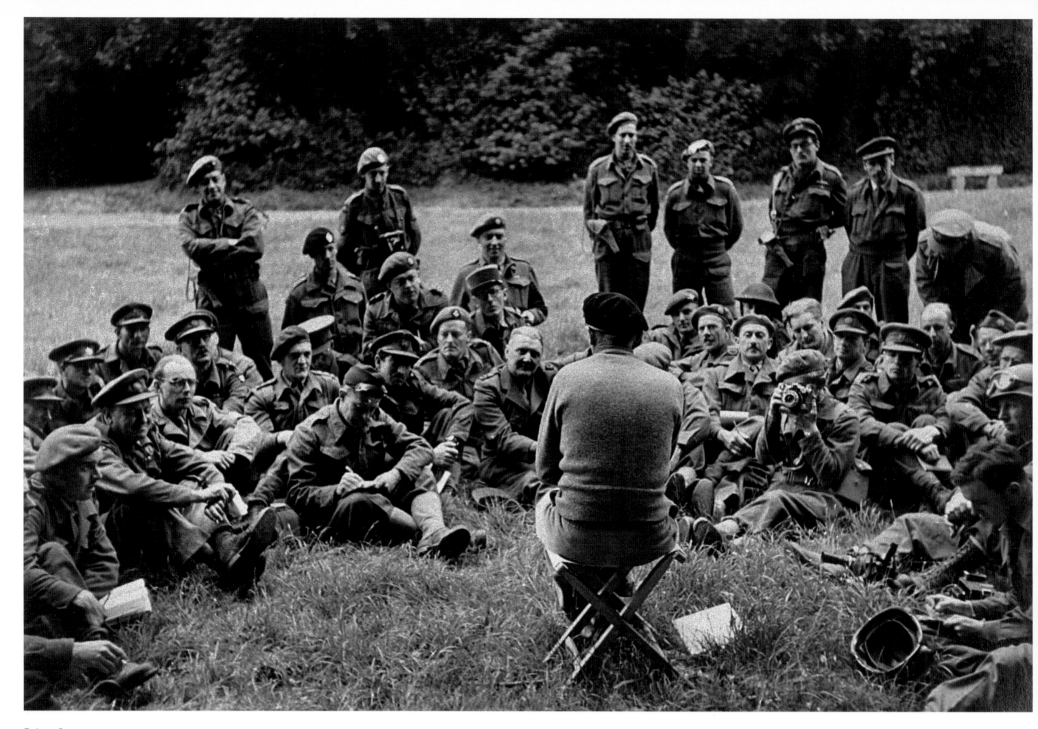

Robert Capa

France

NORMANDY, PRESS CONFERENCE
BY GENERAL MONTGOMERY, JUNE 15

Seated on a folding stool, dressed in a sweater and sporting a black beret—his garb most unlike the usual dress of a commander of all ground forces—Montgomery faces representatives of the Allied press at his headquarters in the Château de Creullet, situated between Bayeux and Caen. He is providing an outline of the situation in Normandy, one week after D-Day. The pastoral backdrop, Monty's relaxed appearance—everything is calculated to make the correspondents feel that the landing operations are proceeding as planned. In the center of the photograph, among the journalists, is Maurice Schumann, a Paris reporter who provided the nightly radio voice of Free France.

NORMANDY CAMPAIGN, CHERBOURG,
THE CAPTURE OF GENERAL VON SCHLIEBEN,
GARRISON COMMANDER, JUNE 26

In the background, with his hands in the pockets of his windbreaker and something like a satisfied expression on his face, stands General Manton Eddy, commander of the Ninth US Infantry Division, the unit which, in the afternoon of June 26, was to capture General Karl Wilhem von Schlieben in the fortress of Cherbourg. After his capture, von Schlieben, with his cap still on his head, and proudly displaying on his right breast pocket the German Gold Cross won on the Russian Front, was transferred to the headquarters of army commander General Collins, close to Valognes, at the Château de Servigny in the commune of Yvetot-Bocage. There he was interrogated and, to his visible displeasure, photographed by a pack of war correspondents.

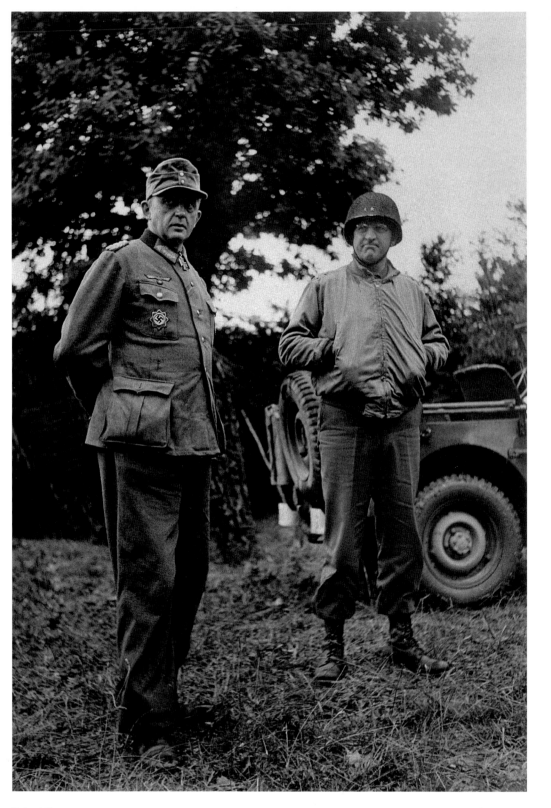

Robert Capa

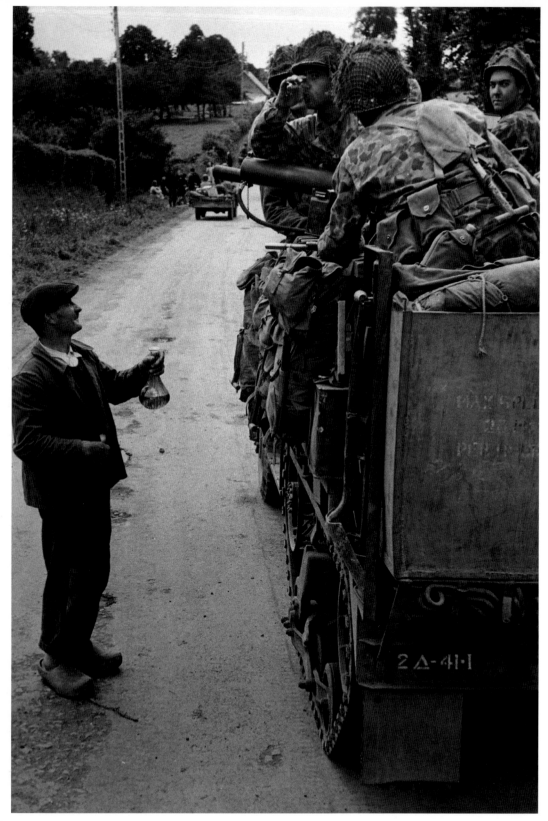

Robert Capa

France

BATTLE OF NORMANDY, NOTRE-DAME-DE-CENILLY, JULY 28

Carafe in hand, smiling broadly, a Normandy farmer offers a glass of eau-de-vie to American soldiers heaped up in a half-track. Three days earlier, General Bradley, following an intense land and air offensive, had pierced the German Front (Operation Cobra). Several American divisions immediately poured into the breach in the direction of Coutances and Avranches, including the column here. These soldiers, belonging to the US Second Armored Division, wear camouflage, just as on the Pacific Front. As it tended to be confused with identical uniforms worn by the Waffen SS, this camouflage battledress was soon abandoned on the Normandy Front by the American command.

BATTLE OF NORMANDY, SS PRISONER FRISKED BY AN OFFICER OF THE US SECOND ARMORED DIVISION, JULY 31

As the Wehrmacht fell back, many prisoners were taken in the pocket at Roncey, including, as underlined in this shot—surely taken for propaganda purposes—an SS soldier belonging to an armored unit. By the beginning of August, all German armored divisions present on the Western Front were fighting in Normandy except the Eleventh Panzer Division that held out in the sector of Toulouse. Out of ten armored divisions facing the Allies in Normandy, five belonged to the Heer (Army) and five to the SS. The thirty-six infantry divisions fighting in Normandy at the end of August, in addition to the ten Panzer divisions, came mainly from France, Belgium, and The Netherlands, with a further six from northern Europe (Denmark and Norway).

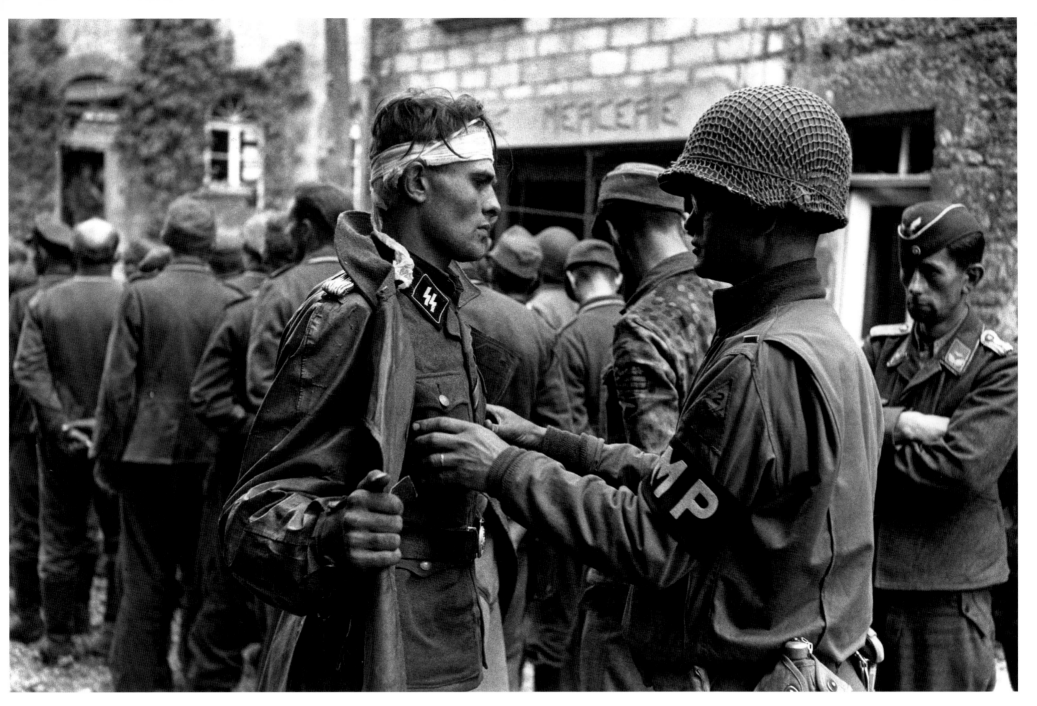

Robert Capa

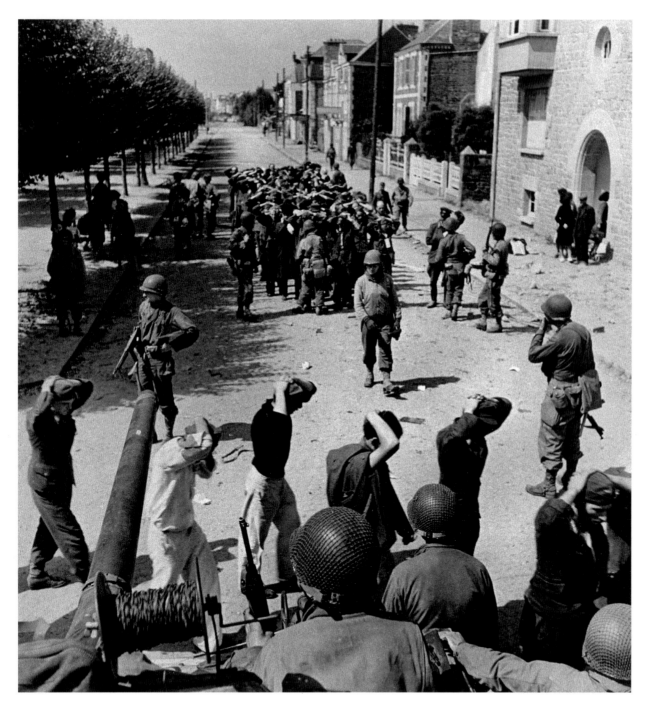

Robert Capa

France

BRITTANY, SAINT-MALO, AUGUST 8–10

Bombarded on several occasions in July and at the beginning of August by the United States Air Force, the city had been abandoned by its inhabitants; hence the relatively few people in the streets on August 9 to witness the orderly surrender of several hundred German prisoners. A week later, the entire citadel laid down its arms.

BRITTANY, MORBIHAN, FRENCH FORCES OF THE INTERIOR, 1944

Members of the Free French forces on guard behind the port at Lorient, which the Germans had transformed into a *Festung* (stronghold). In Brittany, the French Forces of the Interior (FFI) acted as effective guides and support for the American troops.

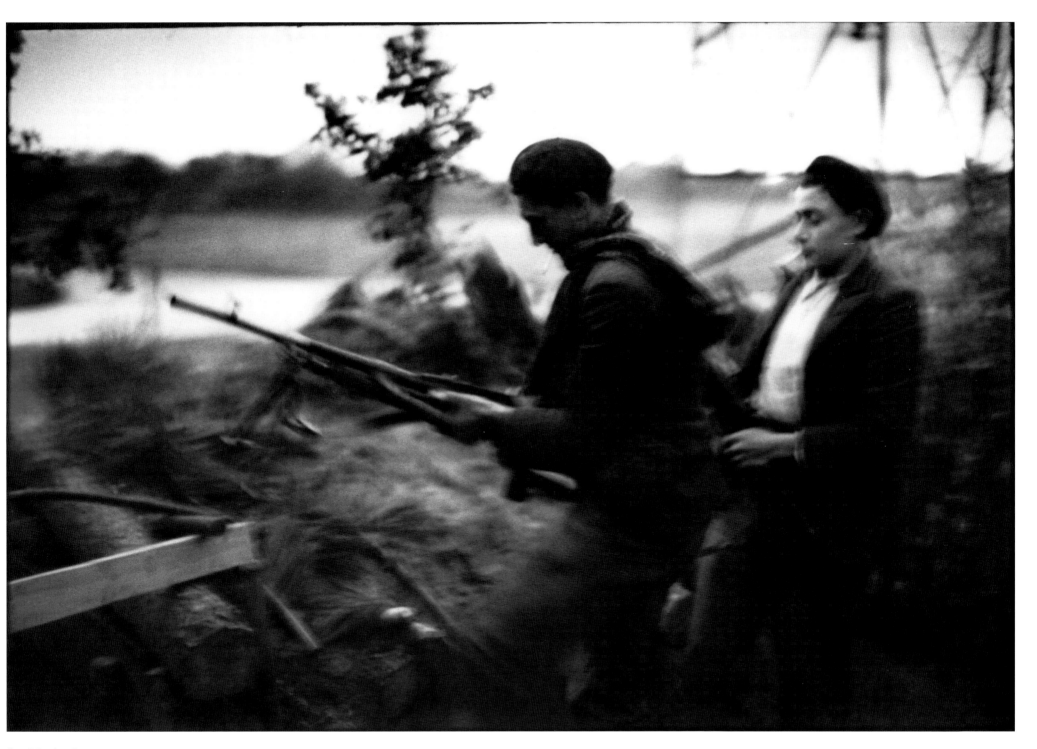

Henri Cartier-Bresson

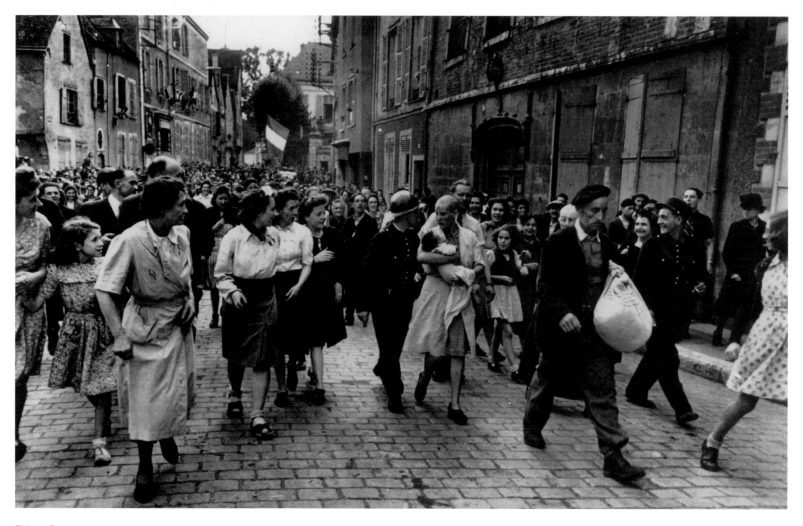

Robert Capa

France

CHARTRES, THE *TONDUES*, AUGUST 18

A mother (only her head is visible, to the right) and her daughter, carrying her child by a German father, have had their heads shaved (*tondu*) at police headquarters. Before being carted off to prison, they have been forced to walk through the city—here they are entering rue Collin-d'Harleville—to the jeers of the crowd. After capturing Chartres, a city located 50 miles (80 kilometers) from Paris, the American troops continued their march on to the Seine, crossing the river at Melun.

MEMBERS OF THE RESISTANCE IN THE CROWD, AUGUST 23

Chartres and another crowd: on August 18, it had been hooting at female collaborators; on August 23 it stands, large and attentive, behind a row of members of the Resistance, wearing armbands and weapons, to listen to a speech by General de Gaulle. Arriving at the Prefecture at 14.00, the general, having reviewed indigenous troops as well as men of the FFI and saluted various notables, "went to the cathedral where, with the members of the clergy, he sang with a strong voice the Magnificat, which he knew by heart."

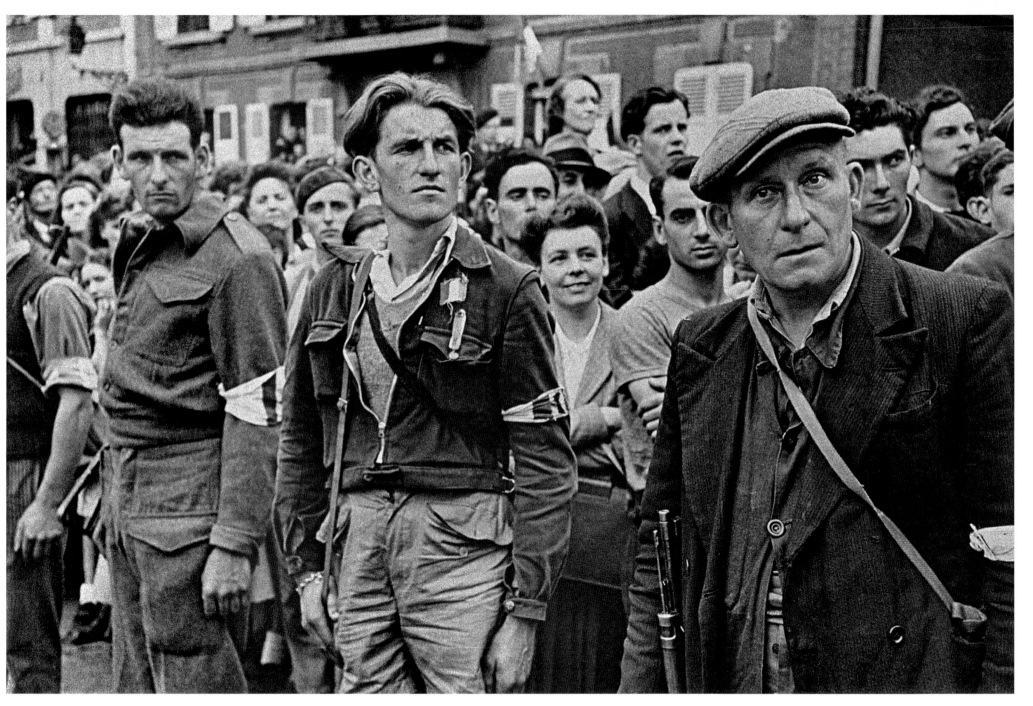

Robert Capa

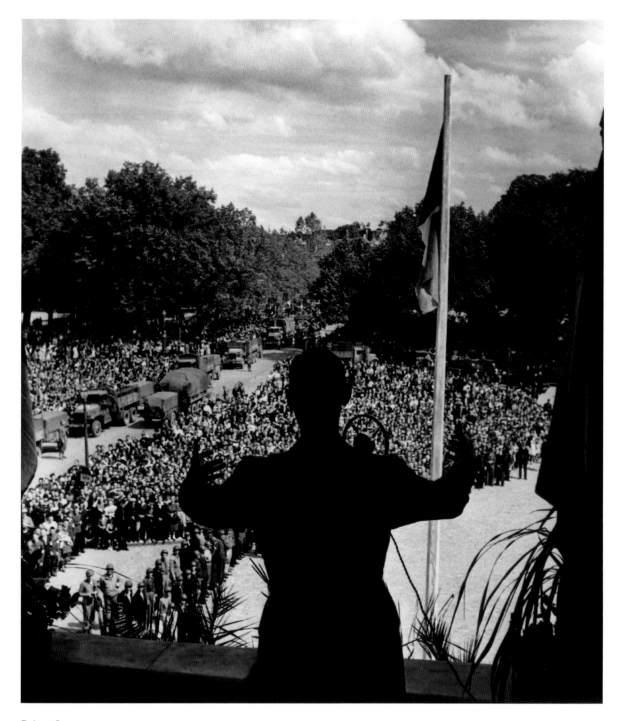

Robert Capa

France

CHARTRES, DE GAULLE'S SPEECH, AUGUST 23

With the American convoys and the crowd massed on the place des Épars in the distance, General de Gaulle, with outstretched arms, invites the French to gather around him. Once more in front of the microphone, just as on June 18, 1940, the head of Free France made a patriotic speech in Chartres, the city where Jean Moulin had been prefect. After lunch at the prefecture, the general took a car back to the Château de Rambouillet, the summer residence of the presidents of the Republic since the late nineteenth century.

PARIS, THE LIBERATION, AUGUST 22–25

Looking back towards Place Vendôme, along the elegant Rue de Castiglione, chockablock with cars, ambulances, and partisans besieging the Continental Hotel, which was occupied by the Germans and from whose windows hang white rags. Bottom left stands a German caterpillar-tracked vehicle and, on the other side of the street, near some pillars bearing the marks of the fighting, another vehicle that appears to have been burnt out.

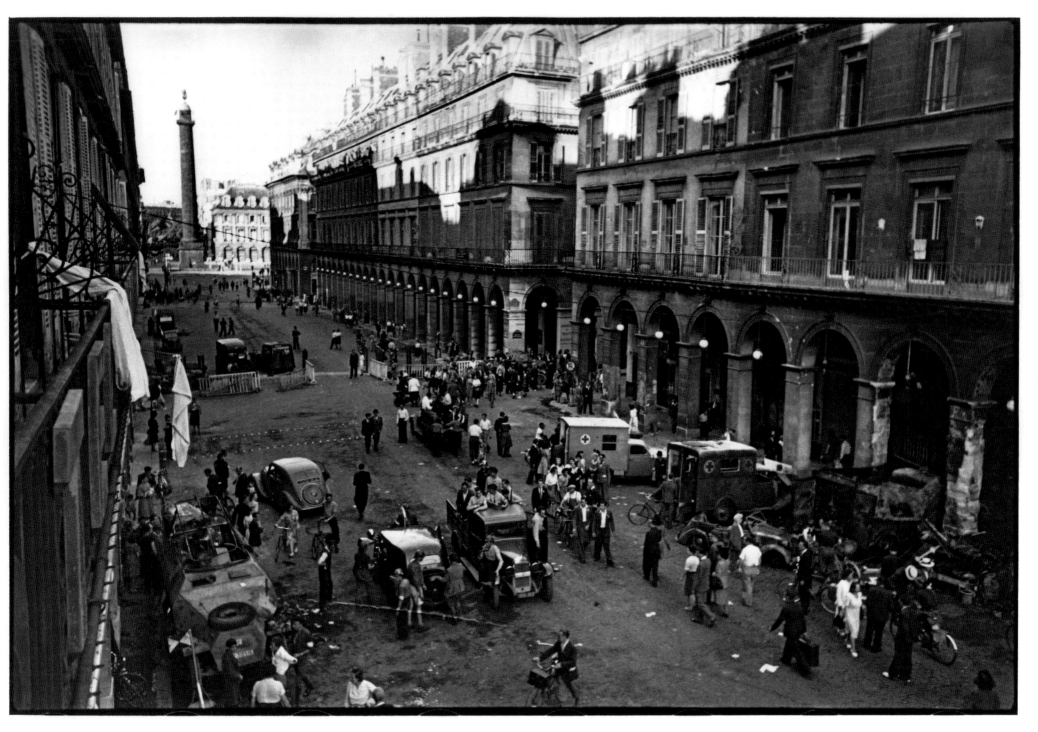

Henri Cartier-Bresson

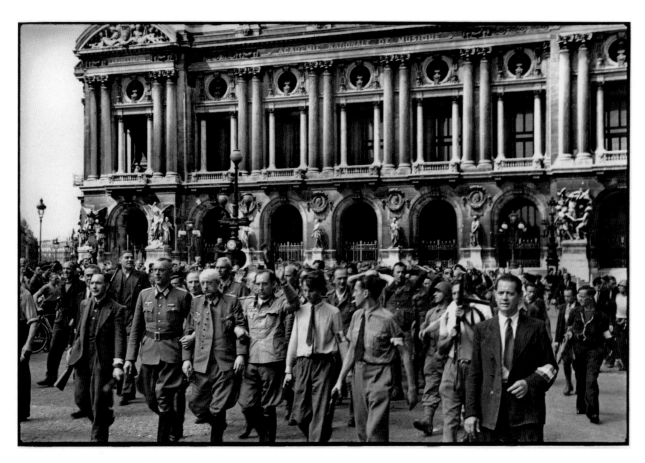

Henri Cartier-Bresson

France

PARIS, THE LIBERATION, AUGUST 25

On August 25, the German commander in Paris, General Choltitz, after surrendering to General Leclerc, ordered his men to lay down their arms. In accordance with this order, all the German troops present in the capital handed themselves over in groups to Leclerc's army or to the FFI. Flanked by patriots, this column of prisoners, hands on head, files passed the opulent façade of the opera house. In his memoirs, de Gaulle recalls how, during the week's fighting, the Resistance captured 15,000 German soldiers and lost 2,500 men, and that 1,000 civilians were killed during the confrontations in Paris.

PARIS, ARREST OF SACHA GUITRY, AUGUST 23

With one elbow on the table, uncommunicative, with a hostile look, the theater director and actor Sacha Guitry, arrested by members of the Resistance on August 23, is being interrogated in the town hall of Paris's seventh arrondissement. He was imprisoned for two months in the prison at Fresnes for having demonstrated a "passive attitude" towards the occupying forces.

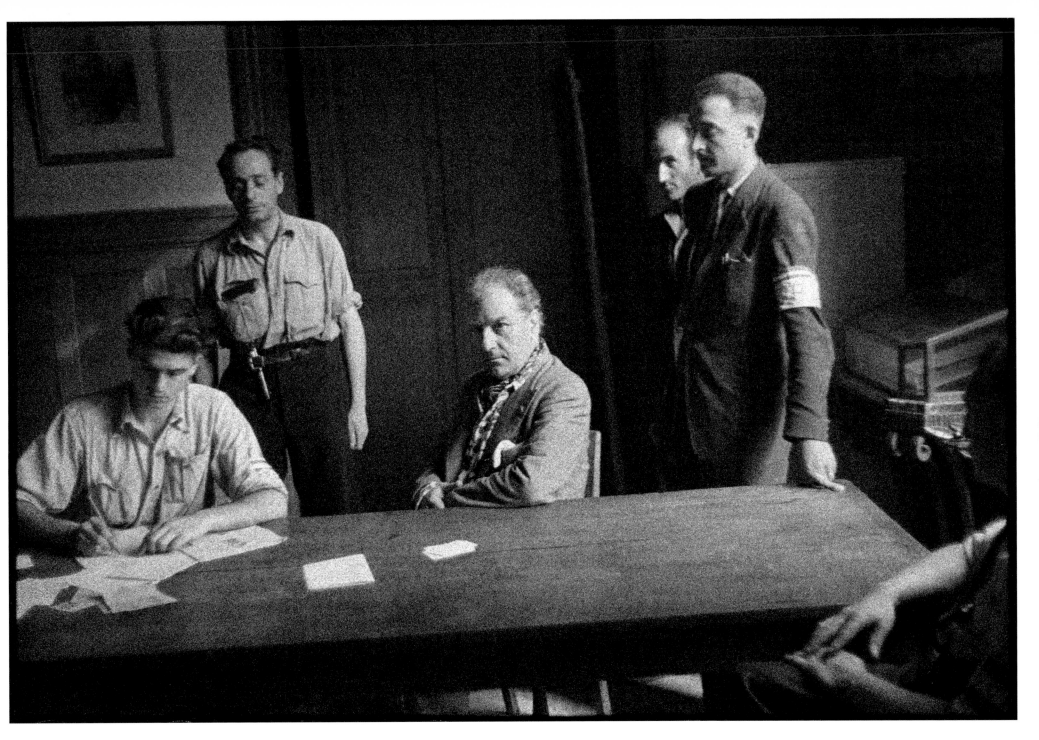

Henri Cartier-Bresson

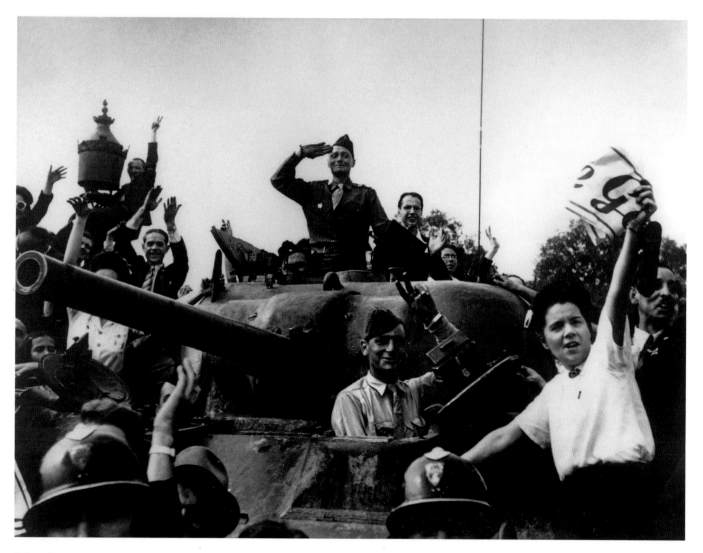

Robert Capa

France

PARIS, THE JOY OF THE PEOPLE AT THE LIBERATION

The crowd expresses its joy with cheers, salutes, raised arms, smiles, and applause. The banner being held up on the right no doubt says something like: "Long live de Gaulle!" The officers in the foreground now wear helmets with the insignia of the Paris police.

PARIS, PROCESSION DOWN THE CHAMPS-ÉLYSÉES, AUGUST 26

After two nights at the Château de Rambouillet, on August 25 de Gaulle paid a visit to General Leclerc. Then, after a detour via police headquarters, he walked—to applause from the crowd—to the Hôtel de Ville, where he met with the National Council of the Resistance. There, he put the finishing touches to the procession through the capital planned for the following day, Saturday, August 26.

This photo shows the start of the route, just after the patriotic ceremony beneath the Arc de Triomphe with members of the provisional government and the top brass of the Resistance. Then, having taken the salute from the Chad Regiment, a unit created in autumn 1940 to fight in Libya and North Africa, de Gaulle began to descend the Champs-Élysées, with behind him Generals Leclerc and Koenig, and in front a posse of reporters and photographers. "In front of me the Champs-Élysées . . . it is a sea, an immense crowd of perhaps two million souls. The roofs too are black with people . . . I go on foot . . . Thus I walk, moved and calm in the midst of the inexpressible exultation of the crowd." In their turn, the Allies organized a huge military parade in Paris on August 29.

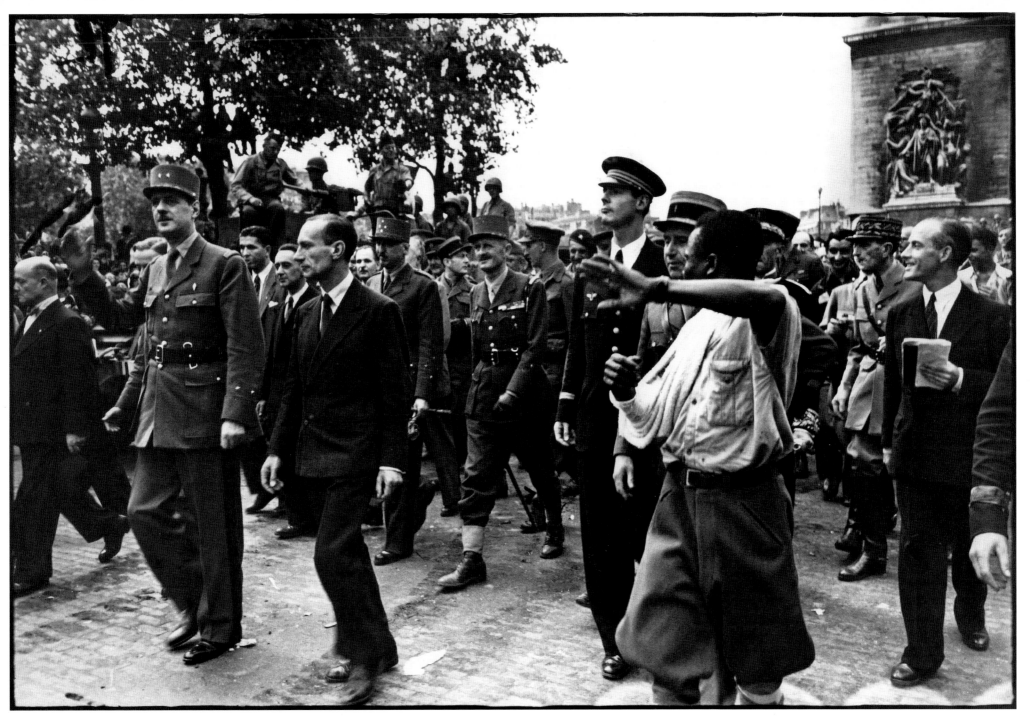

Henri Cartier-Bresson

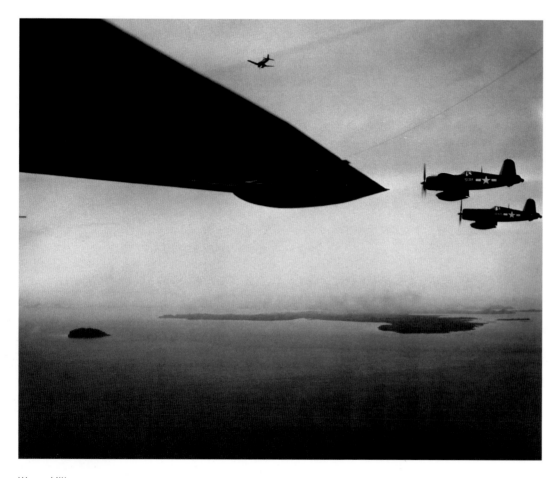

Wayne Miller

1941–45
The War in the Pacific

Having attacked the United States at Pearl Harbor, Japan embarked on a policy of territorial expansion. To secure such conquests so far from home, Japan possessed a recently built fleet of aircraft carriers, an army trained for amphibian operations and jungle marches, and her fanatically patriotic soldiery. Striking out in various directions simultaneously, the Japanese Navy seized Guam, Wake, and Hong Kong, disembarked in the Philippines archipelago, Malaysia, Singapore, and Indonesia, and invaded Burma. Threatening India on one side, on the other Japan strove to cut off Australia. By spring 1942, Tokyo found itself at the head of an immense empire it dubbed the "Greater East Asia Co-Prosperity Sphere."

Using their naval task forces, each made up of a fleet of aircraft carriers escorted by flotillas of other craft, in May 1942 the Americans went on the offensive. Next month, at Midway, they inflicted a second defeat on the imperial fleet and landed on the island of Guadalcanal. In 1943–44, putting into practice the strategy of "island hopping," the US Navy began a series of seizures: New Britain (Rabaul), the Gilbert Islands (Tarawa), the Marshall Islands, the Mariana Islands, and, finally, the Philippines, where the American navy inflicted a crushing defeat on the Japanese fleet at Leyte. By the end of 1944, the Americans could prepare to move on from Saipan to the islands of Iwo Jima and Okinawa.

Above: PHILIPPINES

Aerial photograph showing the coast of Luzon, the main island in the Philippines archipelago, in the background.

Facing page: AMERICAN PACIFIC FLEET, EARLY 1944

An aerial view of a US Pacific Fleet during the retaking of the Marshall Islands. Taken against the light and presenting a rich range of grays, this photo conveys an immense impression of power. On Enewetak Island in the Marshalls, the US Air Force built an aerodrome, allowing B-24 bombers to bombard the island of Saipan almost 1,250 miles (2,000 kilometers) away, the US Navy's next objective.

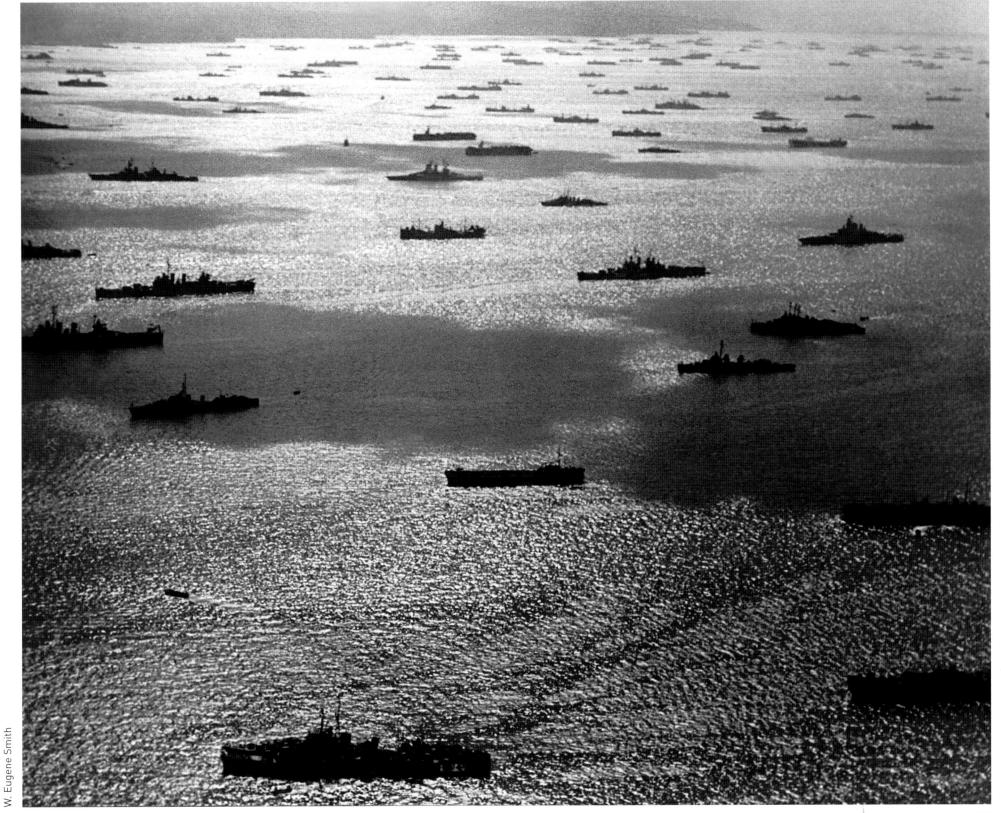

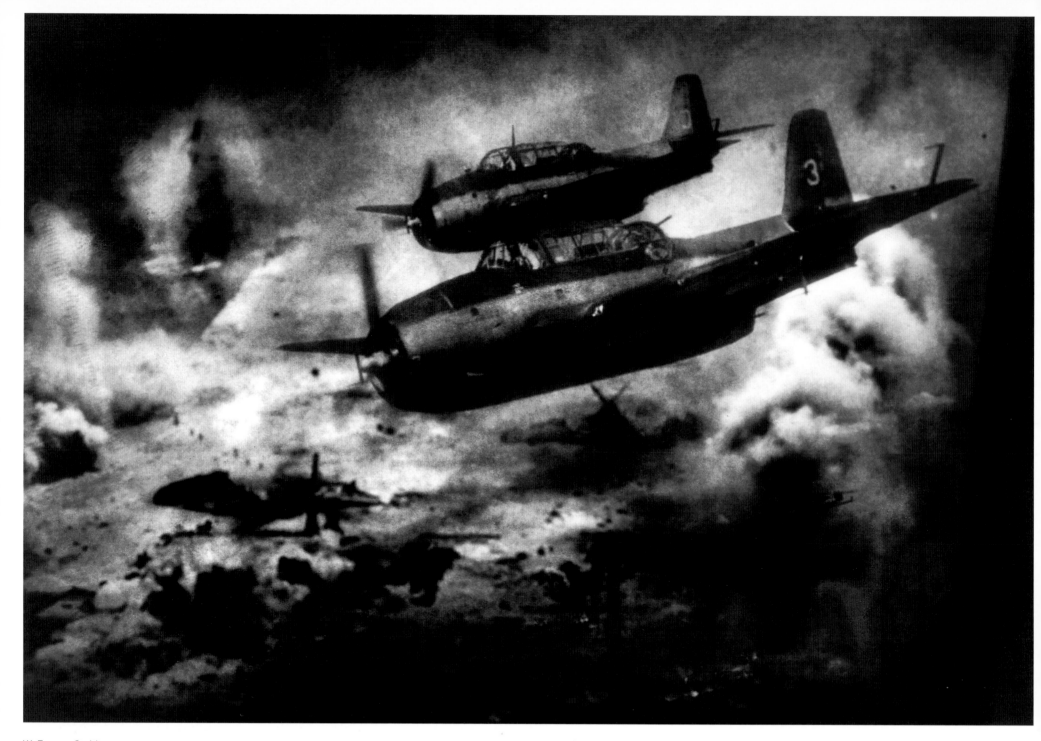

W. Eugene Smith

126

The War in the Pacific

BATTLE OF SAIPAN, JUNE 1944

Prior to its capture—at the time Operation Overlord was being launched in Normandy—the island of Saipan, located in the Mariana Islands, was pounded by naval aviation—that is, by fighter bombers flown from aircraft carriers. Standing out against a sky churning with dust and dense smoke, two Avengers go into attack. This new, single-engine aircraft could fire torpedoes, bomb defenses, or act as a fighter. With an extensive operating range, the Avenger was manned by a crew of three, including a machine-gunner in the turret.

BURIAL OF A SOLDIER AT SEA

In accordance with tradition, the body of this soldier has been placed in a bag and is cast over the side from the top of the rail down a specially designed chute.

W. Eugene Smith

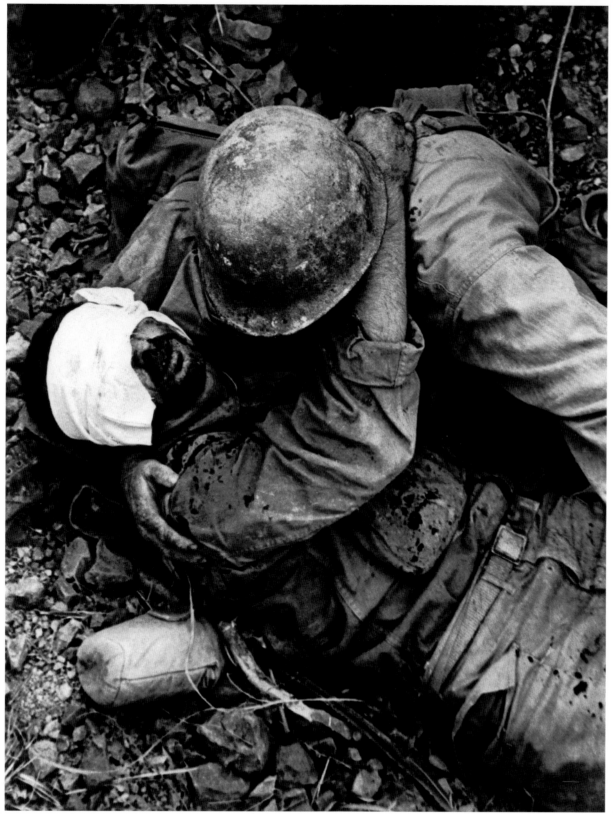

W. Eugene Smith

The War in the Pacific

BROTHERS IN ARMS

Lying stretched out on the ground in the jungle, and seriously wounded in the head despite his helmet, this marine is being comforted by a pal. As this moving image illustrates—especially in the arm gestures of the two men—fraternal feelings can exist on the battlefield, usually a place of slaughter and loathing.

PACIFIC CAMPAIGN, SAIPAN ISLAND, JUNE 27, 1944

Elite men of the US Army, knights of the modern era, these Marines have just had to face Japanese attacks of untold violence on the island of Saipan. This artistic image briefly reveals the Marines' more human side: drinking from the water bottle, this manly looking warrior seems exhausted, staring blankly and lost in thought.

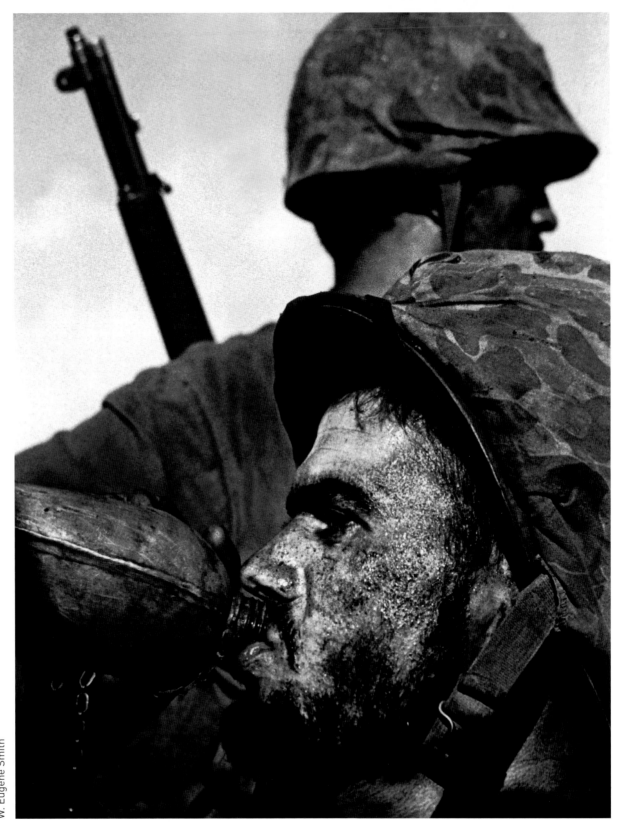

W. Eugene Smith

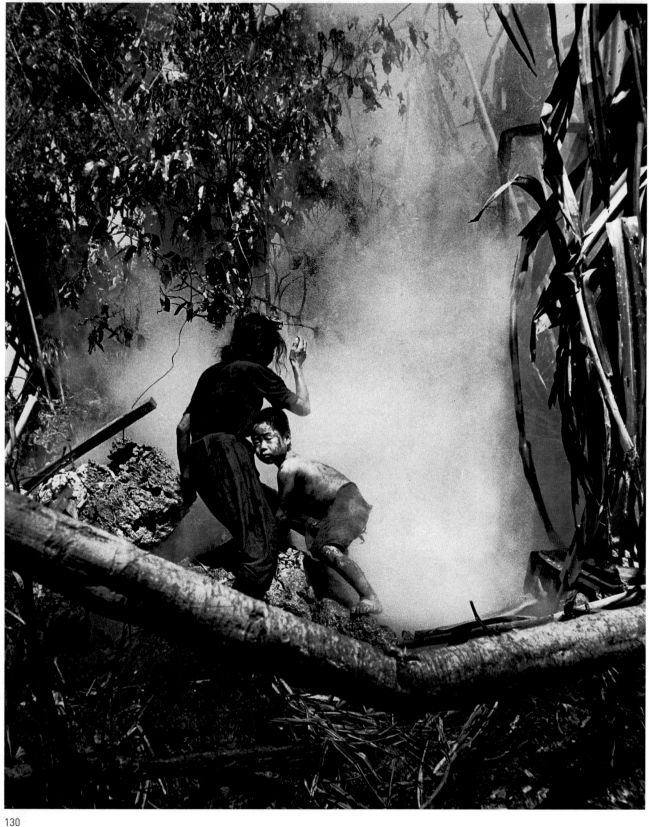

W. Eugene Smith

The War in the Pacific

SAIPAN ISLAND, JAPANESE CIVILIANS

Emerging from one of the many caves peppering the volcanic island of Saipan, a mother and son flee into the jungle. The majority of the Japanese families living on the island refused to leave, instead throwing themselves from the cliff tops with a cry of "banzaï"—that is to say, "long life," meaning to Japan and its emperor.

PACIFIC CAMPAIGN, SAIPAN ISLAND, JAPANESE CIVILIAN IN US NAVY HANDS

As thin as a rake, a father crawls out of the hole in which he had been hiding with his child, while a Marine carrying his helmet looks on. The Japanese military authorities had convinced the thousands of civilians on the island that the Americans would slaughter every last one of them if they ever made it to the island.

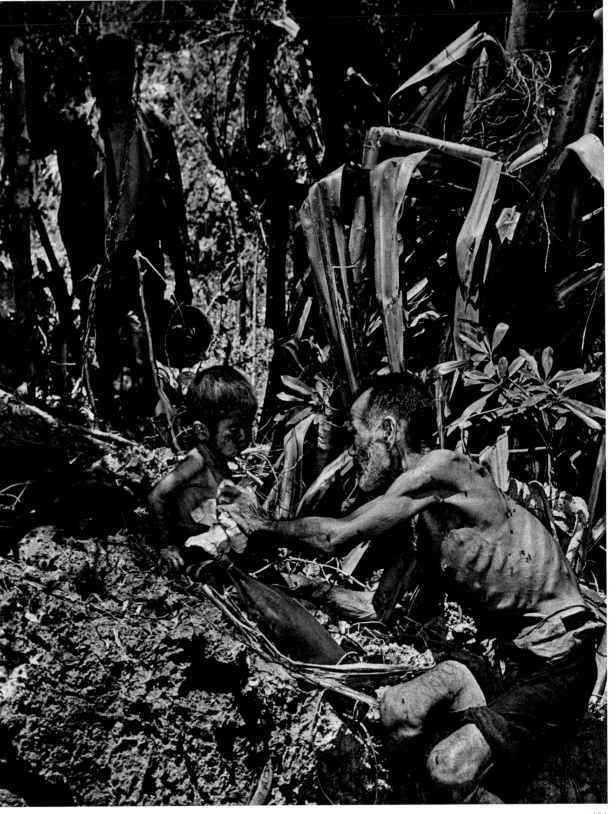

W. Eugene Smith

131

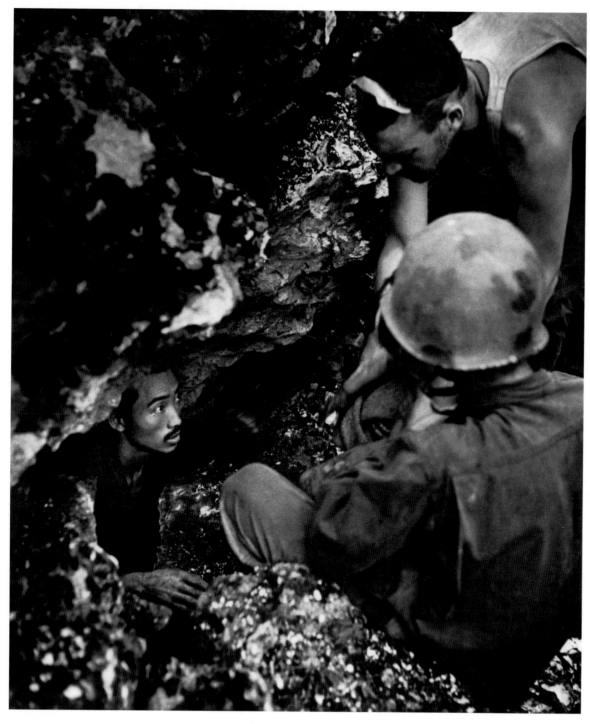

W. Eugene Smith

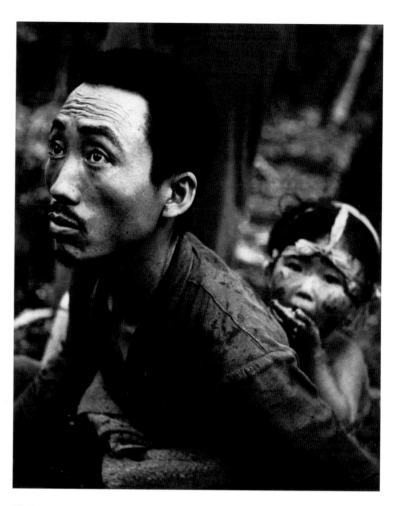

W. Eugene Smith

The War in the Pacific

SAIPAN ISLAND, JAPANESE MAN DISCOVERED IN A CAVE, JUNE 1944

To prevent further collective suicides, the American army began a series of appeals in Japanese for civilians and soldiers alike to come out and surrender. Just dug out, this Japanese man looks around, frightened and still hesitating about what best to do. In the end, he turns himself in, together with the child he is carrying on his back.

SAIPAN ISLAND, A BABY IS FOUND, JUNE 1944

An infant is discovered in a cave. For the briefest of instants, an American soldier is seen delicately carrying off the baby, miraculously alive, and trying to remove it to safety amid the lunacy of war.

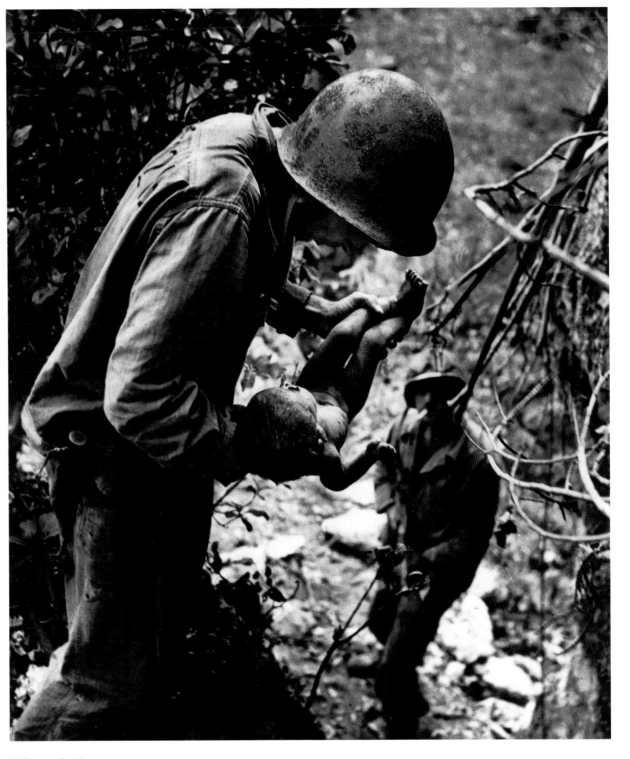

W. Eugene Smith

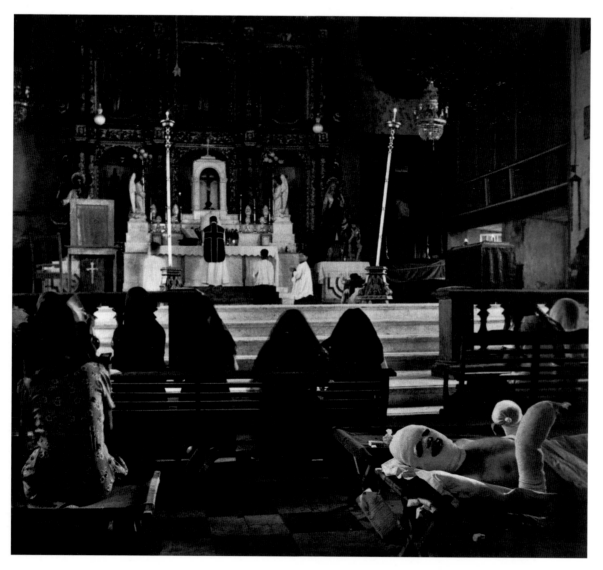

W. Eugene Smith

The War in the Pacific

THE PHILIPPINES, LEYTE, AN AMERICAN
HOSPITAL IN THE CATHEDRAL,
NOVEMBER 1944

An American casualty lies prone on a camp bed in the
Leyte Cathedral, while a priest celebrates Mass for a
handful of faithful. Like so many others, this man is prob-
ably a sailor seriously burned in the conflagration caused
by a kamikaze plane crammed with explosives plum-
meting onto his ship.

THE PHILIPPINES, LEYTE, AN AMERICAN
HOSPITAL IN THE CATHEDRAL,
NOVEMBER 1944

Composed like a painting, this photo—taken in the
Leyte Cathedral, which was converted into a hospital by
the Americans and in which the city's inhabitants also
took refuge—is almost overwhelming. A nurse holds a
torch in one hand and takes the pulse of a casualty on a
drip with the other. The light effects accentuate the des-
perate character of the situation.

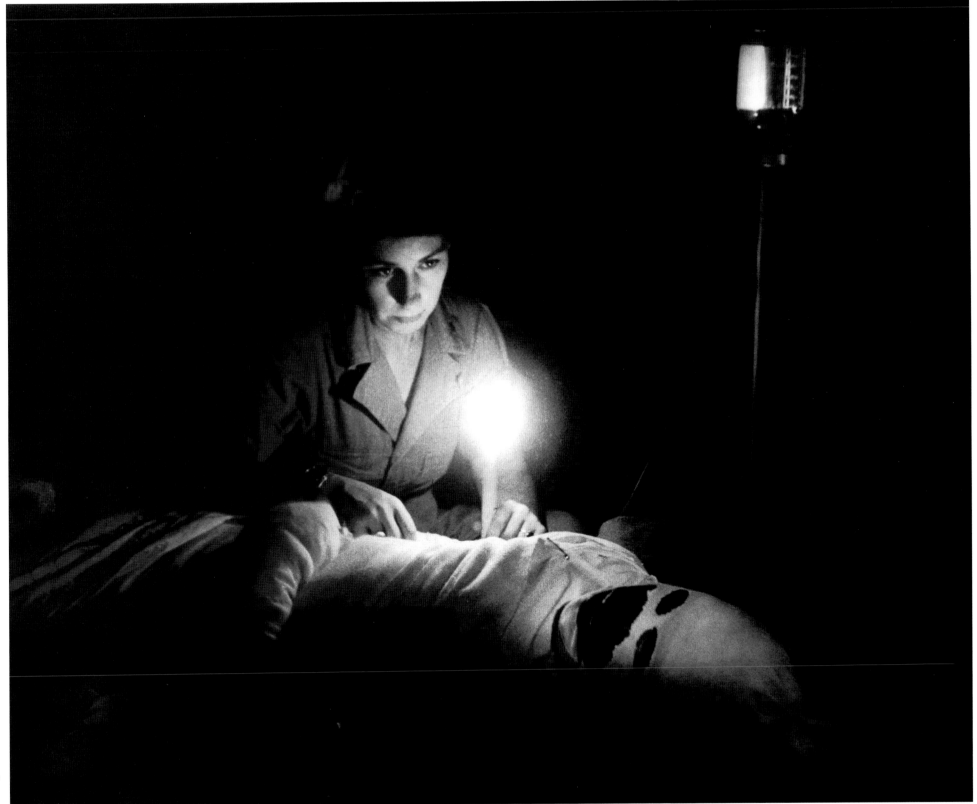

1945 Victory for the Allies

In 1945, the German retreat begun initially on the Eastern Front, where in January the Red Army launched a powerful offensive from the Polish border in the direction of the River Oder, some 300 miles (500 kilometers) away. This push forced Hitler to dismantle the Western Front, thereby easing the task of the Western Allies in crossing the Rhine.

In mid-April, starting from the Oder, Stalin ordered a second and final attack in the direction of Berlin, now only about 100 miles (150 kilometers) distant. A few days later, in Torgau, on the Elbe, Soviet and American soldiers met and shook hands, a unique, historic moment captured by photographers and cameramen. On April 30, Hitler committed suicide and, by that evening, the Soviet flag was fluttering over the Reichstag.

As they advanced into Germany, the Allies discovered the extermination and concentration camps in which, by industrial means, entire populations had been massacred on an inconceivable scale. They also came across the special maternity units designed for the reproduction and breeding of pure-blood Aryan children. Finally, in the lands of the Reich, the Allies encountered millions of displaced people (prisoners, deportees, forced laborers), who, after a stint in one of the transit camps, were to be returned to their country of origin.

Since the defeat of Germany had not been followed by that of Japan, the Americans doggedly pursued their strategy of island-hopping. In February, they disembarked on the island of Iwo Jima, and then, on April 1, on Okinawa, the largest amphibian operation to be carried out in the Pacific and the one during which enemy suicide missions proved the most costly. Simultaneously, the US Air Force was carrying out terribly destructive air raids on many major Japanese centers of population. Undertaken by several hundred B-29s at a time, they were capable of utterly laying waste to a quarter of the agglomeration of Tokyo in a single night.

Given the extent of the destruction wrought by incendiary bombing on traditional Japanese dwellings constructed of bamboo and paper, these air offensives would doubtless eventually have forced the emperor to capitulate. It was not a classic bombing strategy that was to put an end to the war, however, as this would have entailed the prolongation of the conflict, but a bombardment of a wholly new type—carried out with atomic bombs created by physicists.

After Japan surrendered, Chinese Nationalists and Communists suddenly found themselves face to face. In an effort to reconcile the two enemies, the United States tried to play the honest broker between the two camps, but in vain.

In July 1945, the Allied conference at Yalta demonstrated that it was impossible to reach an agreement or to negotiate sincerely with Stalin, who now found himself all-powerful in Europe. The deterioration of the relationship between the old allies was to be made more acute with the interference of the USSR in the Chinese Civil War, and, later, with the Berlin blockade.

Facing page: HIROSHIMA, WOMAN, A VICTIM OF THE ATOMIC EXPLOSION

Covered in flies, this old woman, having suffered the effects of the atomic explosion, is dying in a makeshift hospital. Following the attack on Hiroshima, the bomb on Nagasaki finally brought the curtain down on the greatest catastrophe of the twentieth century.

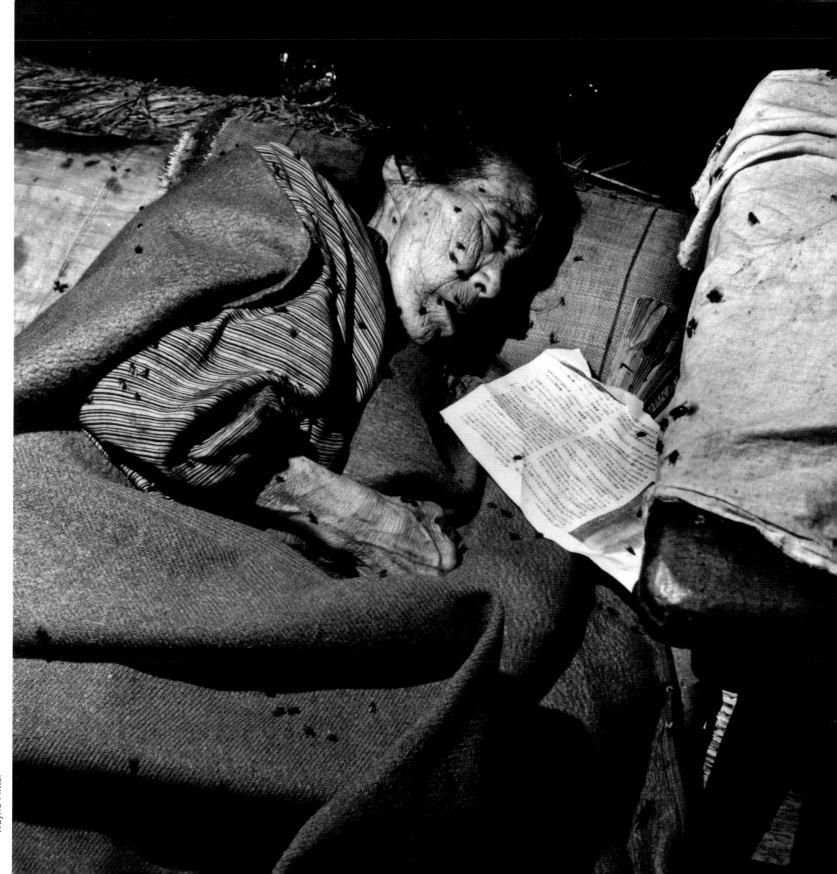

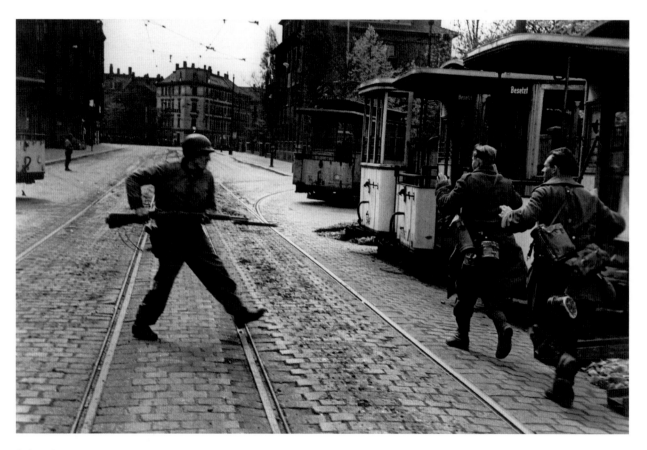

Robert Capa

Germany

AMERICAN SOLDIER WIELDING HIS BAYONET, APRIL 18, 1945

An American soldier, whose comrade has just been killed, is determined to capture the sniper responsible for firing the fatal shot. It required an uncommon nobility of soul not to take revenge on the spot and execute the German soldier, who, in general, once his hiding place was discovered, would simply stand up and put his hands in the air.

NUREMBERG, THE OLD CITY

The historic center of Nuremberg was destroyed in an air raid on January 2, 1945, being further damaged on April 17 by artillery fire from the American army, which entered the city three days later. Here—beneath a cloud-laden sky, as is usual in Soviet photographs—one can see the ruins of the ancient core of this noble city stretching along the River Pegnitz.

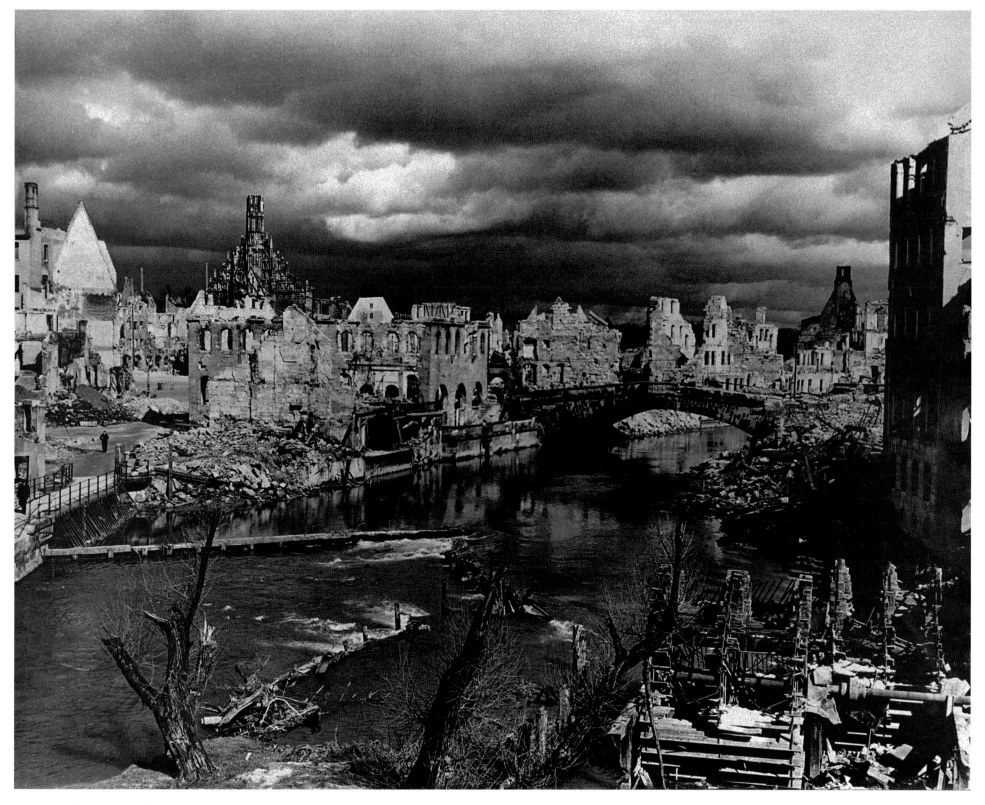

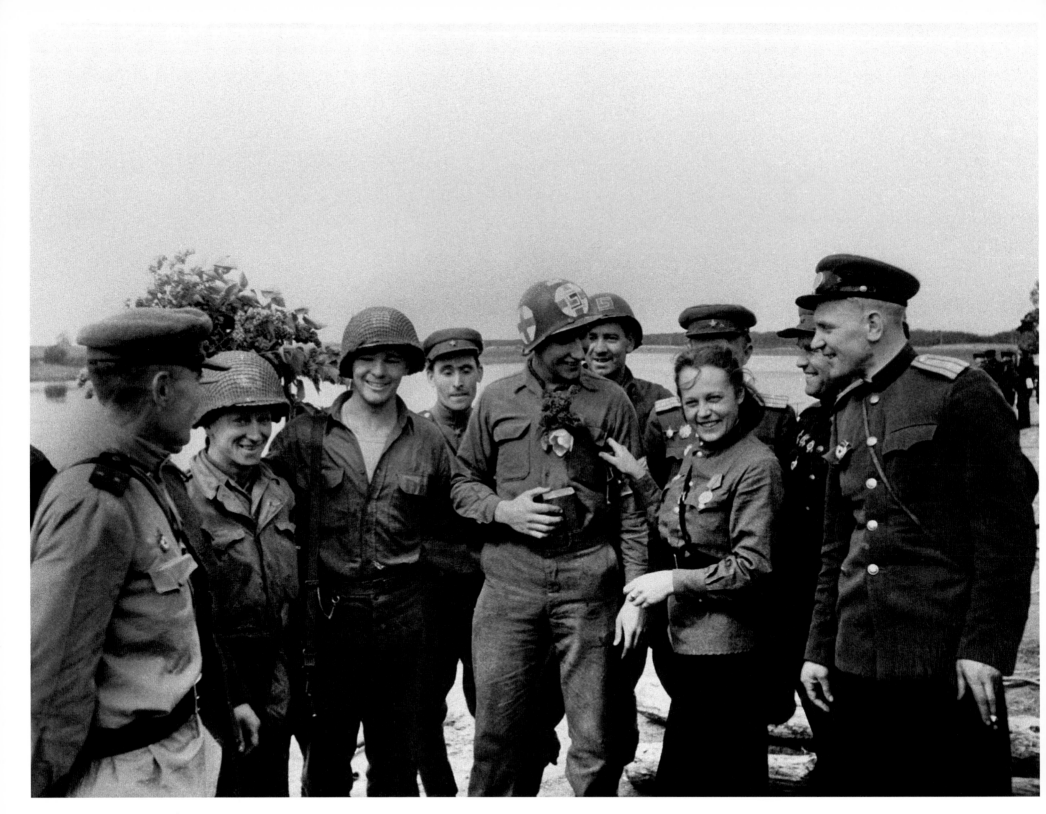

Germany

TORGAU, APRIL 26, 1945

A moving photograph of an exceptional historical event, showing one of the places where American troops met their Soviet counterparts on the Elbe, in the Torgau region, Saxony. Dated April 26, the document shows the encounter between soldiers of the Sixty-Ninth US Infantry Division (their badges can be seen on their caps), a unit that had landed in Germany at the beginning of 1945 and which, commanded by General Emil Reinhardt, had liberated Leipzig on April 19, and those of the Fifty-Eighth Guards Division (General Rusakov). Full of hope, this world-famous photograph provides a vivid illustration of the "grand alliance," the coalition which, after immense sacrifices, finally overcame the barbarism of the Third Reich.

BERLIN, SOVIET TROOPS, APRIL 1945

A classic propaganda image emphasizing the courage and determination of these Red Army infantrymen battling it out in the streets of Berlin. Before entering the German capital, the Soviet command had peppered the city with artillery fire. Even this pummeling was not enough to overcome the German defenses and the infantry had to engage in violent and costly street fighting.

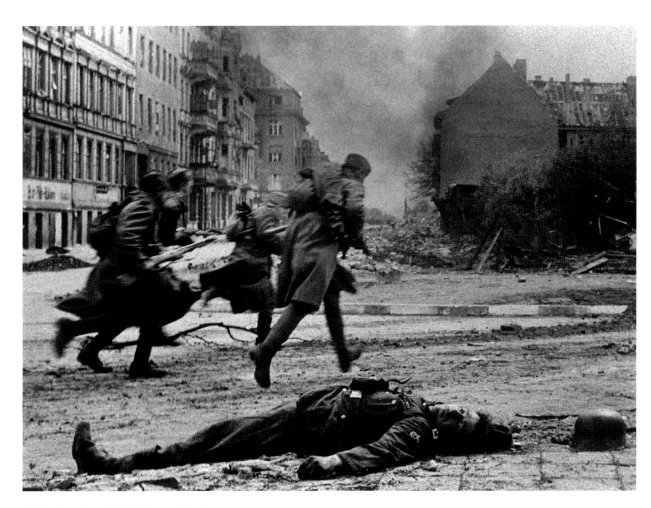

Soviet Group/Ivan Shagin/Magnum Distribution

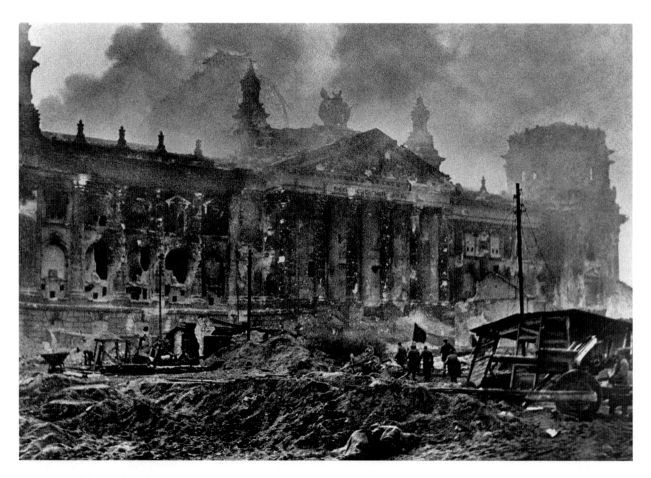

Soviet Group/Magnum Distribution

Germany

BERLIN, SOVIET TROOPS NEAR THE REICHSTAG, APRIL 30, 1945

This photo comes from a report on Berlin made by the official photographers of the Red Army. A small group of Soviet soldiers carrying a flag edges through the ruins towards the entrance to the Reichstag building, flanked by tall columns. Shattered by shells, scarred with shrapnel, the gloomy, filthy façade is almost invisible behind the great clouds of smoke.

BERLIN, SOVIET SOLDIER ON THE TOP OF THE REICHSTAG

This iconic twentieth-century image, showing a soldier planting the Soviet flag on the Reichstag, symbolizes the victory of the Red Army over the Nazi Reich, just as that by the American photographer Joe Rosenthal taken over the summit of Mount Suribachi on the island of Iwo Jima symbolizes the victory of the United States over the Empire of the Rising Sun.

Like Rosenthal's, the Berlin photograph is in fact a reconstruction of the event. It was taken on May 2, and to please Stalin it featured the participation of a soldier who, like the dictator, came from Georgia. Nicknamed the "Russian Capa," Khaldei was much criticized for staging his photos, or retouching the prints in the lab.

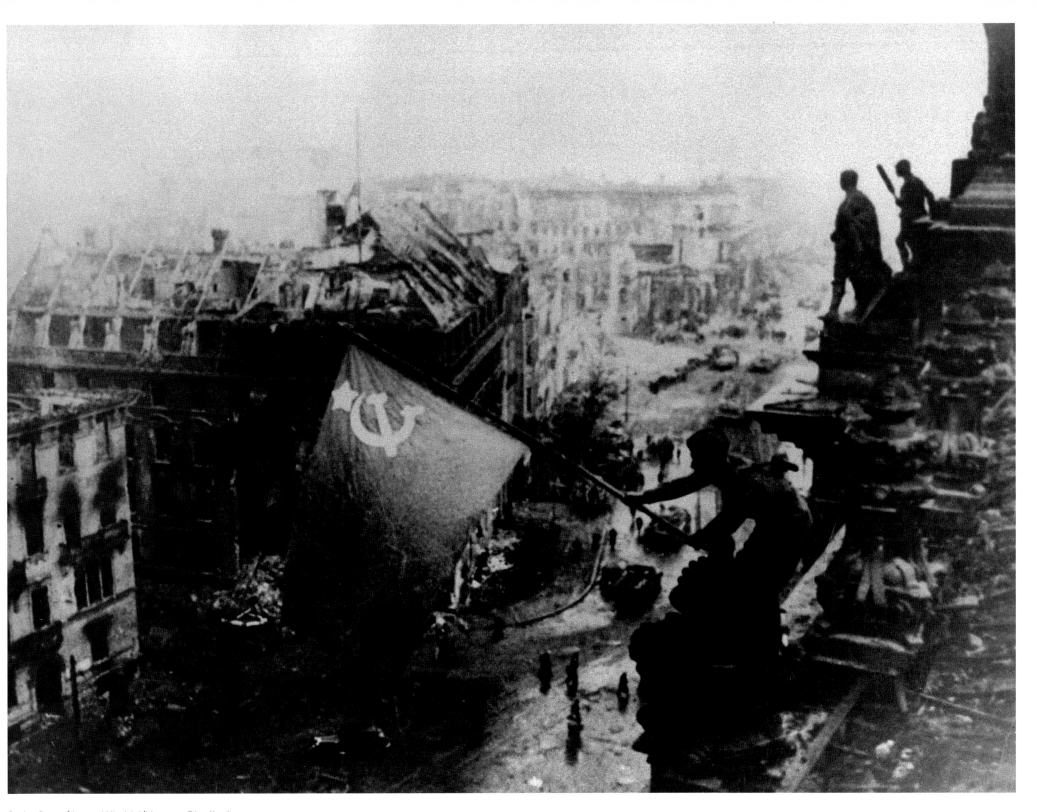

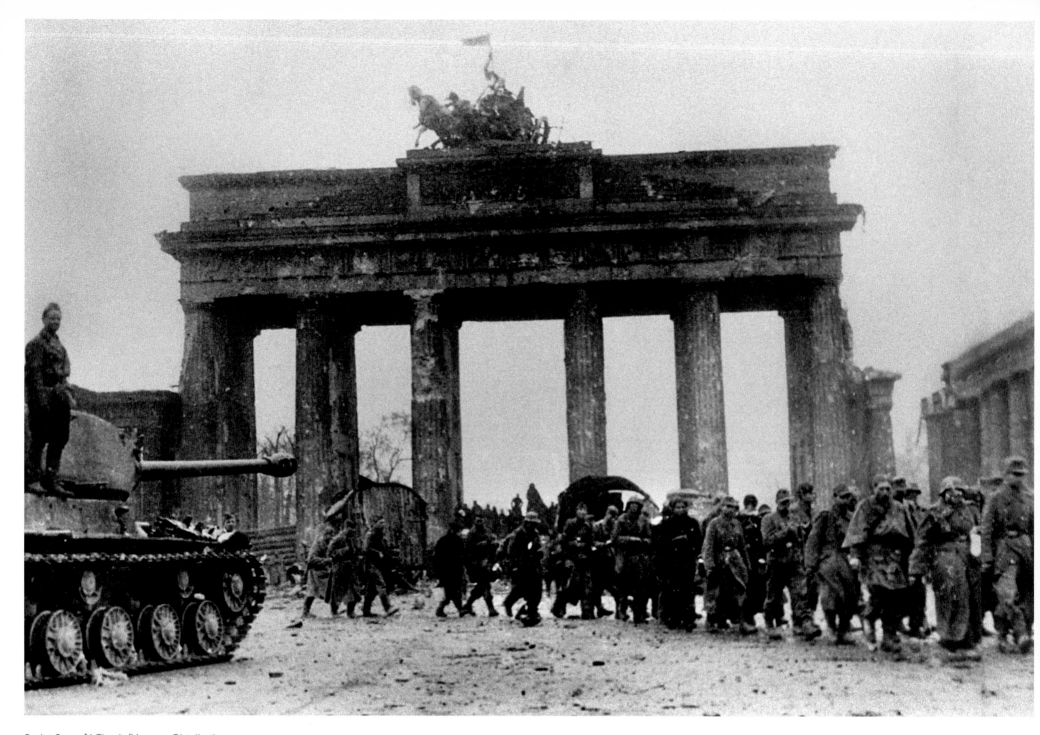

Soviet Group/V. Tiomin/Magnum Distribution

Germany

BERLIN, PRISONERS IN FRONT
OF THE BRANDENBURG GATE, 1945

What humiliation for these German soldiers, taken prisoner
and forced to file past a Soviet tank parked at the foot of the
Brandenburg Gate, which is still surmounted by the chariot of
the goddess of victory. Like the Reichstag, the Brandenburg
Gate, one of the most prestigious monuments of the German
capital, is riddled with shrapnel.

BERLIN, SIGNATURE OF THE ACT
OF SURRENDER, MAY 8, 1945

Considering the signing ceremony for the act of surrender of
the German forces that took place in Reims on May 7 as a pre-
liminary to the signature of the final act of the Wehrmacht's
capitulation, on May 8 Stalin organized a special event in
the old military engineering school of the Wehrmacht in
Karlshorst, Berlin, where the HQ of the First Soviet Army had
been set up. Conducted by Marshal Zhukov, the event was at-
tended by Generals Spaatz (United States), Tedder (Great
Britain), and Lattre de Tassigny (France) and, representing the
opposite camp, Marshal Keitel, Admiral von Friedeburg, and
General Stumpff.

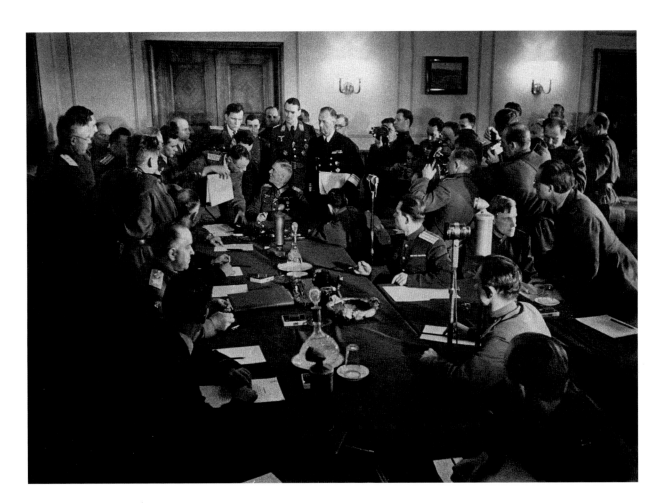

Soviet Group/G. Petrusov/Magnum Distribution

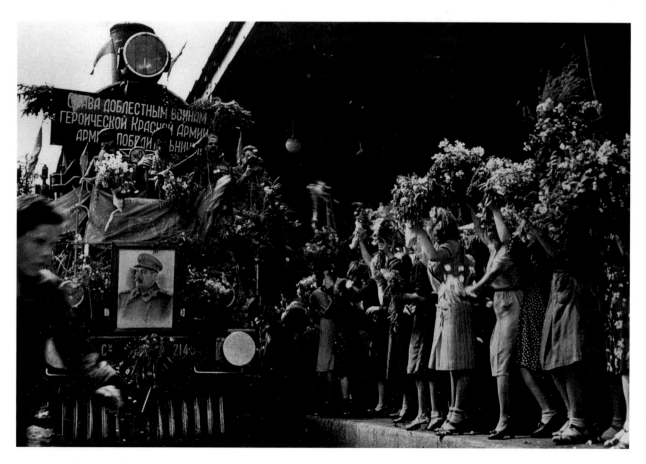

Soviet Group/G. Petrusov/Magnum Distribution

Germany

CROWD HAILING THE TROOPS OF THE RED ARMY, 1945

Led by Stalin, the "locomotive of history" powers down the road to victory. A crowd greets the hero of the Great Patriotic War with bunches of flowers.

POTSDAM, ALLIED CONFERENCE, JULY 17–AUGUST 2, 1945

This photograph, taken by Khaldei in the Cecilienhof Palace in the Berlin suburb of Potsdam—a lugubrious, English-style manor house in the midst of a large park, as Henry Kissinger described it—shows the members of the Soviet delegation in the room set aside for the conference's working sessions; they are seated around a circular table on which stand the flags of the "Big Three" (the three principal victors).

In the center, in the place where all eyes converge, smiling and looking relaxed in his white supreme commander's uniform, sits Stalin, who orchestrated the great victory. To his right, his face turning towards the all-powerful master of the Kremlin, is Molotov, the man behind the Nazi–Soviet Nonagression Pact. Stalin held a strong hand in Potsdam, as a victor over Nazism, and the master of ten European capitals (Berlin, Warsaw, Vienna, Prague, Vilnius, Riga, Tallin, Budapest, Sofia, and Bucharest) liberated and occupied by the Red Army. But his territorial claims, his ambitions, and his refusal to organize free elections in the countries liberated were soon to fuel reciprocal mistrust between the one-time Allies and bring with it the breakup of the "grand alliance." Forty years of Cold War were to follow.

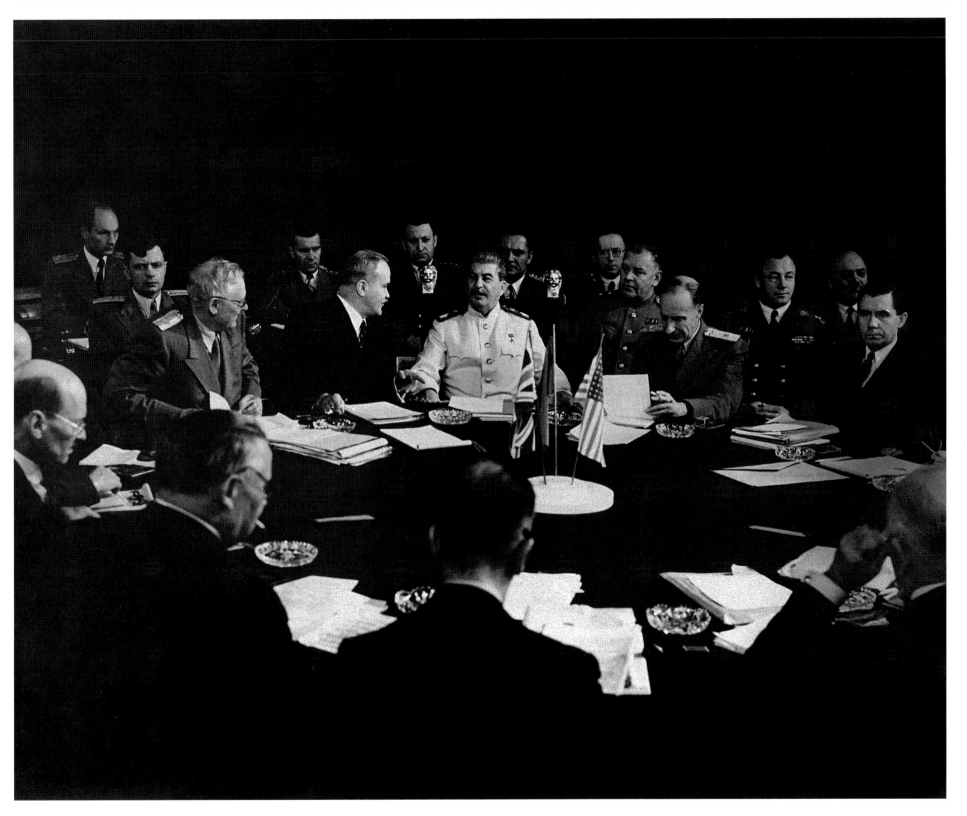

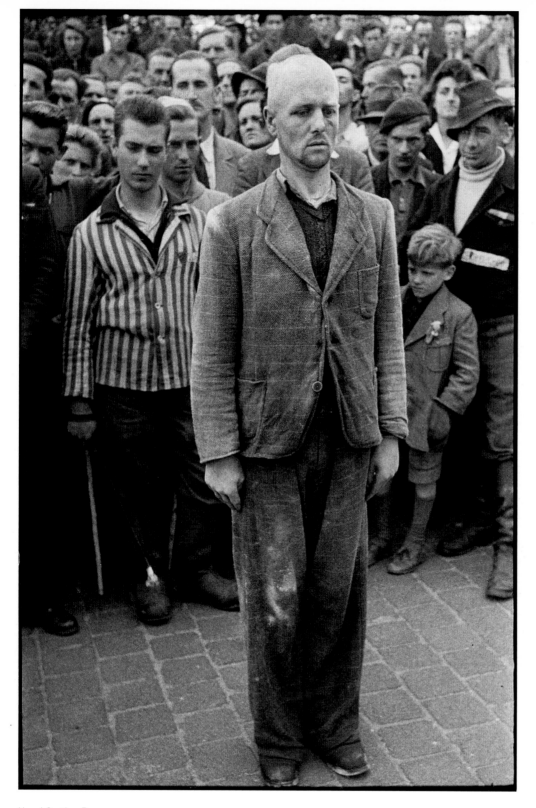

Henri Cartier-Bresson

Germany

DESSAU, TRANSIT CAMP, INFORMER, APRIL 1945

A photograph selected from a set of pictures taken on the territory of the Reich, shortly before the act of surrender was signed. This scene takes place in a former camp for foreigners required for forced labor in Germany, which was located to the north of Leipzig, in Dessau, on the banks of the Elbe, in the zone where Soviet and American troops had met. Employed as a transit camp by the American army, these buildings housed displaced persons from the territories located in the former eastern Reich and liberated by the Red Army. There, these prisoners of war, conscripts into the STO (Obligatory Labor Service), and political deportees awaited their return to their country of origin.

Among this great crowd of stragglers, however, some individuals with a more dubious past hid, such as this ex-informer working for the Gestapo, the police apparatus of the Nazi state. This criminal organization used to recruit prisoners from inside the camps as informers. Fearing retribution for their actions, such informants would try to mingle with the crowds passing through the transit camps.

DESSAU, TRANSIT CAMP, FEMALE GESTAPO INFORMER, APRIL 1945

The photograph catches the moment a victim recognizes a one-time Gestapo informant as she stands before the camp commander seated behind a table.

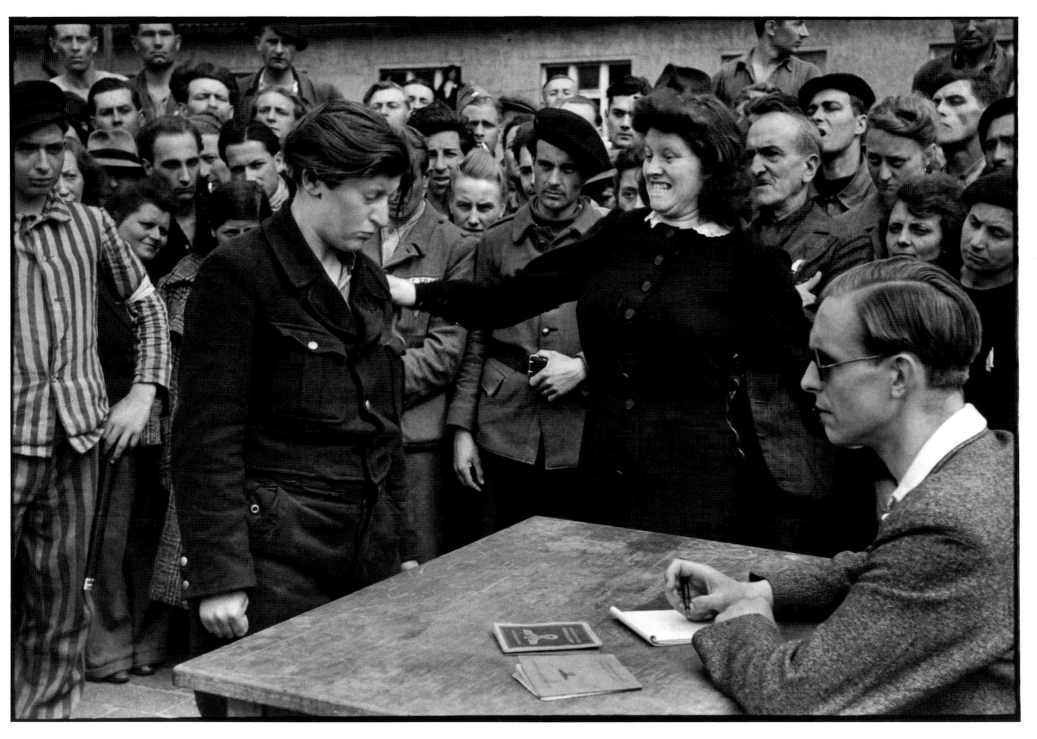

Henri Cartier-Bresson

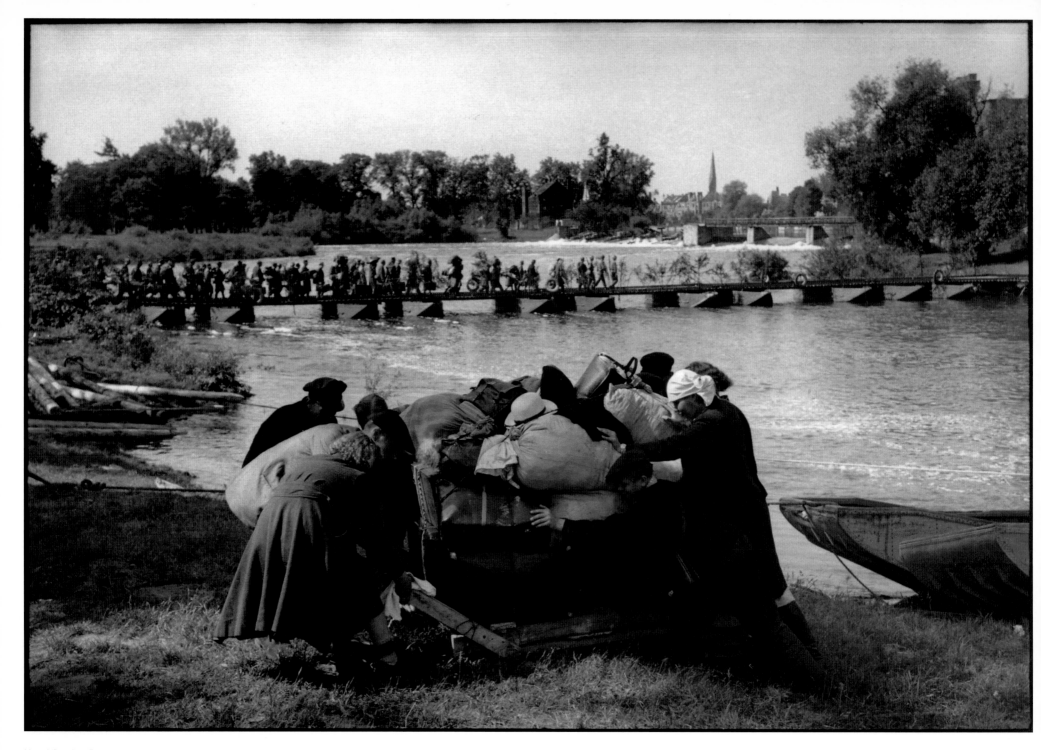

Henri Cartier-Bresson

Germany

DESSAU, TRANSIT CAMP, REFUGEES, APRIL 1945

In the camp at Dessau, in addition to prisoners and those dragooned into the STO, there were also countless refugees from the eastern regions of Germany occupied by the Red Army. Here, a German family, with all its goods piled up on a kind of sleigh, is preparing to get to the zone temporarily under American control on the opposite bank of the Elbe.

DESSAU, TRANSIT CAMP, SOVIET REFUGEES RETURNING TO THE MOTHERLAND

Families of Soviet nationals piled up in a goods truck being returned to their country, as Stalin had stipulated at the Yalta Conference. One can only wonder at the rude good health shown by these "Slavs" after a stay in Reich territory. Perhaps they are Russian soldiers caught up in Vlasov's army accompanied by their families. In that case, the fate reserved for these individuals once back in the motherland would be execution or a Siberian labor camp.

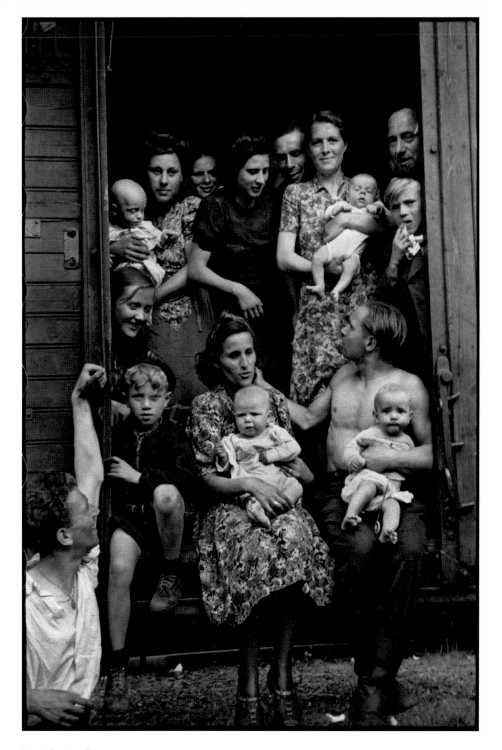

Henri Cartier-Bresson

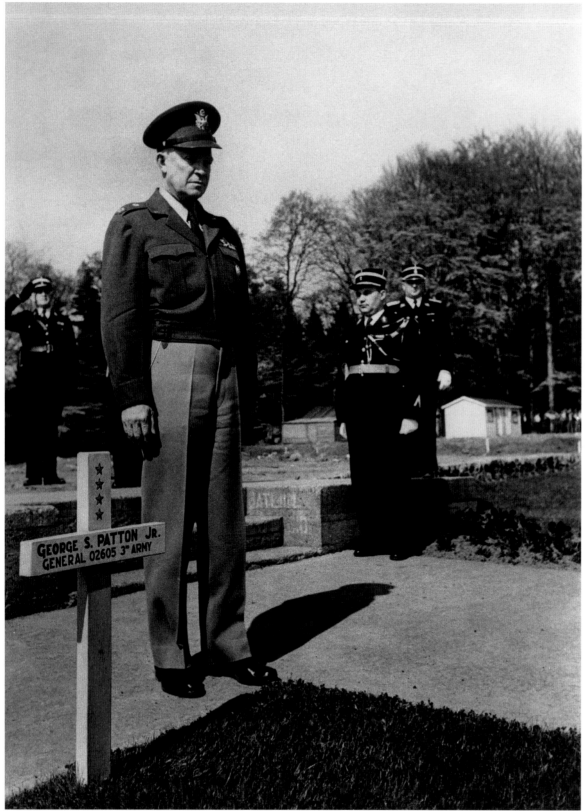

Robert Capa

Belgium and Luxembourg

LUXEMBOURG, HAMM,
GENERAL EISENHOWER AT THE TOMB
OF GENERAL PATTON

As commander in chief of the combined task force in
Europe, Eisenhower demonstrated great skill and diplo-
macy in handling subordinates with strong personali-
ties, such as General Patton. Commander of the Third
Army, Patton had died on December 21, 1945, of an em-
bolism following an accident in a jeep that had occurred
twelve days previously in the Heidelberg region of Ger-
many. His grave is one of 5,076 in the American military
cemetery in Hamm, Luxembourg.

BELGIUM, GENERAL EISENHOWER, 1945

Eisenhower reviews a small detachment of the 101st
Parachute Division. Arriving in Great Britain in September
1943, this famous unit took part in the Normandy Land-
ings, in Operation Market Garden, and in the Battle of
the Bulge. By the end of the war, it was operating in the
Berchtesgaden region. On August 1, 1945, the division
left Germany for Auxerre, France. There it awaited trans-
fer to the Pacific theater, where it was to take part in the
invasion of Japan. Their tour of duty came to an end with
the capitualation of Tokyo.

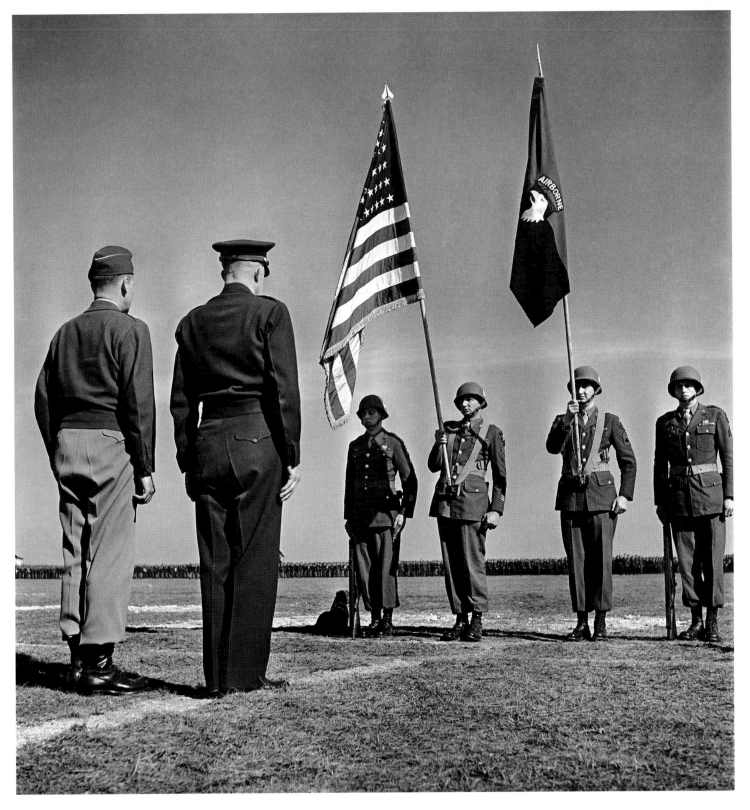

Robert Capa

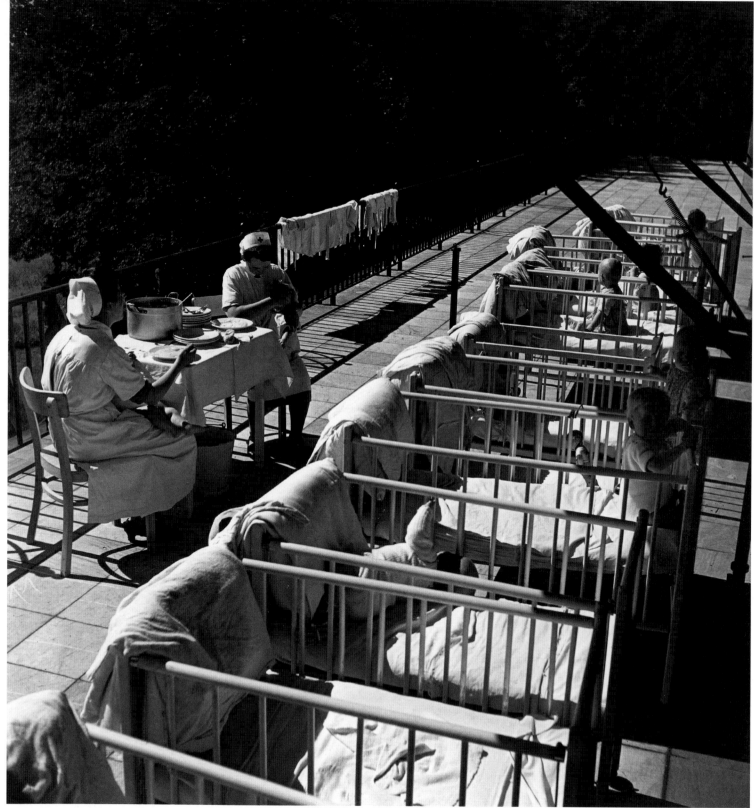

Robert Capa

Germany

HOHENHORST, THE ARYAN "FOUNTAIN OF LIFE"

On a broad, sunlit terrace, stands a row of small wooden beds for Aryan babies whose diapers are drying on a line, while the two child-minders eat a meal. The photo offers a glimpse into a Lebensborn, or "Fountain of Life," i.e., a maternity unit where, once separated from their parents, children born to "racially superior" couples were raised. In centers such as these, children born with defects were promptly euthanized. Lebensborn Centers were created by Himmler all over Europe, in particular in Norway, where German soldiers were encouraged to have children with the "Vikings."

POLAND, AUSCHWITZ-BIRKENAU, ARRIVAL AT THE DEATH CAMP

If there was a higher race, then there had to be lower ones, too, and at the bottom of the ladder were the Jews. Regarded as responsible for the corruption of humanity, the Jewish people were to be eliminated. The war provided an opportunity for the National-Socialist government to implement a program to exterminate all such adversaries of the superior race throughout Europe. Recently arrived by goods truck, and leaning on her cane, this old woman, whose yellow star sewn on to her chest occupies the center of the photo, is destined for certain death.

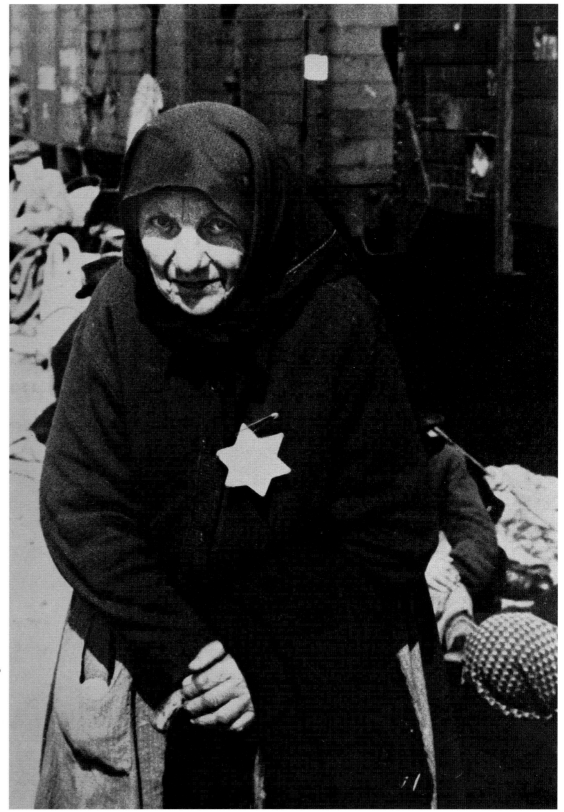

Micha Bar-Am Collection/Magnum Distribution

155

The world of the camps

The concentration camp was one of most extraordinary components of the Third Reich. Reserved until the outbreak of the conflict for the internment of German political opponents, living conditions in these detention centers (Dachau, Bergen-Belsen, Oranienburg, Ravensbrück) were absolutely inhuman. After hostilities commenced, these internees were joined by Soviet prisoners and deportees from all over occupied Europe. At the beginning of 1942, other institutions sprang up: special camps, all located in the General Government of Poland (Chelmno, Sobibor, Majdanek, Treblinka, Auschwitz), intended for the extermination of the Jews and the Gypsies. To accomplish the physical liquidation of all so-called "inferior" races—an operation to which the Nazis gave the code name "Final Solution"—the apparatus of the SS devised factories for mass slaughter (gas chambers and batteries of crematoriums) that were soon working flat out. In these execution centers, several million individuals were wiped out; the large majority of these were Jews living in occupied Europe in a genocide beyond comprehension committed by Hitler's "New Order."

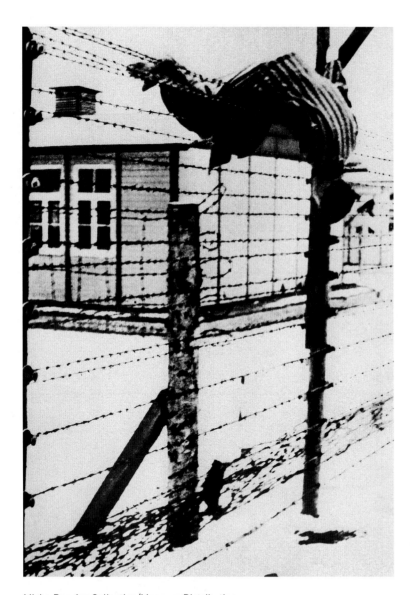

Micha Bar-Am Collection/Magnum Distribution

Left: GERMANY, PRISONER KILLED IN THE BARBED WIRE

Attempting to escape this organized hell, this prisoner in striped pyjamas (a Resistance fighter, Communist, or Soviet prisoner of war?) has been mowed down among the ten-feet (three-meter) high lattice of barbed wire surrounding the camp, by a sentinel in a watchtower, and is left hanging there as an example. In the background, one of the nondescript clapboard blocks in which the prisoners were packed.

Facing page: CHILD WALKING THROUGH THE CAMP AT BERGEN-BELSEN

Located in Lower Saxony in the moors of Lüneburg, the camp of Bergen-Belsen was liberated by British troops on April 15, 1945. In this gigantic death camp containing nearly 60,000 prisoners, the majority of whom suffered from a serious outbreak of typhus, the liberators found thousands of unburied corpses scattered over the ground. An unbearable vision for a child, and indeed for the photographer, who subsequently abandoned war reporting.

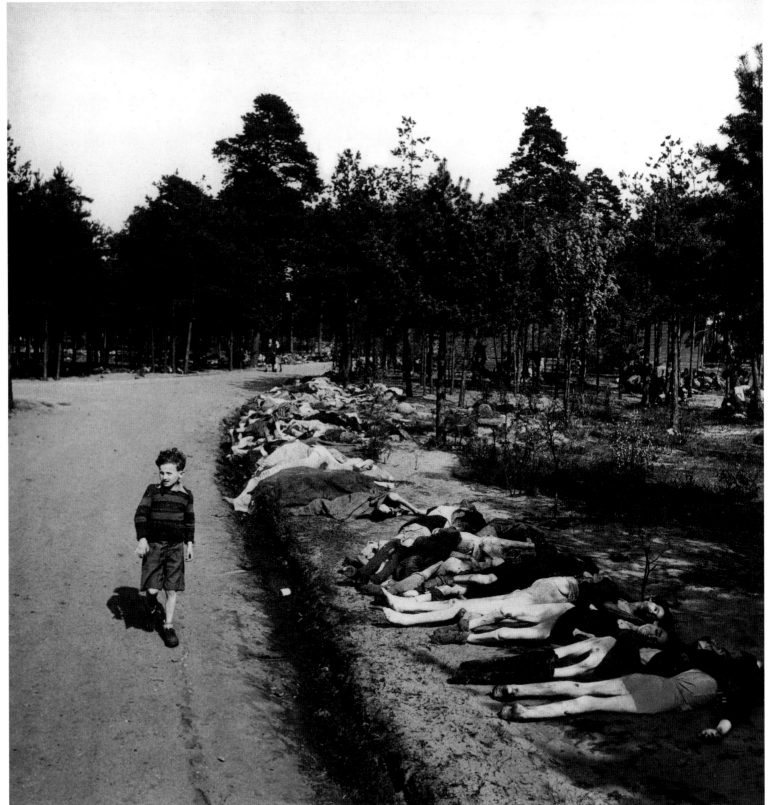

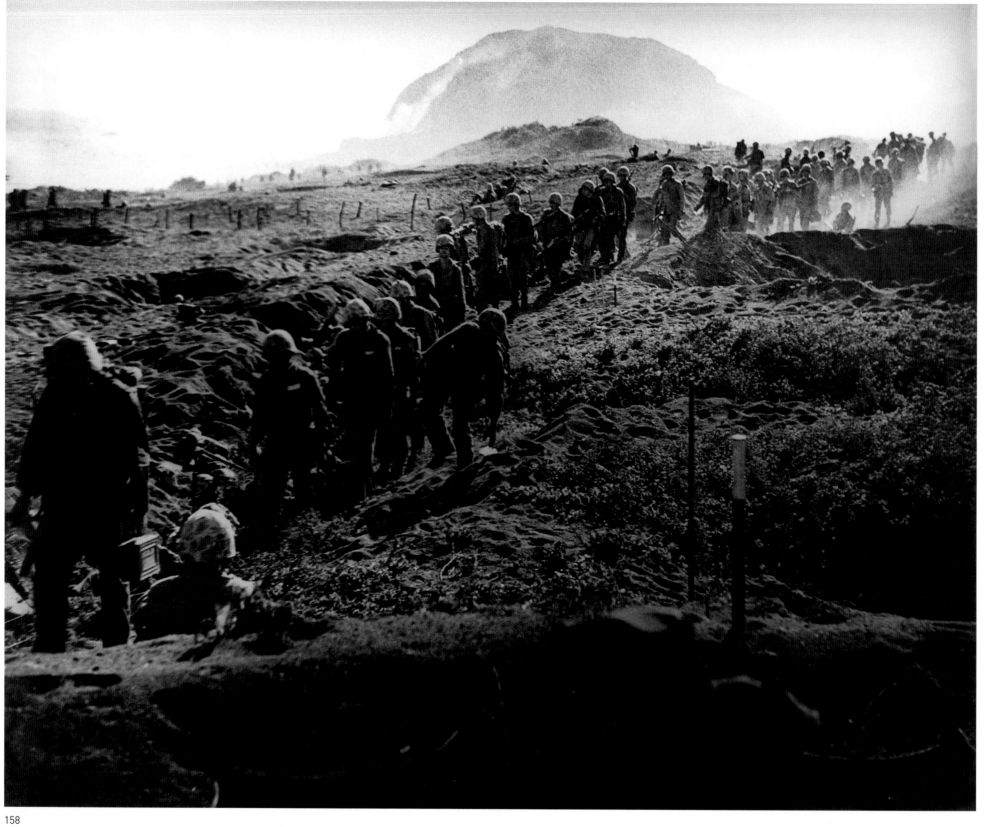

The Pacific

IWO JIMA, FEBRUARY 1945

A column of soldiers on the island of Iwo Jima with, in the background, Mount Suribachi, a since famous volcanic hillock 545 feet (166 meters) high on which, in February 1945, a group of six Marines proudly planted the American flag. Photographed by Joe Rosenthal, a reporter for *Life*, it was an image that was wired around the world. Particularly deadly, the battle of Iwo Jima cost the Americans 5,000 killed out of a total of 54,000 men disembarked and the Japanese nearly 20,000 men—that is to say, practically the entire garrison.

IWO JIMA, HILL 382, FEBRUARY 1945

A team of four sappers visible in the foreground crouching behind a rock uses a powerful charge of dynamite in an effort to dislodge the Japanese holed up in underground defenses. Due to the many fortifications, bunkers, and interminable underground tunnels, in all over 12 miles (20 kilometers) long, the fighting on Iwo Jima proved among the most savage of the entire Second World War.

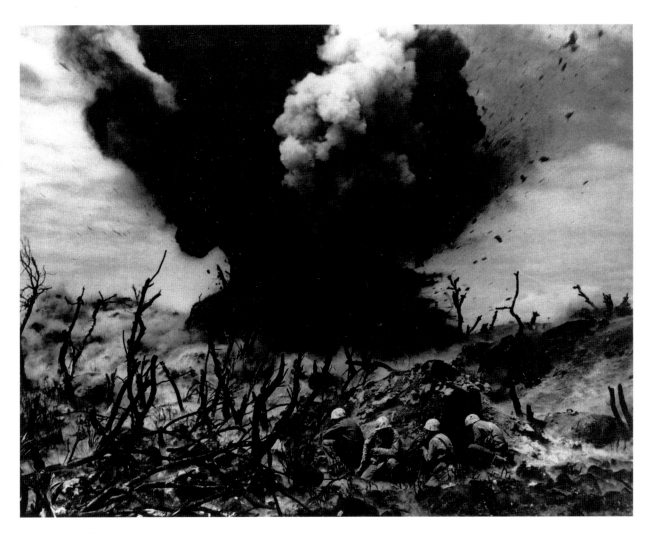

W. Eugene Smith

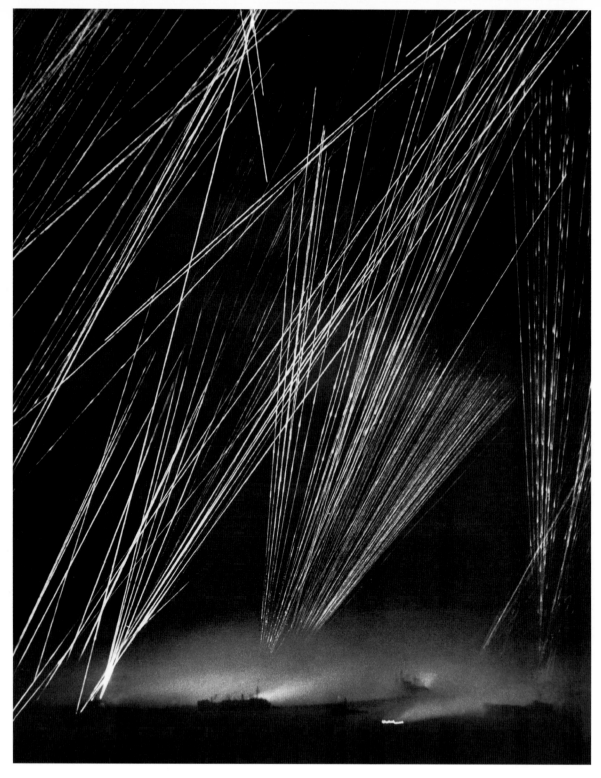

W. Eugene Smith

The Pacific

BATTLE OF OKINAWA, DEFENSE AGAINST KAMIKAZE ATTACKS, APRIL 1945

The anti-aircraft guns of the US Navy in action against night raids and kamikaze attacks. Begun at the time of the battle of the Philippines, these kamikaze raids (suicide dive-bombers) were deployed wholesale at Okinawa. In addition to air raids, the Japanese imperial navy also attacked US Navy craft with pocket submarines, human torpedoes, and motorboats stuffed with explosives. Nearly 5,000 American sailors were to be killed in aerial or naval kamikazes due to the fierceness of the explosions and dreadful fires that a Japanese plane diving onto a flight deck caused.

BATTLE OF OKINAWA, FLAME-THROWING TANK, APRIL 1945

In order to dig out the Japanese defenders armed with guns and machine-guns who had retrenched underground in foxholes, trenches, caves, or bunkers, the Americans, as on Iwo Jima, deployed special tanks on which the gun was replaced by a flamethrower (napalm). The second tank in the photograph is preparing to open fire.

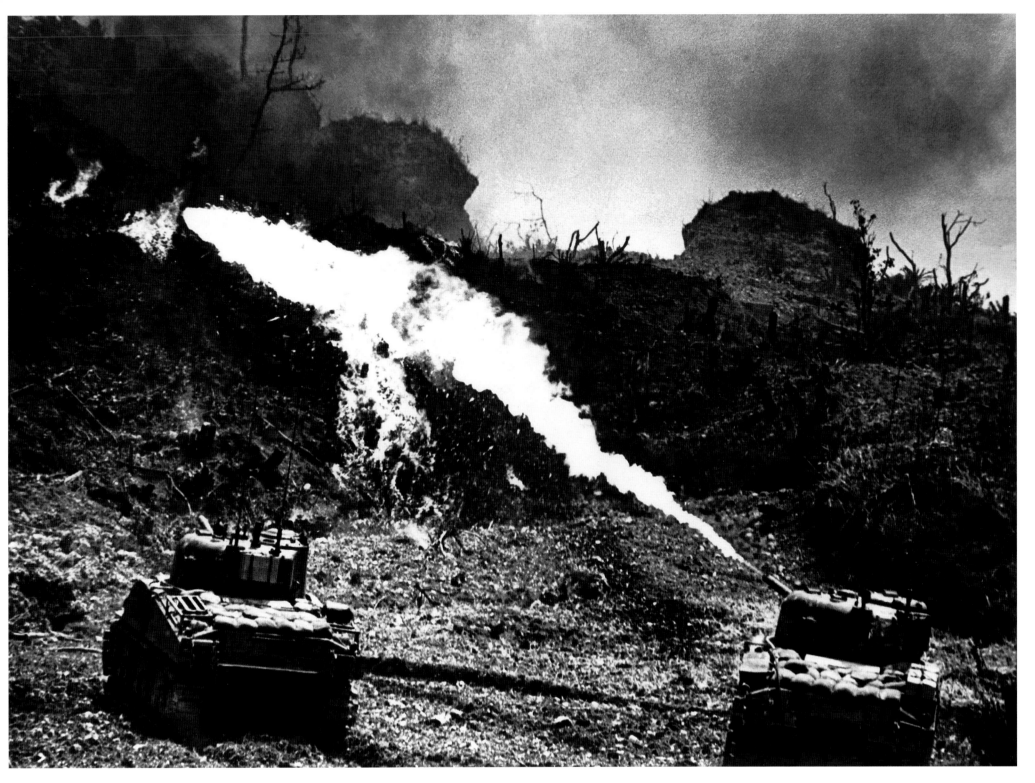

W. Eugene Smith

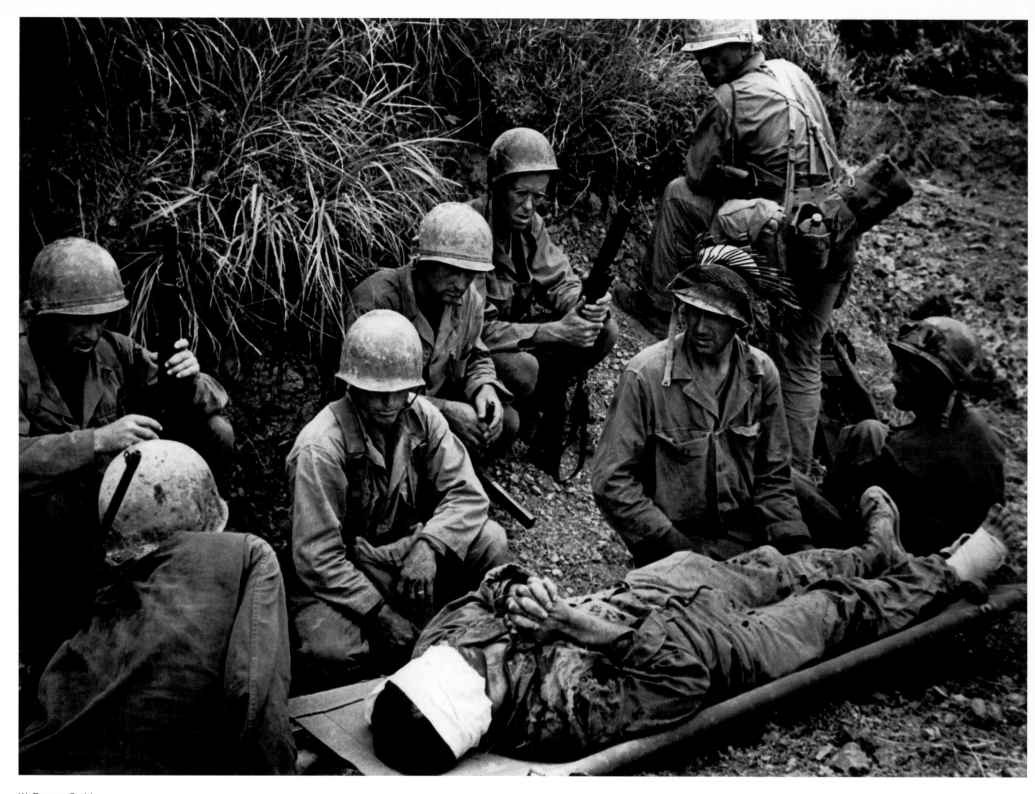

W. Eugene Smith

The Pacific

BATTLE OF OKINAWA, WOUNDED AMERICAN, APRIL–JUNE 1945

Protracted and vicious, the taking of Okinawa was a bloodbath that took place while the war in Europe was coming to a close. On Okinawa, the US Tenth Army suffered nearly 50,000 casualties out of 185,000 deployed, with about 10,000 killed. Here, a Marine, wounded in the head and lying on a stretcher, has put his hands together as if in prayer, while his comrades, their faces grave, gather around him in silence.

BATTLE OF OKINAWA, LOCAL FAMILY

Many civilians wounded during the engagements were to be looked after by the American army. Apparently, some saw nothing wrong with accepting the rations on offer, as the open cardboard box shows.

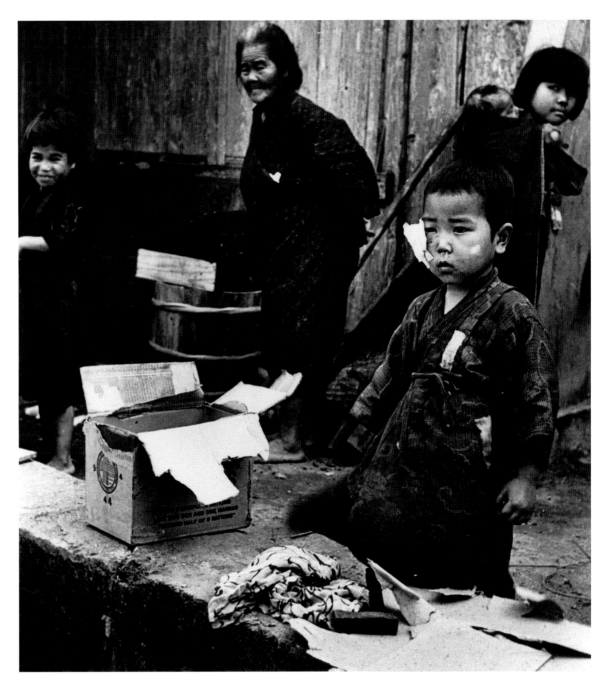

W. Eugene Smith

Wayne Miller

Philip Jones Griffiths

Japan

HIROSHIMA, EPICENTER
OF THE EXPLOSION, AUGUST 6, 1945

Unlike conventional bombing, which makes the battle-field look cratered like the moon, with atomic weapons nothing remains standing: everything is charred, melted, or dissolved by the intense heat, the inrushing shock-wave, the nuclear wind, or else contaminated by the mysterious, invisible, yet deadly radiation.

HIROSHIMA, THE BEGINNING
OF THE ATOMIC ERA

On the sunny morning of August 6, the first atomic bomb was dropped from a B-29 flying at an altitude of 31,168 feet (9,500 meters). Forty-three seconds later it exploded, at 8:15, while still 2,000 feet (600 meters) above the city. Putting a swift end to the war, this ex-plosion propelled the world into a whole new era: the bomb was henceforth to be part and parcel of the human condition; as Albert Einstein put it, the distress-ing thing was that, once invented, "it cannot be disin-vented."

HIROSHIMA, A YOUNG VICTIM
OF THE EXPLOSION

Two first-aid workers tend to a young boy with serious burns to the legs due to the explosion. He was in fact to die a few hours later, as were tens of thousands of oth-ers burned or with their skin blown off by the sheer force of the blast.

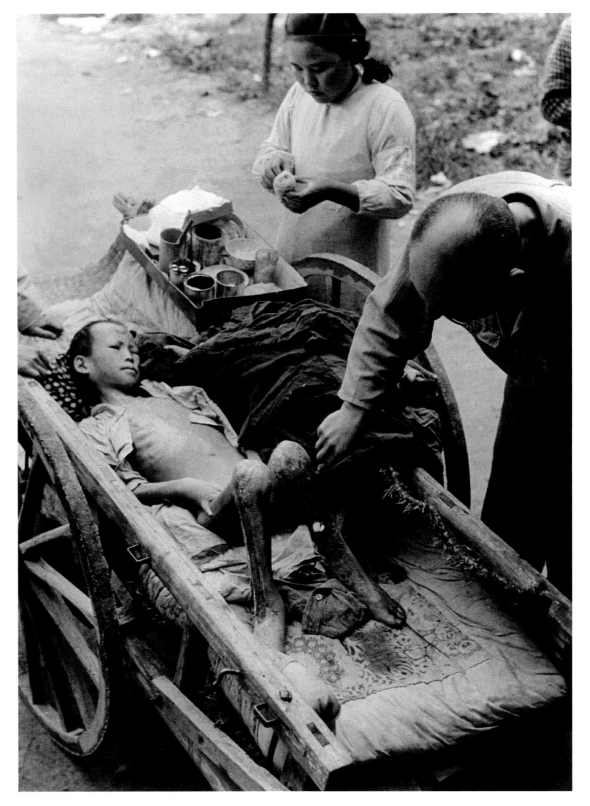

Japanese Collection/Shunkichi Kikuchi/Magnum Distribution

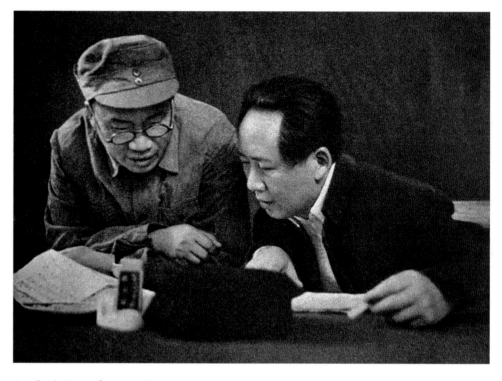

Wu Yinxian/Magnum Distribution

J. A. Fox Collection/Magnum Distribution

China

SEVENTH NATIONAL CONGRESS OF THE CHINESE COMMUNIST PARTY, 1945, MAO AND ZHOU ENLAI, ON THE PLATFORM

This congress was held in Yangjialing, a small village near Yan'an, seventeen years after the Sixth National Congress, which, due to the circumstances at the time, had taken place in Moscow in 1928. Calling on some 550 representatives, this congress, after the presentation of political reports by Mao and Zhou Enlai, went on to discuss a revision of the constitution as well as the question of the formation of a coalition government with the Kuomintang.

MAO AND ZHU DE AT THE SEVENTH NATIONAL CONGRESS OF THE CHINESE COMMUNIST PARTY, 1945

In 1945, the People's Liberation Army, placed under the command of General Zhu De, a long-time comrade of Mao's, boasted a million soldiers—that is to say, about the same number as there were members of the Communist Party. The Americans enjoyed good relations with Mao at the time because, on various occasions, Communist soldiers had picked up and looked after crews who had been forced to make an emergency landing or bail out on their way back from missions attacking Japanese bases. Mao had accepted the presence of a weather and radio station at Yan'an so that the pilots could communicate with Chengdu, the location of the main American air base in China. The Americans and the Chinese were even drawing up plans to extend the landing strip at Yan'an.

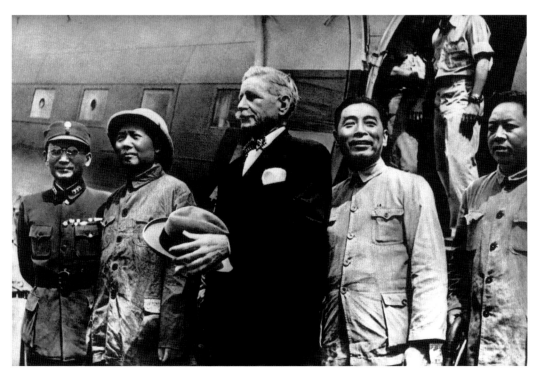

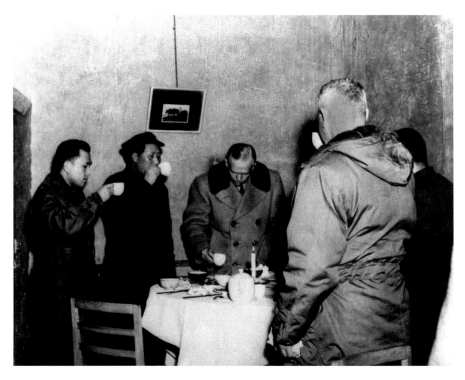

YAN'AN, LEAVING FOR CHONGQING, 1945

In order to forestall civil war and reconcile Nationalists and Communists, in February 1944 President Roosevelt sent his personal representative, diplomat Patrick Hurley, to China. Here, in the base in the Shaanxi, the diplomat is shown standing in front of an American plane, put at the disposal of the Communist delegation comprised of Mao and Zhou Enlai. This took them to Chongqing to negotiate the shape of a coalition government with the Nationalists.

YAN'AN, AMBASSADOR MARSHALL

Disappointed by the outcome of the negotiations concerning an eventual coalition government, in November 1944 Hurley resigned, to be replaced by General Marshall, who was likewise to strive vainly for a compromise between the two Chinas. The mission's failure was followed by the outbreak of what was to become a pitiless civil war between the two sides. Chiang Kai-shek benefited from support from the United States, while Mao could rely on the USSR. This photograph shows Marshall, in December 1945, shortly after his arrival in China, drinking tea in the Communist capital of Yan'an in the company of Mao. In January 1947, Marshall was to leave China for good.

1946 Peace among the ruins

The source of the greatest cataclysm of the twentieth century, Germany, the ringleader of the Axis powers, was now to suffer the consequences of its terrible actions. Defeated, dismembered, occupied, an outcast among nations, no longer existing as a state, its youth killed in combat or held captive, in the immediate aftermath of the war, Germany was no more than ruins and chaos.

Allied air raids, artillery bombardments, and close-quarters fighting had destroyed the industrial centers, shipyards, hydroelectric dams, monuments, dwellings—even entire cities. The critical lack of housing, gas, and electricity was compounded by a terrible food shortage that spawned a black market, theft, and pillage.

Reduced to penury, the women of Berlin, in the absence of their menfolk, would collect wood in the Tiergarten for heating, turning every park in the capital into a vegetable garden so as not to die of hunger. The unprecedented disaster that the country was undergoing was accentuated still more by the huge influx of millions of displaced persons from the eastern regions of what had been Germany that had passed under Polish control, along with others from the Sudetenland that had been restored to Czechoslovakia.

Under the terms of the decisions taken at the great conferences between the Allies, an international military tribunal was set up, at the end of the conflict, to try the most significant war criminals. Sitting in the law courts at Nuremberg, the city in which the congresses of the National Socialist Party had been held until 1938, this tribunal condemned a dozen or so high-ranking members of the Nazi regime to death.

Much less well known, other trials were to be held in each occupied zone to judge second-level war criminals. In their zone of occupation, in a building in the former concentration camp at Dachau, not far from Munich in Bavaria, the Americans converted a hall large enough to contain several hundred people so that the public could watch as the leaders of the Buchenwald camp were tried. It had been in this camp that, for the first time, at the end of April, horrified American soldiers had encountered huts crammed with nearly a thousand children reduced, like the adults, to skeletal states, and traumatized for life. Following the guilty verdict, the ten commanders at Buchenwald, a camp located near Weimar, the city in which the Republic had been proclaimed in 1919, were condemned to be hanged and duly executed. After the war, the infrastructure of the camp at Dachau, as with other places formerly used as prisons for deportees, were to be turned into internment camps for numerous Nazis, in the context of an operation—known as "denazification"—to cleanse German society of the earlier regime.

Examining the consequences of the war on children, these final few visual documents are especially moving: we see Teresa, a Polish girl who spent her entire childhood in a concentration camp; some young orphans from Monte Cassino; a young Italian woman, raped and locked up after the War in a reformatory; Greek refugees trapped between two fronts.

Facing page: GERMANY. FREIBURG-IM-BREISGAU, 1945

Having occupied and plundered Europe, in its turn Germany was to suffer a wretched fate. Ruins, heaps of stones all neatly piled up, the street looks clear enough—but there is not a single shop.

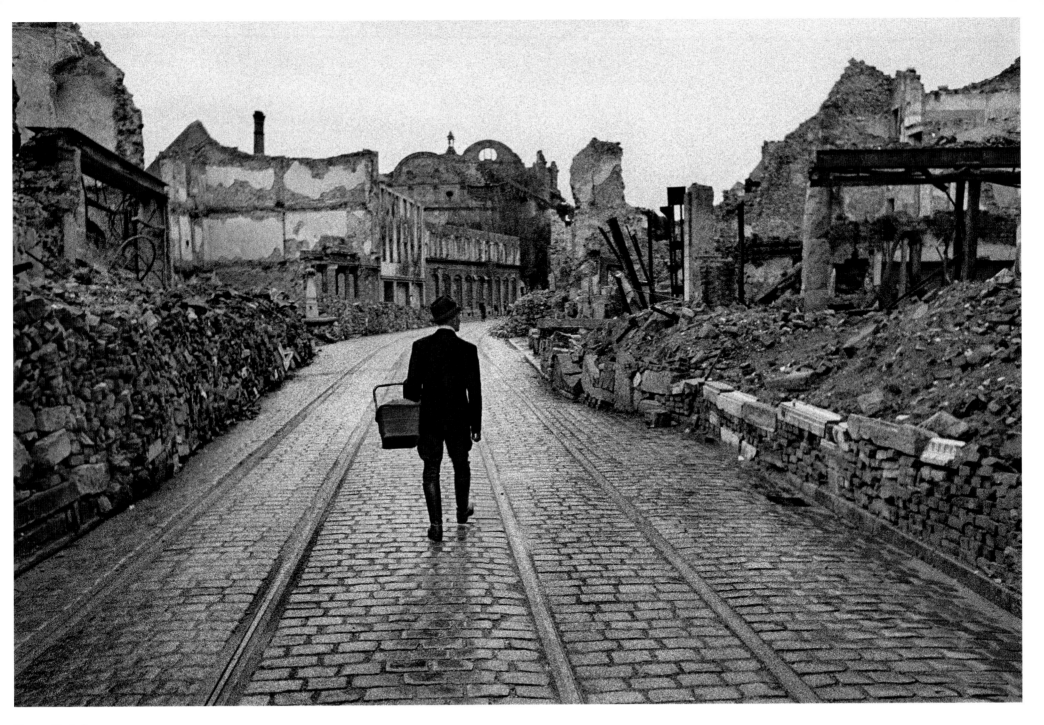

Werner Bischof

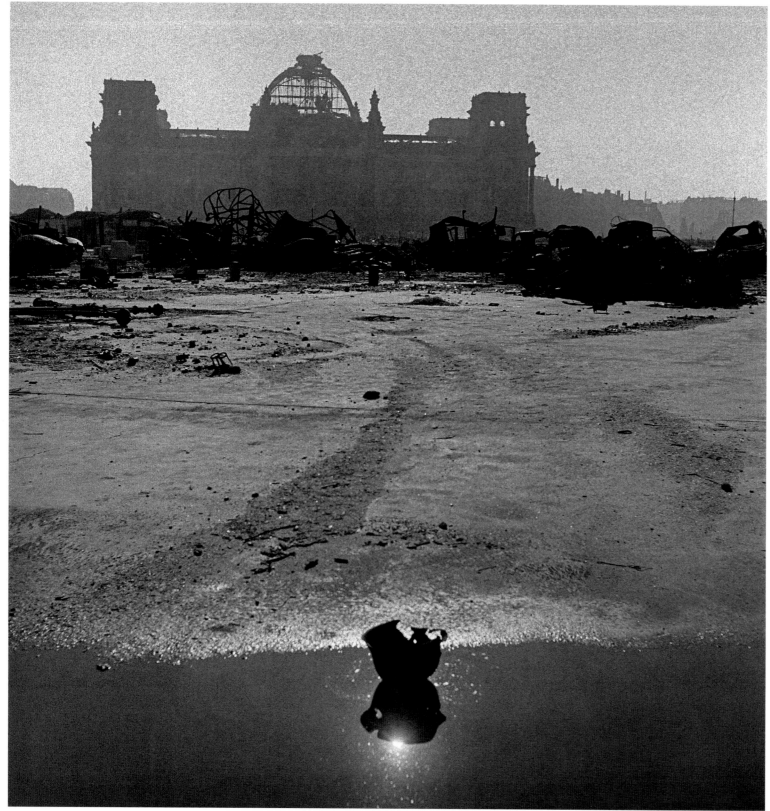

Werner Bischof

Germany

BERLIN, THE REICHSTAG, 1946

This picture, showing the half-destroyed Reichstag building veiled beneath a light blanket of fog with, at its foot, charred carcasses of military matériel, recalls the domed building in Hiroshima obliterated in the atomic blast.

BERLIN, REFUGEES, 1945

On a glorious sunny day, women without husbands and children without fathers drag themselves across an eviscerated, ruined capital now occupied by the Allies. Berlin was an obligatory stop before people were allowed to enter one of the occupied zones in the West.

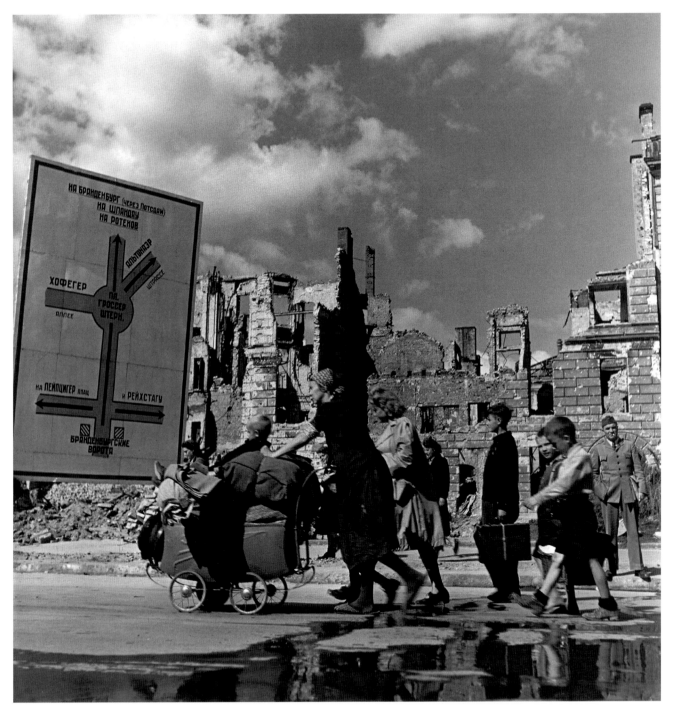

Robert Capa

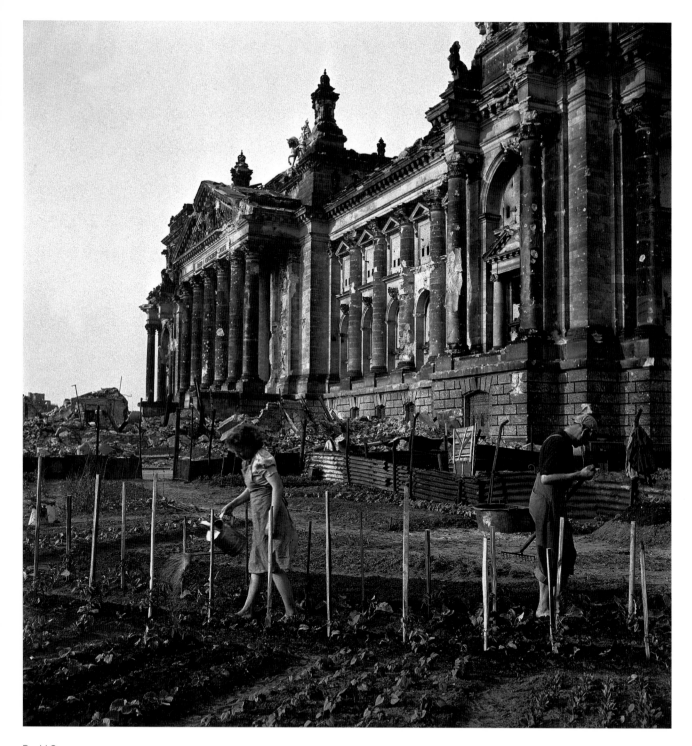

David Seymour

Germany

BERLIN, GARDENS AMONG THE RUINS, 1947

Divided after the war, like Germany itself, into four sectors, the city of Berlin—three-quarters destroyed by bombardment and street fights—experienced a massive food shortage. Here, at the very entrance to the Reichstag, two Berliners tend a little plot of land they have turned into a kitchen garden.

BERLIN, TIERGARTEN, COLLECTING WOOD, 1946

In the background stands the Reichstag with, on the far right, a few columns from the Brandenburg Gate. A one-time princely hunting reserve, the vast park of the Tiergarten, located in the very heart of the German capital, had been severely damaged by air raids and Soviet artillery in April 1945.

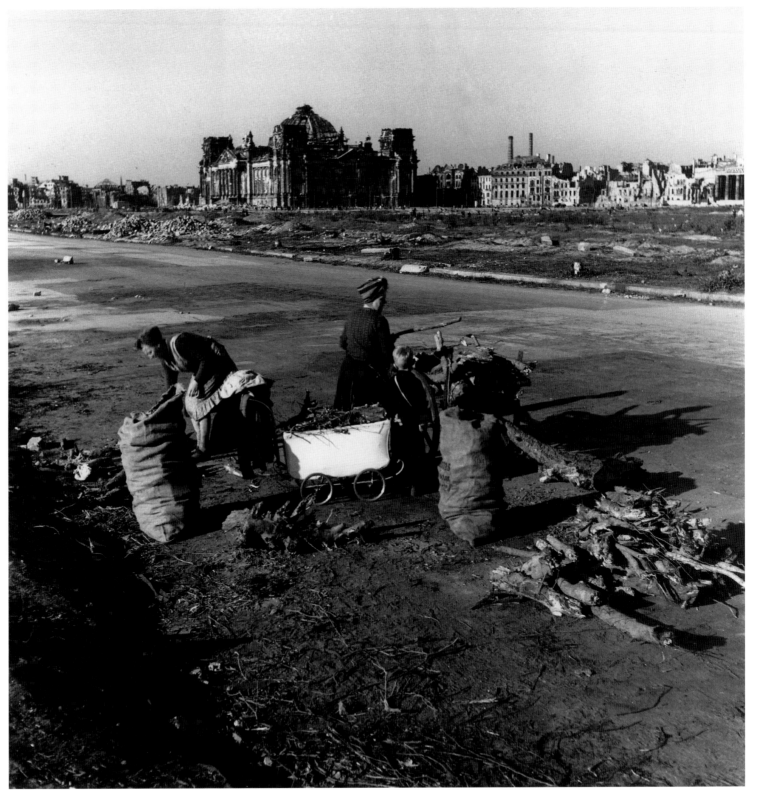

Werner Bischof

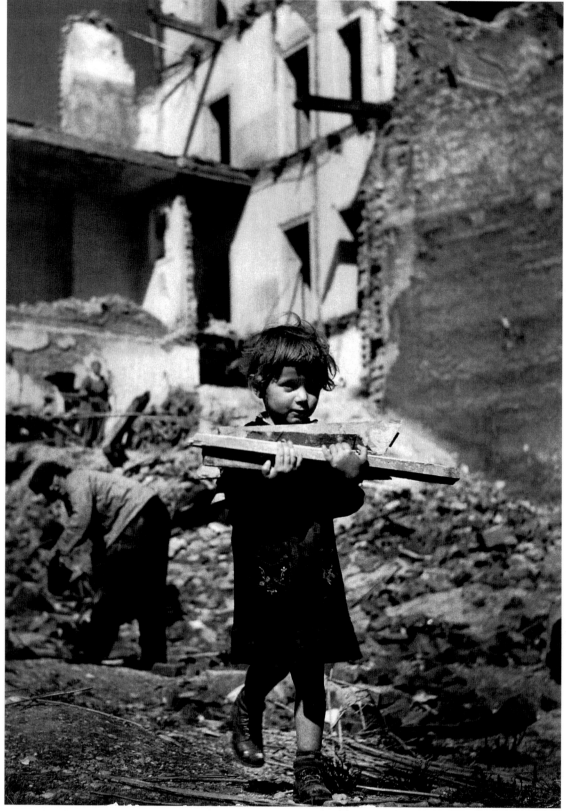

Herbert List

Germany

MUNICH, A CHILD CARRYING PIECES OF WOOD GLEANED AMONG THE DEBRIS, AUTUMN 1945

A photo taken from an illustrated report carried out by Herbert List on everyday life in Munich immediately after the end of the war. Germany had to wait for the next generation to regain the confidence of the world. Unlike their parents, this new generation, seen here in Munich, believed that, rather than defeating Germany, the Allies had in fact liberated it from tyranny.

BERLIN, NEAR THE BRANDENBURG GATE, APRIL 1945

The best-known monument in Berlin, the Brandenburg Gate opens onto Unter den Linden, the most famous avenue in the city. During the battle at the end of April 1945, the building was to be seriously damaged, as was the chariot of Victory surmounting it.

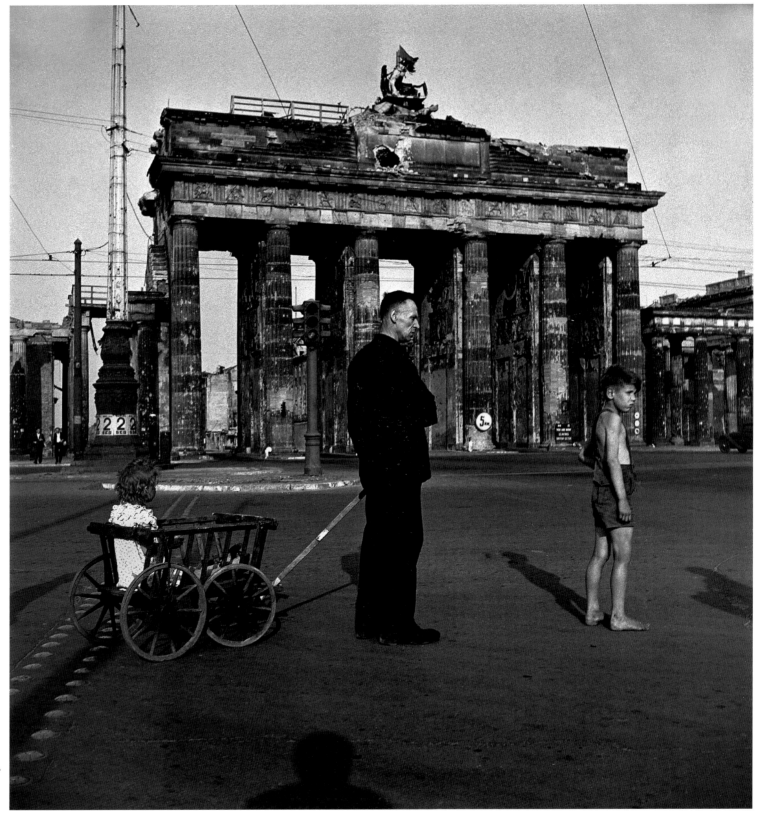

175

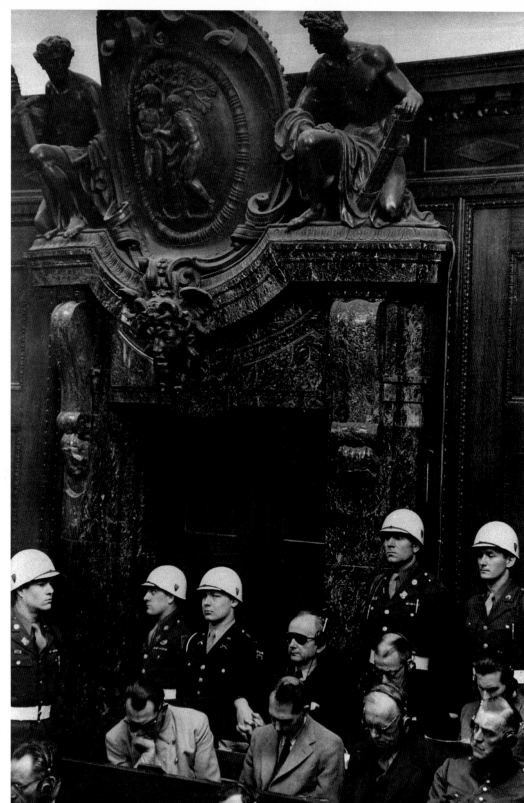

Germany

NUREMBERG, COURTROOM DURING THE TRIALS, NOVEMBER 20, 1945–OCTOBER 1, 1946

Seated in the dock in the severe-looking law courts at Nuremberg, the principal Nazi leaders, heads bowed, some sporting dark glasses, listen in silence through headphones to the indictment. Out of the twenty-four leading Nazis to be found guilty, twelve, designated as war criminals, were to be executed—except for Göring, who succeeded in committing suicide in his cell.

GERMANY, TRIAL OF THE LEADERS OF THE CAMP AT BUCHENWALD, HELD IN THE CAMP OF DACHAU, 1947

A courtroom installed in a building of the former camp at Dachau furnished with the scales of justice. A symbol, like Auschwitz, of Nazi terror, this huge camp was opened in Thuringia for German political prisoners in 1937; it witnessed the arrival of 200,000 deportees from all over Europe. Here, in rows opposite the table where the judges sit, are pictured some of the thirty-one defendants, each bearing a number, who had overseen the *Konzentrationslager* at Buchenwald. Out of the thirty-one accused, twenty-two were condemned to death, including Hermann Pister, aged sixty-two, husband and father of three children. He had been the camp commandant, but claimed to have been unaware that in the institution he ran there were monstrous medical experiments being carried out on prisoners, before and after their deaths. Two years previously, on April 12, 1945, after visiting a former salt mine in which the Nazis had hidden many pictures as well as gold bullion, General Eisenhower, accompanied by other generals, went on to the forced labor camp at Ohrdruf, a division of Buchenwald, whence he emerged deeply disturbed by the evidence of Nazi cruelty he had witnessed.

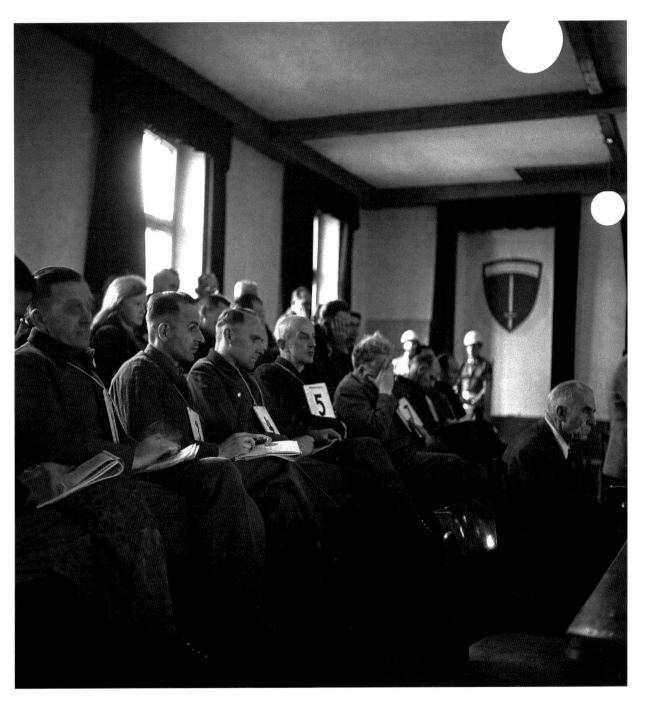

David Seymour

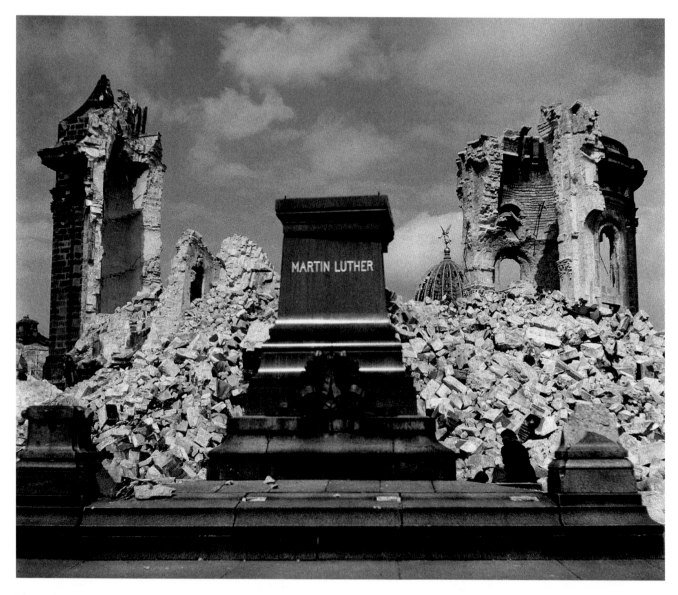

Werner Bischof

Germany

DRESDEN, LUTHER MEMORIAL, 1946

A onetime princely residence and capital of the kingdom of Saxony, Dresden—known for its monuments built along the banks of the Elbe—was to feel the full power of the Allied air forces during February 1945. Under the deluge of bombs (7,000 tons, that is a third of the power of the atomic bomb on Hiroshima), whole swathes of the city were razed to the ground, including the vast Frauenkirche, reduced to a heap of stones. The first German city to adopt the Reformation (1537), Dresden venerated Luther. A statue of the preacher once stood on this black marble pedestal next to the cathedral.

BERLIN, A TRIBUTE TO THOSE WHO SUFFERED UNDER NAZISM, SEPTEMBER 9, 1945

On September 9, 1945, in Berlin, a city divided into four sectors by the victors whose flags can be seen flying in the background, a vast ceremony was held to honor the memory of those who had suffered under Nazism. Presented as a national duty for all Germans, this huge demonstration took place in the stadium at Neukölln (a Berlin borough) and was attended by more than 60,000 Berliners. Seated on the terraces or standing, bareheaded, on the lawn, the crowd awaits the arrival of a delegation who will place a wreath at the foot of a small monument dedicated to the German wrestler Werner Seelenbinder, decapitated on October 24, 1944, in the prison of Brandenburg-Görden, for his anti-Nazi stance. In addition to the initials "KZ" (an abbreviation of Konzentration), set in a triangle at the top of a pyramid, the crowd could read on scraps of the shattered perimeter wall from a camp the following sentence: "The dead are recalled to the memory of the living." An integral part of the process of denazification planned at the Allied conferences, this pilgrimage was designed to make the participants reflect on the fact that, between 1939 and 1945, there were courageous Germans who had sought to oppose the Nazis and had paid the ultimate price.

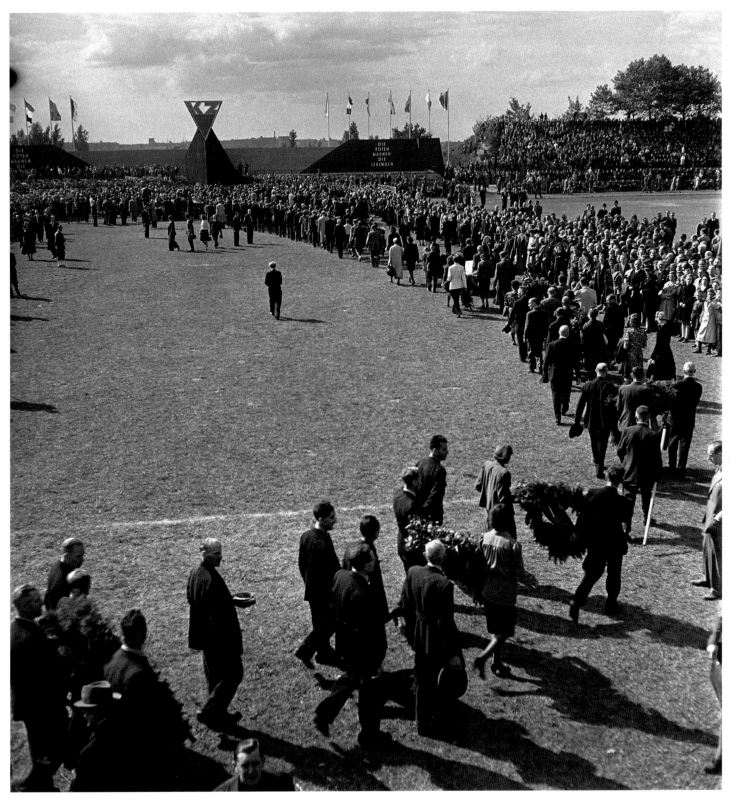

Robert Capa

Children of the War

POLAND, TERESA, A LITTLE GIRL
SAVED FROM THE CAMP AT LODZ, 1948

A drawing meant to represent a house, made by Teresa, a little Polish girl who spent her entire childhood in the concentration camp built close to Lodz in the General Government. In this "little Auschwitz," Himmler placed children whose parents had been arrested by the Gestapo under the pretext of being partisans. After her stay in the hell of the camp, Teresa, released at the end of January 1945 by the Soviets, was placed in a unit for disturbed children. This scribble, which belies her age, shows why.

ITALY, NAPLES, VICTIM OF RAPE, 1948

Here, she was to be taught embroidery by Catholic nuns. Well after the war, a dispute broke out between Italy and France concerning the theft of thousands of sheep in the Italian countryside carried out by the indigenous troops (Moroccan, Algerian, and Tunisian) making up General Juin's task force, and, more importantly, concerning the many rapes perpetrated in the region around Monte Cassino in 1944 by these same troops. Vittorio De Sica recounts this episode in a film entitled *La Ciociara* (*Two Women*).

David Seymour

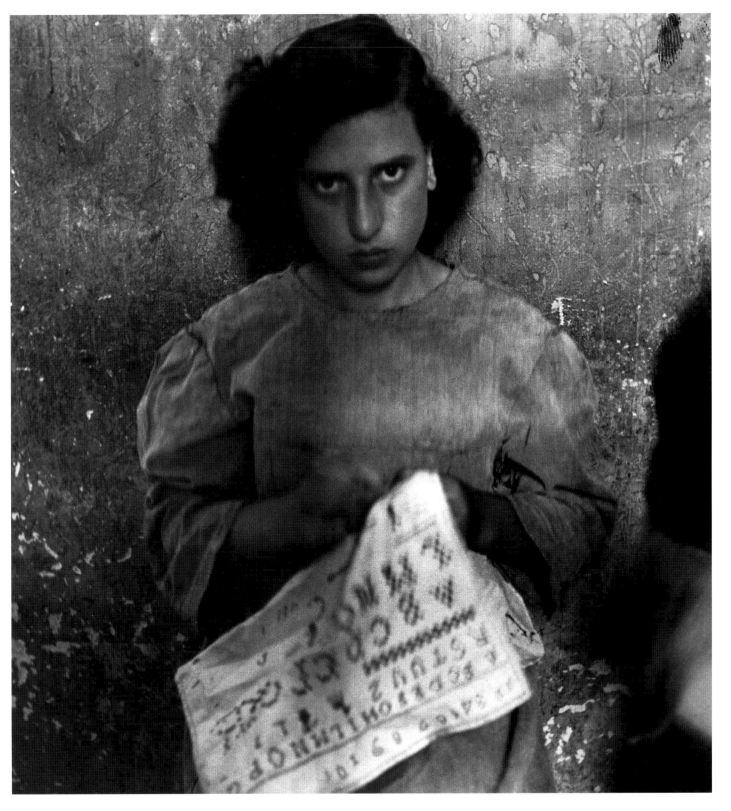

David Seymour

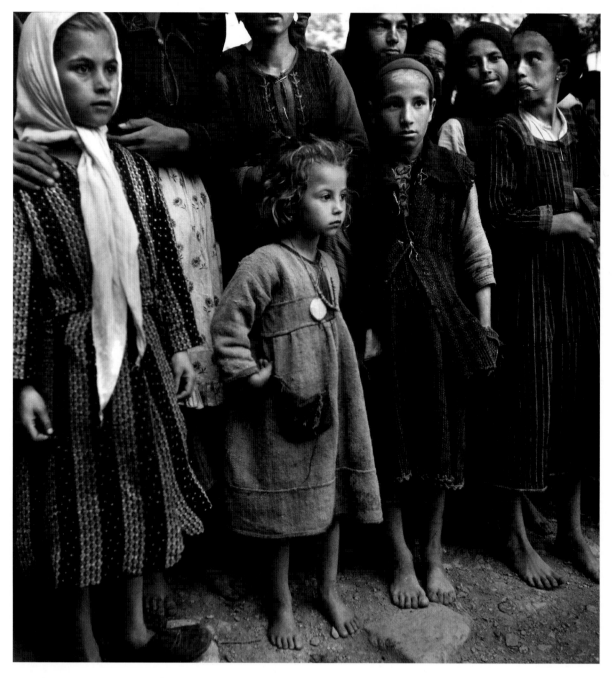

David Seymour

Children of the War

GREECE, REFUGEES FROM THE CIVIL WAR, 1948

Flaring up in 1946, the civil war between the Greek Communists, backed by the USSR, and the Royalists, supported by Great Britain and, later, by the Americans, was to ravage the country for years: ambushes, attacks, fires, atrocities, and the destruction of harvests ravaged the land. Held to ransom by both sides, the civilian population was to suffer hugely in the conflict, as this photograph of barefoot children demonstrates.

ITALY, MONTE CASSINO, ORPHANS PLAYING WITH A BALL, 1948

In the background stand the ruins of the orphanage, an image of the war and of the past. Their backs turned on the destroyed stretch of wall, a group of children—the upcoming generation—are gathered; in the sky soars a ball: the future.

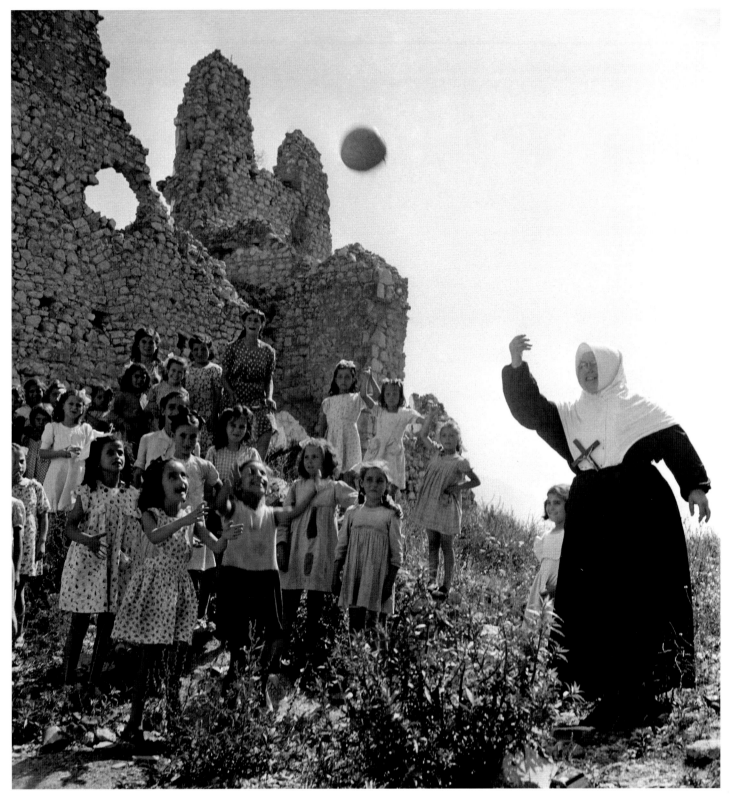

David Seymour

BIBLIOGRAPHY

Alanbrooke, Field Marshal Viscount. *War Diaries 1939–1945*. Edited by Alex Danchev and Daniel Todman. Bristol: Phoenix Press, 2001.

Anders, Leslie. *The Ledo Road*. Norman, OK: University of Oklahoma Press, 1965.

Anderson, Charles R. *Leyte: The US Army Campaigns of World War II*. Washington: Office of the Chief of Military History, 1994.

Antier, Jean-Jacques. *La bataille de Leyte (1944)*. Paris: Presses de la Cité, 1985.

Balkoski, J. *Omaha Beach*. Mechanicsburg, PA: Stackpole Books, 2004.

Baris, Tommaso. "Le corps expéditionnaire français en Italie. Violences des 'libérateurs' durant l'été de 1944." *Vingtième siècle, Revue Historique* 93 (2007).

Bauer, Eddy. *Histoire controversée de la Seconde Guerre mondiale 1939–1945*. 7 vols. Paris: Rombaldi, 1966–67.

Bauer, Eddy. *History of the Second World War*. London: Orbis, 1995.

Beaton, Cecil. *War Photographs 1939–1945*. London: IWM, 1981.

Berelowitch, Wladimir, and Laurent Gerbera. *Russie-URSS 1914–1991. Changements de regards*. Paris: Éditions Bibliothèque de Documentation internationale contemporaine/Nanterre, 1991.

Bergère, M.-C., Lucien Bianco, and Jürgen Domes. *La Chine au xxe siècle. D'une révolution à l'autre 1895–1949*. Paris: Fayard, 1989.

Bernard, Henri. *La guerre totale et la guerre révolutionnaire: Le reflux et l'effondrement de l'Ordre nouveau*. 3 vols. Brussels: Brepols, 1967.

Birtle, Andrew J. *Sicily: The US Army Campaigns of World War II*. Washington: US Army Center of Military History, 1994.

Blumenson, Martin. *Anzio: The Gamble that Failed*. Washington: US Army Center of Military History.

Blumenson, Martin. *The Battle of the Generals*. New York: William Morrow and Co., 1993.

Blumenson, Martin. *Liberation*. New York: Time-Life Books, 1993.

Blumenson, Martin. *Patton: The Man Behind the Legend, 1885–1945*. New York: William Morrow and Co., 1985.

Blumenson, Martin. *Salerno to Cassino*. Washington: US Army Center of Military History, 1993.

Boot, Chris. *Great Photographers of World War II*. Greenwich: Brompton Books Corp, 1993.

Breuer, William B. *Hitler's Fortress Cherbourg*. New York: Stern and Day, 1984.

Bullock, Alan. *Hitler: A Study in Tyranny*. New York: Harper, 1962.

Buton, Philippe, ed. *La guerre imaginée*. Paris: Arslan, 2002.

Candar, Gilles, and Frederic Sorbier. "Quelles photos pour l'Histoire." *Revue TDC* 805 (December 2000).

Churchill, Winston (with *Time-Life*). *The Second World War*. 2 vols. New York: Time Incorporated, 1959.

Crowl, Philip A. *Campaign in the Marianas: The United States Army in World War II*. Washington: Office of the Chief of Military History, Dept. of the Army, 1960.

D'Almeida, Fabrice. *Images et propagande*. Florence: Casterman/Giunti, 1995.

D'Este, Carlo. *Eisenhower: A Soldier's Life*. New York: Henry Holt and Co., 2002.

De Gaulle, Charles. *The Complete War Memoirs*. New York: Carroll & Graf, 1998.

De Gaulle, Charles. *Discours et messages*. 5 vols. Paris: Plon, 1970.

Delporte, Christian, Laurent Gervereau and Denis Maréchal, eds. *Quelle est la place des images en histoire?* Paris: Éd. Nouveau Monde, 2008 (see in particular the chapters by Christian Delporte, "L'histoire contemporaine 'saisie' par les images," pp. 55–64; Elizabeth Parinet, "Regards d'historiens sur l'univers des images fixes," pp. 97–106; and Ilsen About and Clément Chéroux, "L'histoire par la photographie," pp. 143–180).

Desquesnes, Rémy. *Normandie 44; le débarquement et la bataille de Normandie*. Rennes: Éditions Ouest France-Mémorial, 2009.

Direction du Service d'Information du Ministère des Armées. *L'Armée française dans la guerre: du Tchad au Danube*. Paris: Éd. G. P., 1948.

Domenach, Jean-Luc, and Philippe Richer. *La Chine*. Paris: Imprimerie nationale, 1987.

Eisenhower, Dwight D. *Crusade in Europe: a Personal Account of WWII*. New York: Doubleday, 1948.

Gallo, Max. *L'affiche, miroir de l'histoire*. Paris: Robert Laffont, 1982.

Gervereau, Laurent. *Ces images qui changent le monde*. Paris: Seuil, 2003.

Gervereau, Laurent. *Dictionnaire mondial des images*. Paris: Ed. du Nouveau Monde, 1996.

Gervereau, Laurent. *Les images qui mentent. Histoire du visuel au xxe siècle*. Paris: Seuil, 2000.

Gervereau, Laurent. *Montrer la guerre? Information ou propagande*. Paris: Isthme Éditions/CNDP, 2006.

Hackett, David A. *The Buchenwald Trials: Nazi War Crimes and the Pursuit of Justice*. New York: Perseus Books Group, 2007.

Hoffman, Carl. *The Seizure of Tinian*. Washington: Historical Division, Headquarters US Marine Corps, 1951.

Image et mémoire. Sens: Obsidiane, 2007.

Khrushchev, S., ed. *Memoirs of Nikita Khrushchev*. University Park, PN: Pennsylvania State University Press, 2005.

Kissinger, Henry. *Diplomacy*. New York: Simon & Schuster, 1994.

Knightley, Philip. *The Eye of War*. Washington: Smithsonian Books, 2003.

Kunhardt, Philip B. Jr. ed. *Life, The Second World War*. Boston: Little, Brown, 1990.

Laran, Michel, and Jean-Louis von Regemorter. *La Russie et l'ex-URSS, de 1914 à nos jours*. Paris: A. Colin, 1996.

Le Marec, Gérard. *Les photos truquées: un siècle de propagande par l'image*. Paris: Éd. Atlas, 1985.

Leonard, Charles J. "Okinawa." *After the Battle* 43 (1984).

Lewis, Adrian R. *Omaha Beach: A Flawed Victory*. Chapel Hill, NC: The University of North Carolina Press, 2001.

Liddell Hart, B. H. *History of the Second World War*. New York: Putnam, 1971.

Linderman, Gerald F. *The World Within War*. Cambridge, MA: Harvard University Press, 1997.

Lormier, Dominique. *C'est nous les Africains. L'épopée de l'armée française d'Afrique 1940–1945*. Paris: Calmann-Lévy, 2006.

Mansoor, Peter R. *The GI Offensive in Europe: The Triumph of American Infantry Divisions, 1941–1945*. Lawrence, KS: University Press of Kansas, 1999.

Martin, Gibert. *The Second World War*. London: Weidenfeld and Nicholson, 1999.

Morison, Samuel Eliot. *History of United States Naval Operations in World War II* (vol. 14: *Victory in the West Pacific*). Boston: Little, Brown, 1975.

Morison, Samuel Eliot. *History of United States Naval Operations in World War II* (vol. 5: *Sicily, Salerno, Anzio January 1943–June 1944*). Boston: Little, Brown, 1971.

Morris, John G. *Robert Capa: D-day*. Bonsecours: Point de Vue, 2004.

Mosley, Leonard, and the editors of *Time-Life*. *The Battle of Britain*. New York: Time-Life Books, 1979.

Motter, T. H. Vail. *The Middle-East Theater: The Persian Corridor and Aid to Russia*. Washington: US Army Center of Military History, 2000.

Murray, Williamson, and Alan R. Millett. *A War to be Won: Fighting the Second World War*. Cambridge, MA: The Belknap Press of Harvard University Press, 2000.

Overy, Richard. *Why the Allies Won*. New York: W. W. Norton and Co., 1996.

Les pouvoirs des images (texts collected by Sylviane Leprun). *Figures de l'art 11. Revue d'Etudes esthétiques*. Pau: University of Pau, 2006.

Pyle Ernie. *Brave Men*. New York: Henry Holt and Co., 1944.

Robin, Marie-Monique. *Cent photos du siècle*. Paris: Éd. du Chêne/Hachette, 1999.

Romanus, Charles F., and Riley Sunderland. *Stilwell's Mission to China: The US Army in World War II*. Washington: Center of Military History, 1985.

Romanus, Charles F., and Riley Sunderland. *Time Runs out in the China, Burma, India Theaters: US Army in World War II*. Washington: Center of Military History, 1959.

Roux, Alain. *La Chine au xxe siècle*. Paris: Sedes, 1998.

Saunders, Hilary St. George. *Royal Air Force 1939–1945. The Fight is Won*. London: HMSO, 1952.

Shirer, William L. *The Rise and Fall of the Third Reich*. New York: Simon & Schuster, 1960.

Shulman, Major Milton. *Defeat in the West*. New York: E. P. Dutton, 1947.

Stilwell, Joseph W. *The Stilwell Papers, an Iconoclastic Account of America's Adventures in China*. New York: Sloane Associates, 1948.

Taylor, Fred. *The Goebbels Diaries 1939–1941*. London: Sphere, 1982.

Taylor, John. *Body Horror, Photojournalism, Catastrophe and War*. Manchester: Manchester University Press, 1998.

Toland, John. *Rising Sun: Rise and Fall of the Japanese Empire*. New York: Bantam Doubleday, 1970.

Tournier, Michel. *Le bonheur en Allemagne?* Paris: Gallimard, 2006.

Weinberg, Gerhard L. *A World at Arms: A Global History of World War I*. Cambridge: Cambridge University Press, 1994.

Weinberg, Gerhard L. *Visions of Victory*. Cambridge: Cambridge University Press, 2005.

Whelan, Richard et al. *Robert Capa, The Definitive Collection*. Oxford: Phaidon, 2001.

Wheeler, Keith, and the editors of Time-Life Books. *Bombers over Japan, World War II*. Alexandria, VA: Time-Life Books, 1983.

Wheeler, Keith, and the editors of Time-Life Books. *The Fall of Japan, World War II*. Alexandria, VA: Time-Life Books, 1983

Werth, Nicolas. *Histoire de l'Union soviétique. De l'Empire russe à la Communauté d'Etats indépendants 1900–1991*. Paris: PUF, 1990.

Wilt, Alan. *The Atlantic Wall*. New York: Enigma Books, 2004.

Wormser-Migot, Olga. *Quand les Alliés ouvrirent les portes*. Paris: Robert Laffont, 1965.

Zich, Arthur, and the editors of Time-Life Books. *The Rising Sun, World War II*. Alexandria, VA: Time-Life Books, 1977.

PHOTOGRAPHERS AND COLLECTIONS

Werner Bischof (1916–1954)

A Swiss photojournalist initially attracted by painting, during the war Bischof was mobilized for two years (1940–42) and began reporting for the magazine *DU*. In 1945, with his friend Emil Schulthess, he embarked on a major reporting venture through various countries devastated by the war: France, Germany, and Holland. In 1949, he joined the Magnum Photos agency, producing a famous photo-essay in 1951–52 for *Life* magazine on the famine in India.

After a year in Japan, he undertook three journeys in South Korea and traveled to the air base at Okinawa. He also acted as a war correspondent for *Paris Match* in Indochina. He died in a car accident in the Andes in May 1954.

Robert Capa (1913–1954)

Born André Friedmann into a Jewish family from Budapest, he was forced to go into exile when only seventeen, settling in Berlin. In 1933, after Hitler took power, he moved to Paris. His encounter with Henri Cartier-Bresson and David Seymour, known as "Chim," was to prove decisive: together with the Briton George Rodger, they were to found the celebrated Magnum Photos agency in 1947.

Important pictures from the Spanish Civil War brought him recognition and fame; he worked alongside his partner, the photographer, Gerda Taro, who was to perish during the retreat at Brunete. Employed by *Life* magazine, he was to cover major conflicts such as the Chinese resistance against Japanese invasion (1938), the American involvement in the Second World War (1941–45), and the war in Indochina (1954). Tragically, he was to die after stepping on a mine; however, he leaves an extensive photographic oeuvre that bears witness to great events.

Henri Cartier-Bresson (1908–2004)

Born in Chanteloup, France, Cartier-Bresson was at first a keen painter. He attended the studio of André Lhote in Paris, as well as some of the surrealist meetings. He spent a year in the Ivory Coast before crisscrossing Mexico in 1934. Back in France in 1935 after a period in the United States, he became assistant to Jean Renoir and was held as a prisoner of war in Germany during the Second World War. After three escape bids, in February 1943 he was finally successful; he then joined the French Resistance. He photographed and filmed the return of POWs and refugees from the internment camps. With David Seymour, George Rodger, Robert Capa, and William Vandivert, he founded the Magnum Photos agency in 1947. In 1954, he was to be the first Western photographer to enter the USSR after the death of Stalin.

From the 1970s on, he devoted his attention primarily to drawing. In 2003 in Paris, together with his wife and her daughter, he established the Fondation Henri Cartier-Bresson, which has, as he stipulated, an "open door" policy, in keeping with the independent spirit that characterized its founder. Cartier-Bresson died in 2004 in the family residence in the south of France.

Philip Jones Griffiths (1936–2008)

Born in Wales, he became a freelance photographer in 1961, covering the war in Algeria in 1962. In 1966, he joined Magnum Photos and left for Vietnam where he took some iconic images which were later turned into a seminal book, *Vietnam Inc.*, which had a crucial impact on American public opinion and played an essential role in the onset of the peace process. He was subsequently to cover the Yom Kippur War in 1973 and worked in Cambodia, before choosing to base his activities in Thailand in 1977. As both screenwriter and photographer, his oeuvre denounces the unequal struggle between technology and humanity and the devastating effects of armed conflict.

Herbert List (1903–1975)

Born in Hamburg into a prosperous Jewish family, List first studied history of art and literature at Heidelberg University. Around 1930, attracted by the European avant-garde, he met the photographer Andreas Feininger, developing his own highly personal style. When the Second World War broke out, he took refuge in Athens to escape the conflict, but was forced to return to Germany in 1941. Part of his output, stored in a Paris hotel, was lost forever.

Among his most masterly works were his 1946 photographs showing the ruined city of Munich. He met Robert Capa in 1951 and joined the Magnum Photos agency. He devoted the following decade to Italy, significantly influenced by the work of Henri Cartier-Bresson and Italian neorealism. He gradually moved away from photography, concerning himself increasingly with drawing and the great Italian masters.

Wayne Miller (1918)

Born in Chicago in 1918, Wayne Miller joined the army in 1942, engaging in the US Navy, when he was attached to a naval air force unit commanded by Edward Steichen. At the end of the war, he left the army and went back to Illinois, when he set up as a freelance photographer. Thanks to a grant, he was able to make a lengthy documentary on the Afro-American population of Chicago's South Side in 1946–48.

In 1953, he became assistant to Steichen, the director of the photography department in the Museum of Modern Art, preparing for the exhibition *Family of Man*. He entered the Magnum Photos agency in 1958. He was active in many ecological projects in America, in particular defending the forests of California, and abandoned professional photography in 1975.

George Rodger (1908–1995)

Of British nationality, Rodger embarked on a merchant navy cargo ship in 1925, settling, after a number of circumnavigations, in the United States, during the Wall Street crisis of 1929.

He started out in photography in earnest in London, while working for the BBC (1936–38). His account of the London Blitz attracted the attention of *Life* magazine, which took him on as a war reporter (1939–45). He was to follow the epic struggle of the Free French army in Africa and met Robert Capa in North Africa.

Having covered the Liberation of France, on April 20, 1945, he became the first photographer to enter the camp of Bergen-Belsen, where the young Anne Frank had been murdered. He then decided to give up war reporting, leaving for the Middle East and Africa where he was to take many photographs of the customs and rituals of the indigenous people (1947–79). Rodger was one of the founders of the Magnum Photos agency.

David Seymour, known as "Chim" (1911–1956)

Born in Warsaw, Seymour spent his childhood in Russia where his family settled on the outbreak of the First World War. After studying at the academy of art in Leipzig, Germany, by the early 1930s he had become a photographer in Paris, meeting Henri Cartier-Bresson and Robert Capa. He covered the Spanish Civil War from 1936 to 1938, moving to New York at the beginning of the Second World War.

Between 1942 and 1945, he enlisted in the intelligence services of the American army as an interpreter and photographer. In 1947, together with Cartier-Bresson, George Rodger, and Robert Capa, he founded the Magnum Photos agency. After the death of Capa, he was to become president of the Magnum agency, remaining so until his own tragic death, on November 10, 1956, while reporting on prisoner exchanges in the vicinity of the Suez Canal.

W. Eugene Smith (1918–1978)

William Eugene Smith was born in Wichita, Kansas, and took his first photos at the age of fifteen. Quickly abandoning his studies, he settled in New York in 1937, where he worked for *Newsweek* magazine. During World War II, he was dispatched as a correspondent to the Pacific and photographed the American offensives against Japan in Saipan, Guam, Iwo Jima, and Okinawa. He was seriously wounded on Okinawa on May 22, 1945. After a lengthy convalescence, he returned as a photographer for *Life* magazine, joining Magnum Photos in 1955. He left the agency's books in 1959, composing, together with his wife, a documentary on an ecological catastrophe in Minamata, Japan.

MAGNUM COLLECTIONS

Soviet Group Collection/Magnum Distribution

Dimitri Baltermants, Anatoly Garanin, Yvegeni Khaldei, G. Petrusov, Yakov Ryumkin,
Ivan Shagin, V. Tiomin, Mikhail Trakhman, Alexander Ustinov, Georgi Zelma.

Dimitri Baltermants, doyen of the Soviet Group, represented the association of the photographers of Russian wars and was invited by Cornell Capa
(Robert Capa's brother) to plan a major retrospective at the International Center of Photography in 1987.

Micha Bar-Am Collection
Barbey Collection/Magnum Distribution
J. A. Fox Collection/Magnum Distribution
Japanese Collection/Shunkichi Kikuchi/ Magnum Distribution
Lessing Collection/Magnum Distribution

Wu Yinxian/Magnum Distribution

PHOTO CREDITS

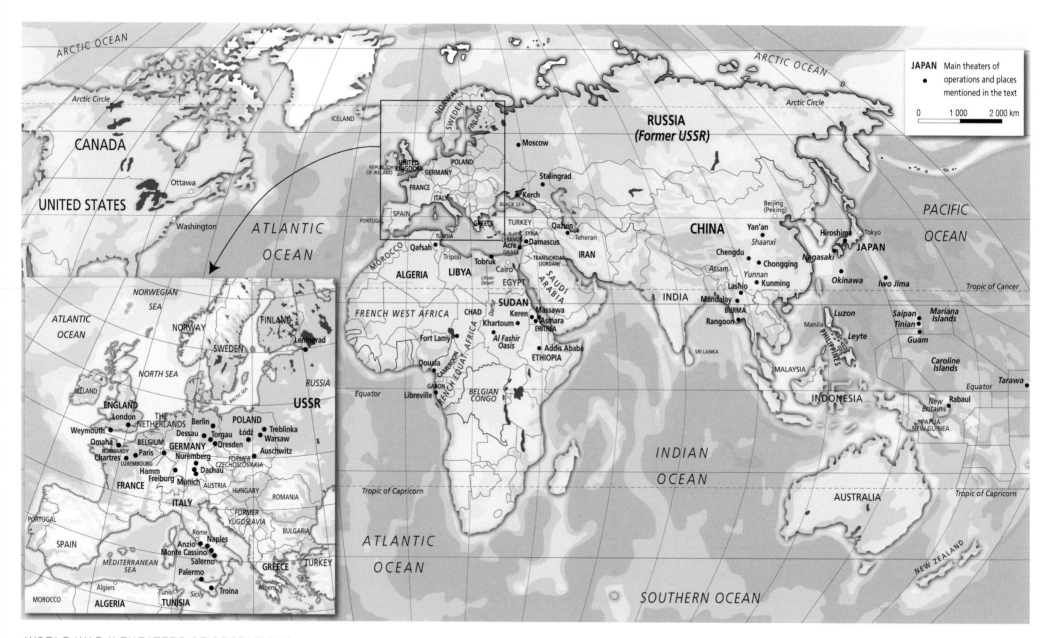

WORLD WAR II THEATERS OF OPERATIONS

ACKNOWLEDGMENTS

The author wishes to thank:

Anne-Marie Plante of Minneapolis, Minnesota

Caroline Brou of Éditions Ouest-France, Rennes

Marie-Christine Biebuyck of the Magnum Photos agency, Paris

Michèle Neveu at the Médiathèque l'Apostrophe: Section Patrimoine, Chartres

Philippe Patrice

Éditions Ouest-France give particular thanks to:

Clarisse Bourgeois

Stéphan Minard

James A. Fox for his kind participation.

Translated from the French by David Radzinowicz (pp. 6–7 and 44–191) and Kirk McElhearn (pp. 8–43)
Design: Studio graphique des Éditions Ouest-France
Copyediting: Penelope Isaac
Typesetting: Gravemaker+Scott
Proofreading: Chrisoula Petridis
Color Separation: graph&ti, Cesson-Sévigné, France
Printed in Tours, France, by Mame Imprimeurs

Distributed in North America by Rizzoli International Publications, Inc.

Simultaneously published in French as *Les Photographes de Magnum sur le front de la Seconde Guerre mondiale*
© Éditions Ouest-France, 2009
© MAGNUM Photos for the photographs

English-language edition
© Flammarion, S.A., Paris, 2009
© MAGNUM Photos for the photographs

editions.flammarion.com
www.magnumphotos.com

09 10 11 3 2 1

ISBN-13: 978-2-08-030114-7

Dépôt légal: 10/2009